Civilizing American Cities

THE MIT PRESS
CAMBRIDGE,
MASSACHUSETTS,
AND LONDON, ENGLAND

Civilizing American Cities

A Selection of Frederick Law Olmsted's Writings on City Landscapes

edited by S. B. Sutton

First MIT Press paperback edition, 1979

Introductions by S. B. Sutton
Copyright © 1971 by
The Massachusetts Institute of Technology

Set in Linotype Bodoni
Printed and bound by The Alpine Press Inc.
in the United States of America.

ISBN 0-262-19070-2 (hard)
ISBN 0-262-65012-6 (paper)

Library of Congress catalog card number: 72-113729

Civilizing American Cities

1 Frederick Law Olmsted, 1822–1903: Introduction by S. B. Sutton

I have lived a half a block from his masterpiece, Central Park, in New York City. And though I have walked through it at least a hundred times, I have always found some new place; my most recent discovery was the bird sanctuary. Today I live in Boston, on a street which is part of Olmsted's metropolitan park plan, and I move through some other portion of that landscape almost every day of my life.

As my admiration for Olmsted's work and my affection for his character grew, I simply gave up all efforts at impartiality. Reading Olmsted gives special delight. Olmsted does not hide among his words. One feels his passion, sensitivity, responsiveness, irritation, stubbornness, and optimism on every page. He tells jokes, describes personal experiences, and never fears to insult if an insult can serve his purpose. He has no reverence for meaningless traditions or inappropriate forms, either in architecture or in human behavior.

One must make some allowances, of course. Olmsted repeated himself often in his letters, articles, and books. But this happened because he represented minority causes and could not avail himself of mass media as one can today. (However, mass media have certainly not eliminated more ponderous repetitions!) His concept of the "good" life is dated, for although he rejected formalized religion, he did not entirely escape his upbringing. Yet his gentle humanism cuts through his stylized morality. Olmsted believed, with his contemporaries, in the spiritual progress of man. As a landscape architect he tried, above all, to civilize the city; his parks simulated nature in response to the needs of an urban population. He recognized the necessity of extensive planning to provide for logical development of the city as an environment where a man could lead a meaningful life; and he saw the seeds of our contempo-

rary problems and tried to prevent them from germinating. Obviously, the task was too large for one man.

With the advantage of hindsight, it is easy to see how Olmsted finally became a landscape architect and a manipulator of city spaces; retrospect somehow invests accident with a kind of logic. His beginnings were provincial, and his early life disorderly. Olmsted's father, John, was a successful dry-goods merchant in Hartford, Connecticut, and Frederick was his first son. Olmsted had the consideration to assist his biographers by committing to paper some reflections upon his childhood experiences.[1] In these written fragments, he recalled, with special affection, his father as a quiet, unaffected man who communicated his spontaneous pleasure in ordinary things, particularly in nature, which most people took for granted.

Determined that his son should have the firm, puritanical background that he knew himself incapable of providing, John Olmsted — most likely encouraged by his second wife — placed the child in care of six successive ministers of varying temperament and intelligence. Thus, between the ages of six and twelve, Olmsted's head was crammed with religious instruction that he was forced to parrot back on command. This had precisely the opposite effect of what was presumably intended. Instead of becoming a stern Puritan, he developed a youthful suspicion of orthodox religion. Passed from one teacher to another, he loathed classroom learning at an early age and cherished intellectual independence. His happiest moments came between schools or during vacations when his family took him on long trips through New England or permitted him to roam freely near Hartford, visiting in the households of his numerous relatives, who always welcomed him warmly.

[1] Frederick Law Olmsted, Jr., and Theodora Kimball, eds., *Frederick Law Olmsted: Landscape Architect*, Vol. 1 (New York: G. P. Putnam's Sons, 1922), pp. 45–57.

Olmsted should have entered Yale at the age of sixteen, but a temporary eye disorder resulting from sumac poisoning necessitated a change of plans, and he passed the next two and a half years studying topographical engineering with a tutor. By his own admission, however, this period was "really for the most part given over to a decently restrained vagabond life, generally pursued under the guise of an angler, a fowler, or a dabbler on the shallowest shores of the deep sea of the natural sciences."[2] Thereafter, he continued upon his random course: he worked, bored to death, for nearly two years in a French importing house in New York; in 1843–1844 he made a sea journey to China — seeing a lot of water but little of China; and upon his return he passed several months with an uncle, studying practical agriculture. Meanwhile, his younger brother John enrolled at Yale and, though disapproving of the rigors of conventional education, Olmsted joined him there for months at a time, sat in on lectures, made friends, and generally amused himself.

At this stage of his life — in his mid-twenties — farming attracted him most. His father indulged his whim (which, naturally, did not manifest itself frivolously) first by purchasing a farm for him in Connecticut, and, when that failed after a year, by setting him up on a second one on Staten Island. For some time, Olmsted worked enthusiastically, investigating scientific techniques to begin a fruit-tree nursery, consulting with agricultural and horticultural experts, including Andrew Jackson Downing, and introducing contemporary farming methods to his neighbors. He made landscape improvements around the farmhouse, and his friends praised his ingenuity. He had come to agriculture with a mission to educate farmers and improve their standards, believing farming to be an innocent, spiritually and physically wholesome, useful way of life.

[2] *Ibid.*, p. 61.

But the simplicity and regularity that initially pleased him grew tiresome. The farm alone could not satisfy his imagination. He voraciously read novels, horticultural journals, art books, political philosophy, had amiable conversation with friends, and fell rapidly in and out of love.[3] He also worried about the purposes of religion. Christian ethics held him, and he believed in God. But Christian rituals seemed to him to bear little relationship to the teachings of Christ or to human experience as he understood it.

In 1850, Olmsted took a vacation from his Staten Island farm and, on April 30, embarked upon a six-month trip to England and the continent with his brother and Charles Loring Brace, a friend from Yale days and later a pioneering social worker in the slums of New York. Olmsted's avowed purpose was to learn something about English agricultural methods, but note the dates of his absence: a dedicated farmer would not usually leave his land during planting, growing, and harvesting seasons. In England, his attention, which he took no particular pains to discipline, wandered; and, for all his good intentions, it is clear he was losing his interest in agriculture as a career. The trip, however, provided the excuse for his first book. He began the manuscript for *Walks and Talks of an American Farmer in England* a few months after his return, and the volume was published in 1852. Here, as in all his writings, Olmsted delights with his unaffected style, and one sees clearly his wit, his perception of the nuances in any situation. In view of his later accomplishments, one notes particularly his enthu-

[3] In 1859, Olmsted married Mary Cleveland (Perkins) Olmsted, widow of his brother John, who died of tuberculosis in 1857. He thus became stepfather to four children. He had three children of his own, but the first son died in infancy. In his thesis ("Selected Letters of Frederick Law Olmsted," Harvard University, 1960), Charles C. McLaughlin remarks that Olmsted was jilted by a young lady, ca. 1858, and that his disappointment partially accounts for the relentless energy with which he attacked the Central Park project.

siastic description of Sir Joseph Paxton's design for the People's
Garden in the Liverpool suburb Birkenhead.

The publication of *Walks and Talks* and the efforts of Charles
Brace brought Olmsted to the attention of Henry Raymond of *The
New York Daily Times,* who in 1852 commissioned him to report
upon conditions in the southern United States. He thought Olmsted
could provide a balanced view, which might offset the extreme pic-
tures of southern degeneracy painted by northern abolitionists, and
perhaps help quell the rising war fever. In December, Olmsted
began the first of three tours through those disturbed, paradoxical
states in the South.[4] His writings for *The Times* are noted today as
among the most sensitive and objective observations on southern
culture before the Civil War. The *Times* editors, apparently expect-
ing a more conventional rundown of politics, were initially baffled
by his homely observations, but noting the response of readers in
both the North and the South, withdrew their objections and let
Olmsted do as he pleased.

Whether or not he was supposed to be "objective," Olmsted set
out with preconceptions. Brace had brought him to meet William
Lloyd Garrison, the fiery abolitionist, and to a great extent he sym-
pathized with Garrison's moral arguments. But Olmsted was
more Social Democrat than abolitionist. Though he did not favor
the extension of slavery into other states, he did not want to go to
war over the issue. Instead of imagining white southerners as
monsters, he viewed them as hapless victims of a bad system. In
his judgment, neither earnest nor self-righteous damnation of
southern iniquities would contribute solutions to the problem. He

[4] Arthur M. Schlesinger, ed., *The Cotton Kingdom: A Traveller's Observations on
Cotton and Slavery in the American Slave States,* by Frederick Law Olmsted (New
York: Alfred A. Knopf, 1953). This is the most recent edition of Olmsted's southern
writings.

believed that slavery had to be economically and socially unsound and that if one could demonstrate this theory and present alternatives, the South could be won over to a free labor system.[5]

The slave system humiliated not only the black man but the entire South. ". . . The oppression and deterioration of the negro race is much more lamentable than is generally supposed by those who like myself have been constrained, by other considerations, to accept it as a duty to oppose temperately but determinately the modern policy of the South, of which this is an immediate result. Its effect on the white race, I still consider to be infinitely more deplorable."[6] The economic waste and neglect that he saw offended him, and, as a student of agriculture, it pained him that the South should fall so short of its obvious potential. Olmsted despaired over the plight of the "poor whites" whose physical and moral condition he observed to be little better than that of the slaves, and who were as much victims of slavery as the blacks. Slavery had cast a cultural pall, and as long as the system and the attitudes that accompanied it prevailed, the South was doomed to provincialism.

Olmsted's southern trips nourished his disenchantment with rural life. His prolonged absences and his preoccupation with his writing did not contribute to his agricultural efforts. Though he kept his Staten Island farm into the 1860s, he did his last real farming in 1854. In 1855–1856, he joined two friends in a publishing venture, *Putnam's Monthly Magazine*, which failed, leaving him with debts and doubts. He was then thirty-four years old.

More and more of the opinion that the city was the best place for him, in September 1857 he armed himself with letters and recommendations, applied for, and received the position of Superin-

[5] For an excellent discussion of Olmsted's southern writings see: Broadus Mitchell, *Frederick Law Olmsted: A Critic of the Old South* (Baltimore: The Johns Hopkins Press, 1924).
[6] Schlesinger, ed., *The Cotton Kingdom*, p. 479.

tendent of the Central Park in New York City. By April of the following year, he had become a landscape architect.

In his autobiographical fragments, Olmsted has referred to himself as a "wholly unpractical man," and he clearly relished this epithet. In Victorian America, practicality was a much admired virtue; in Olmsted's vocabulary, "practical" was an insult. The practical man was the expedient man, in the worst sense of the word. The practical man chose the quickest, easiest solution to any problem, without reference to excellence. In Olmsted's experience, the self-interested politician was the prototype of the "practical" man. From the day he first applied for the position of Superintendent of Central Park until his last major project, the World Columbian Exposition in Chicago in 1893, Olmsted spent a good part of his career in conflict with "practical" men — grappling with the Establishment, so to speak.

Central Park is Olmsted's best-known achievement, and since at least one heavy volume has already been devoted to the history of this work, there is not much point in repeating it at length.[7] At the time he became its Superintendent, Central Park was a huge tract — 770 acres, including about 150 acres of reservoirs — which the city had obtained earlier in the decade with the intention of creating a public park. It was then, as it is now, vulnerable to political fancies, and it is probably one of the miracles of the last hundred years that a superior plan was selected, executed, and permitted to remain more or less intact.

Olmsted had barely taken up his duties as Superintendent when Calvert Vaux invited him to collaborate on a design for the park area. Their plan, prepared at night and on weekends, and called

[7] Olmsted, Jr., and Kimball, *Olmsted; Landscape Architect*, 2. See also, Albert Fein, *Landscape into Cityscape* (Ithaca, New York: Cornell University Press, 1968), pp. 47–88.

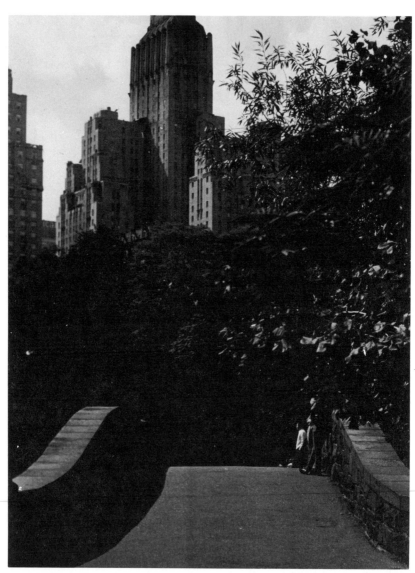

Central Park, New York. S. B. Sutton.

"Greensward," was submitted in open competition and chosen over thirty-two other proposals. In May 1858, the Board of Commissioners appointed Olmsted as Architect in Chief for Central Park. The precise nature of the working relationship between Olmsted and Vaux is not at all clear, a situation that is frustrating to historians. Vaux, an Englishman, was educated as an architect. Andrew Jackson Downing met him during a voyage and convinced him to come to the United States in 1850. Downing was a horticulturist, tastemaker, and proponent of naturalism in landscape gardening in the tradition of Ruskin and "Capability" Brown; during the 1840s, he had been active in popularizing the notion of a public park for New York, but his accidental death in 1852 prevented him from seeing that dream materialize. Vaux, trained in building design, learned landscape architecture from Downing. Olmsted, of course, came to landscape architecture with a background in botany and horticulture, but he had no practical experience beyond his efforts at the Staten Island farm, and one must conclude that he learned the professional crafts from Vaux. However, because of his literary abilities and his missionary zeal, it was Olmsted who emerged as the principal spokesman for their projects; and though he gave Vaux due credit, the latter's name faded into the background. The two men were partners until 1872, when they separated, presumably amicably. One current historian has remarked that Vaux became bitter, feeling that he had somehow been denied his share of notoriety.[8]

Altogether, it took almost twenty-five years to complete Central Park, and the tensions of confrontations with "practical" men brought the high-strung Olmsted to the brink of nervous collapse on more than one occasion. He resigned from the project five times, but always returned, attentive to every detail, protecting it against

[8] Fein, *Landscape into Cityscape*, p. 43n.

the frivolities of politicians or amateur do-gooders. In the case of Central Park, as in all his parks, he argued for his design not as art for its own sake but because the park fulfilled the physical and psychological needs of city people.

Long before the New York park was finished, Olmsted — both singularly and in partnership with Vaux — had earned a reputation. Between 1860 and 1865, of course, the country was trapped in its Civil War, and nobody, including Olmsted, was building parks. Disqualified by a leg injury from military service, he took a leave of absence from his New York obligations and went to Washington as Secretary of the U.S. Sanitary Commission (the parent organization of the American Red Cross), which he helped to organize. Unsure that landscape architecture, as a profession, had anything better than ulcers to offer him, he considered applying for the position of U.S. Commissioner of Agriculture and Statistics. Instead, in 1863, overworked and exhausted, he resigned from the Sanitary Commission and moved to California to become Superintendent of the Mariposa Mining estates in Bear Valley. As the war ended in 1865 and the country returned to a semblance of normalcy, however, he became tentatively involved in advising the city of San Francisco on a park and in site planning in Berkeley for a branch of the University of California. Meanwhile, Vaux urged him to return to New York and collaborate on a park project in Brooklyn. Terrified at the prospect of wrangling anew with political forces, Olmsted vacillated; but he finally packed up his family and returned East. With that decision, he committed himself to landscape architecture and, through it, to city planning.

Arguments between Olmsted and respective city officials recurred with Greek inevitability, and it is quite easy to understand the sources of conflict. The success and popularity of Central Park started a trend, and city administrators throughout the country woke

up to the advantages of open spaces. The land they were willing to purchase and sacrifice for this purpose, however, was usually some site undesirable for commercial or residential buildings, and in no way integral to the established patterns of city life, for example: the Fens in Boston; the mountain in Montreal; the swamps in Buffalo; the marshland in Chicago. In general, the officials adopted simplistic notions of a park, separating it in their minds from the activities of the city. Olmsted's effort was to integrate the two, and his designs spilled over the borders of the sites allotted him. He advised the extension of public transportation facilities, and planned tree-lined avenues to and from the proposed park areas, thus offering the harassed city dweller daily relief from crowded streets, buildings, and the spiritual aggravations of commerce and densely populated neighborhoods. While he desperately explained how the intelligent development of the park, and related spaces and services, would benefit the growth of the city in future decades, many politicians could not visualize anything beyond the next election.

There were happy exceptions when artist and administrators shared objectives. Olmsted and Vaux worked harmoniously with the Brooklyn Park Commission and, after defeating initial tirades against his plan, Olmsted established friendly relations with Boston authorities. Enlightened newspaper editors and important individuals often rallied to his defense and were influential in obtaining popular and legislative support. Olmsted sometimes lost his battles. A group of "practical" men — this time developers, not politicians — turned down his proposals for a seaside park at Rockaway Point in Queens, and his recommendations for the improvement of Staten Island were never acted upon. In many instances, of which the Mount Royal Park in Montreal is a stunning example, the basic character of Olmsted's design prevailed, but

"practical" men permitted the introduction of offensive, small-scale alterations.[9]

By the later 1860s, Olmsted was in constant demand as a designer and consultant. After dissolving his partnership with Vaux, he worked for a while in loose association with Jacob Weidenmann. Later, he took his stepson, John Charles Olmsted, as an apprentice and, eventually, as a partner. In 1883, he transferred his home and offices from New York to Brookline, Massachusetts, a suburb of Boston similar in character to the suburban community Riverside, which he and Vaux designed near Chicago. As his office expanded, Olmsted instructed Charles Eliot, son of the Harvard president, Philip and Henry Codman, and F. L. Olmsted, Jr., in the profession, thus assuring an Olmstedian tradition in landscape architecture and city planning for at least another generation.[10] (Unfortunately, both Eliot and Henry Codman died young.) The office handled private jobs as well as city parks. One of the biggest private commissions was George Washington Vanderbilt's huge estate, "Biltmore," in Asheville, North Carolina.

Olmsted's contemporaries recognized and applauded his genius. Universities awarded him honorary degrees, and artists and architects admired his landscapes, though his relations with the latter were not entirely free from anxieties.[11] During the celebrations relative to the World Columbian Exposition, for which he had prepared the site plan, Olmsted — by then in his seventies — was toasted, praised, and honored.

[9] See A. L. Murray, "Frederick Law Olmsted and the Design of Mount Royal Park, Montreal," *Journal of the Society of Architectural Historians* 26, no. 3 (October 1967) : 163–171.

[10] The firm of Olmsted Associates, landscape architects, still conducts business from Olmsted's old house on Warren Street in Brookline.

[11] Perhaps his most serious quarrel was with Stanford White over architectural embellishments that White had designed for Prospect Park in Brooklyn. Convinced that White was spoiling the pastoral character of the Park, Olmsted branded him a fanatic. Charles C. McLaughlin, ed., *Selected Letters of Frederick Law Olmsted*. Ph.D. Thesis, Harvard University, 1960.

Evaluating his own career, he wrote:

I need not conceal from you that I am sure that the result of ‚what I have done is to be of much more consequence than any one but myself supposes. As I travel, I see traces of influences spreading from it that no one else would detect, which if given any attention by others, would be attributed to "fashion." There are, scattered through the country, seventeen large public parks, many more smaller ones, many more public or semi-public works, upon which, with sympathetic partners or pupils, I have been engaged. After we have left them, they have, in the majority of cases, been more or less barbarously treated, yet as they stand they are a hundred years ahead of any spontaneous public demand, or of the demand of any notable cultivated part of the people. And they have an educative effect perfectly manifest to me — a manifestly civilizing effect. I see much indirect and unconscious following of them. It is strange how often I am asked "where did you get that idea?" as if an original idea on the subject had not been expected. But I see in new works of late much evidence of effects of invention — comprehensive design; not always happy, but symptomatically pleasing. Then I know that I shall have helped to educate in a good American school a capital body of young men for my profession — all men of liberal education and cultivated minds. I know that in the minds of a large body of men of influence I have raised my calling from the rank of a trade, even of a handicraft, to that of a liberal profession, an art, an art of design.[12]

Olmsted did not usually invoke art. When challenged by "practical" men, he seldom argued from the position of an artist. No doubt he believed that however dazzled these men might be by the artist's mystique, they could only be moved by the logic of cost effectiveness, real estate values, and, perhaps, social benefit. But note the following agitated passage from one of his letters of resignation from the Central Park project:

The work of design necessarily supposes a gallery of mental pic-

[12] Olmsted, Jr., and Kimball, *Olmsted; Landscape Architect*, Vol 1: 68–69. McLaughlin quotes this entire letter in his thesis and identifies it as one written from Olmsted to Elizabeth Baldwin Whitney, Dec. 16, 1890.

tures, and in all parts of the park I constantly have before me, more or less distinctly, more or less vaguely, a picture, which as Superintendent I am constantly laboring to realize. Necessarily the crude maps which are laid before you are but the merest hints of the more rigid outlines of these pictures, of these plans.

I shall venture to assume to myself the title of artist and to add that no sculptor, painter or architect can have anything like the difficulty in sketching and conveying a knowledge of his design to those who employ him which must attend upon an artist employed for such a kind of designing as is required of me. The design must be almost exclusively in my imagination. No one but myself can feel, and without feeling no one can understand *at the present time* the true value or purport of much that is done in the park, of much that needs to be done. Consequently except under my guidance these pictures can never be perfectly realized, and if I am interrupted and another hand takes up the tools, the interior purpose which has actuated me will be very liable to be thwarted, and confusion and a vague discord result. Does the work which has thus far been done accomplish my design? No more than stretching the canvas and chalking a few outlines, realizes the painter's. Why, the work has been thus far wholly and entirely with dead, inert materials: my picture is all alive — its very essence is life, human and vegetable. The work which has been done has had no interest to me except as a basis, as a canvas, as a block.[13]

In this letter, written three and a half years after work had started on Central Park, Olmsted addressed one of the peculiar and most difficult aspects of his art: the awkward transition between the design and realization of a landscape, a task that requires the landscape architect to project his imagination into a distant future and to be the most patient and persistent of artists. The initial phases of blasting, grading, preparation for drainage, road construction, and planting create a bruised and battered ter-

[13] Frederick Law Olmsted, Letter to the Board of Commissioners of the Central Park, January 22, 1861, quoted in Olmsted, Jr., and Kimball, *Olmsted*, Vol. II; 310.

rain. Freshly planted saplings appear spindly and hopelessly inadequate. The clients surveying the battlefield tend to get nervous. The politician who has been elected for four years is not easily persuaded by the argument that the park will outgrow this painful adolescence in, say, ten years and will acquire the graces of maturity in twenty or thirty years.

The long period necessary for development made Olmsted's art vulnerable to assaults upon its integrity: encroachments, suggestions for instant showy foliage, land-grabbing, neglect, and well-intentioned but thoughtless architectural embellishments and frivolities inconsistent with the coherence of the design. Olmsted could never divest himself of artistic responsibility. It was characteristic of him to persist in his attention for years after the initial construction and planting of his schemes. He watched over park maintenance and tried to fight off violations of his plans — often at great expense to his peace of mind. If, to honor his metaphor, he conceived of each landscape design as a canvas, it was a canvas of living, growing, changing materials, forever unfinished.

Reflecting upon his art in another context, Olmsted advanced the following explanation in the hope of dispelling popular misconceptions of his intentions:

A mere imitation of nature, however successful, is not art, and the purpose to imitate nature, or to produce an effect which shall seem to be natural and interesting, is not sufficient for the duty before us.

A scene in nature is made up of various parts; each part has its individual character and its possible ideal. It is unlikely that accident should bring together the best possible ideals of each separate part, merely considering them as isolated facts, and it is still more unlikely that accident should group a number of these possible ideals in such a way that not only one or two but that all should be harmoniously related one to the other. It is evident,

however, that an attempt to accomplish this artificially is not impossible, and that a proper study of the circumstances relating to the perfect development of each particular detail will at least enable the designer to reckon surely on a certain success of a high character in that detail, and a comprehensive bringing together of the results of his study in regard to the harmonious relations of one, two or more details may enable him to discover the law of harmonious relation between multitudinous details; and if he can discover it, there is nothing to prevent him from putting it into practice. The result would be a work of art, and the combination of the art thus defined, with the art of architecture in the production of landscape compositions, is what we denominate landscape architecture.

The first process in the application of this art upon any given site, is the formation of a judgment upon the capabilities and the limitations of that site, with reference to the artistic purpose. It is obviously impossible, for instance, to produce in the vicinity of Brooklyn such scenery as will affect the mind as it is affected by the Alps or the Sierras, on the one hand, or by the luxuriant vegetation of a tropical swamp on the other.

Moreover, there are certain kinds of scenery which experience shows to be most satisfactory within a town park, which require an extensive aggregation of their elements. It will be readily seen, for instance, that if all the wood, water and turf, within a certain area of ground, were distributed in patches, strips and pools, however extensive as a whole, and however varied in detail it might seem to those who should thoroughly explore all its parts, there would be no part which would not seem confined, there could be no large open single scene, and no such impression or effect on the mind would be produced as there would be if all the water were collected in one lake, all the trees in one grove, all the strips of grass in one broad meadow. Such aggregations, and consequently the degree of the impression intended to be produced by them, must be limited by consideration for two other purposes: the purpose of variety of interest, and the purpose to make all the scenery available to the satisfaction of the public by ways

of communication. Other limitations upon the artistic purpose, again, are imposed by conditions of soil and exposure, by rocks and springs. How far each of these can be overcome, as by blasting, draining, grading, screening, manuring and other processes, must be in every case a special study, and the artistic purposes of the plan must be affected in every part and particular by the conclusions arrived at.[14]

This description, of course, is a modest definition of Olmsted's art, circumscribed by the outlines of the park site. If he had remained within those confines, there would be far less current interest in his work and he would be remembered only by a few enthusiasts as a superb manipulator of horticultural elements. And indeed, he commanded a knowledge of plant materials that very few modern landscape architects can match. (In fact, there was a period during the fifties and sixties when students of landscape architecture learned a lot about concrete and precious little about plants; happily, the trend seems to be changing.)

But Olmsted deliberately extended his art well beyond the circumference of the park. He conceived of the urban park as an integral part of the complex system of a city. It is in descriptions of the relationship of the park to the city that his writing tends to turn into dated rhetoric — and sometimes distracts the modern audience. All that talk about the social, moral, and physical benefits of parklands, though it contains much wisdom, often fails to capture the greater wisdom of his art: the attention to edges, the connections to the city proper, the formal implications of the park thoughtfully spun out and integrated into the design. Where his words obscure, however, his works speak eloquently in his behalf. Central Park, for instance, interrupts an otherwise monotonous grid, but its edges do not conflict with it; the park is easily acces-

[14] "Preliminary Report to the Commissioners for Laying out of a Park in Brooklyn, New York: Being a Consideration of Circumstances of Site and Other Conditions Affecting the Design of Public Pleasure Grounds" 1866.

sible and makes the grid more readable. In Boston, Olmsted's most sophisticated design, the boundaries have been stretched taut, and the park system has been conceived as a series of parkway links and park joints in the city skeleton. Olmsted's parks never end at their edges. Sometimes by design, sometimes by implication, they send tentacles into the city; they suggest consequential dispositions of streets, traffic patterns, and neighborhoods. Even where later planners or developers have ignored the formal implications, Olmsted's parks often continue to exert influences far beyond their boundaries.

Olmsted was not an arrogant man. He did not propose to plan entire cities; rather he suggested measures that would influence their incremental growth. In the same way that he could imagine a two-inch-caliper sapling as a majestic shade tree, so he could imagine means of transportation, building technologies, and social priorities still unknown to him that would generate their own appropriate urban forms.

Fashion is fickle. It waxes and wanes with far less predictability than the moon. Celebrated as the dean of American landscape architecture by the end of his life, Olmsted later subsided into near obscurity as architects and planners fought to shed the burden of the historic past and fixed their attention upon the International School and other modern movements. That energetic propagandist of a "new architecture," Le Corbusier, complained about Central Park in *When the Cathedrals Were White*, "Central Park is too large and it is a hole in the midst of buildings. It is a lesson. You go through Central Park as if you were in a no man's land. The verdure, and especially the space, of Central Park should be distributed and multiplied throughout Manhattan." But never bashful about contradicting himself, even in the same volume, Le Corbusier also called the park an "immense treasure." The "capital

body of younger men" that Olmsted had educated in the nineteenth century could not sustain his initiatives, and their work fell by the side of the design mainstream. Designers of landscape and buildings embraced the aesthetics of technology and engineering. Landscape architecture as practiced by Olmsted declined as an art.

Still later — perhaps because they had liberated themselves from traditional constraints — architects and planners returned to study the past, to find its values, and to rediscover Olmsted. Sometime in the late 1960s, Olmsted became the subject of a great revival of enthusiasm on the part of professionals and laymen. Many people wished to protect his parks, often under the banner of historic monuments; professionals studied him in hope of finding remedies for ailing cities. And so, through his living parks, his plans, and his writings, Olmsted educates a new generation of women and men.

Olmsted left a colossal written record of his life and career in published and unpublished documents and letters. His heirs donated the entire collection to the Library of Congress in Washington, where twenty-four thousand items occupy twenty-three linear feet of shelf space and are available to scholars. A great deal of that material, including personal correspondence, is still in manuscript form. *Walks and Talks of an American Farmer in England* and Olmsted's southern writings — and I particularly commend the Schlesinger edition — are readily found in public and university libraries. Olmsted's printed documents relating to landscape design, however, are somewhat more difficult to locate. The library at the Graduate School of Design at Harvard University has what may be the most complete set of these documents apart from the Library of Congress collection.

For the purposes of this anthology, I have drawn only from printed matter.[15] In the hope of elucidating Olmsted's theories and solutions relevant to city design, I have edited these documents in order to reduce overlapping discussions of social concepts and technical or detailed political problems that no longer seem significant. While such a distillation necessarily sacrifices some historical content, it helps to sharpen the focus upon Olmsted's understanding of and solutions for urban spaces.

[15] For further writings by Olmsted, I refer the reader to *Frederick Law Olmsted: Landscape Architect*, edited by F. L. Olmsted, Jr., and Theodora Kimball, in two volumes entitled "Early Years and Experiences" and "Central Park" (New York: G. P. Putnam's Sons, 1922) ; and to *Landscape into Cityscape* edited by Albert Fein (Ithaca, N.Y.: Cornell University Press, 1968), in which several of Olmsted's reports relating to his work in the greater New York area have been reprinted. *Frederick Law Olmsted, Sr.: Founder of Landscape Architecture in America* by Julius G. Fabos, Milde, and Weinmayr (Boston: University of Massachusetts Press, 1968) contains reproductions of many Olmsted designs and maps, accompanied by brief explanatory notes.

Perhaps the most pleasing volume, however, is the Sierra Club's photographic essay on Central Park in New York, with an introduction by Marianne Moore. Those of us familiar with the Sierra Club's long record of protecting wilderness areas appreciate this departure from traditional policy and recognize it as a very special tribute to the art of Olmsted and Vaux. David Brower, ed., *Central Park Country: A Tune Within Us* (San Francisco, New York, London: Sierra Club, 1968).

2

Expanding Cities:
Random versus
Organized Growth

Olmsted's writings in this section are representative of his views
on urban society, landscapes, and city design. The themes he stated
in these documents recurred — with variations — in other papers
and motivated his plans. His sensitivity to growth as an urban
problem was uncommonly acute in an era when men generally took
a static approach to planning.

As he designed urban parklands, Olmsted became increasingly
convinced that the problems of the nineteenth-century city resulted
from inorganic growth and the abuse of space; his historical ob-
servations, in Europe and in the United States, confirmed his belief.
He frequently discussed traditional dispositions of parks and
streets and, under this heading, the "grid system," America's an-
swer to city planning. The idea of creating street lines by indiscrim-
inate cross-hatching particularly aggravated him as a simple-
minded, unnatural, and dehumanizing method. He advised against
perpetuating solutions that, though perhaps convenient in the past,
could not meet the requirements of the modern and future city. In
this context, he defended the necessity for taking large areas as

public parklands and weaving them, by street systems and public

transport, into the fabric of the city.

Wary of the potential pitfalls of planning, he warned: "A judi-

cious laying out . . . requires a certain effort of forecast, as to what

the city is to be in the future. In this respect, there is as great a

danger in attempting too much as in attempting too little."[16]

[16] Frederick Law Olmsted and James R. Croes, "Preliminary Report of the Landscape
Architect and the Civil and Topographical Engineer, Upon the Laying Out of the
Twenty-third and Twenty-fourth Wards," City of New York, Document No. 72 of the
Board of the Department of Public Parks, 1877.

The Structure
of Cities:
A Historical
View[17]

. . . At present, large towns grow up because of the facilities they
offer mankind for a voluntary exchange of service, in the form of
merchandise; but nearly all the older European towns of impor-
tance, from which we have received the fashion of our present street
arrangements, were formed either to strengthen or to resist a pur-
pose involving the destruction of life and the plunder of merchan-
dise. They were thus planned originally for objects wholly different
from those now reckoned important by the towns which occupy the
same sites, and an examination of the slow, struggling process by
which they have been adapted to the present requirements of their
people, may help us to account for some of the evils under which
even here, in our large American towns, we are now suffering.

HISTORICAL DEVELOPMENT OF EXISTING STREET ARRANGEMENTS, FIRST STAGE

They were at the outset, in most cases, entrenched camps, in which
a few huts were first built, with no thought of permanence, and still
less with thought for the common convenience of their future citi-
zens. The wealth of their founders consisted chiefly in cattle, and in
the servants who were employed in herding and guarding these
cattle, and the trails carelessly formed among the scattered huts
within the entrenchments often became permanent foot-ways which,
in some cases, were subsequently improved in essentially the same
manner as the sidewalks of our streets now are, by the laying upon
them of a series of flat stones, so that walkers need not sink in the
mud. If the ground was hilly, and the grades of the paths steep,
stairs were sometimes made by laying thicker slabs of stone across
them. Convenience of communication on foot was, of course, the
sole object of such improvements.

If, in these early times, any highways were more regularly laid

[17] Olmsted, Vaux & Co., "Observations on the Progress of Improvements in Street
Plans, with Special Reference to the Parkway Proposed to Be Laid out in Brooklyn,"
Brooklyn, 1868, pp. 7–21.

out, it was simply with reference to defence. For example, although two nearly straight and comparatively broad-ways were early formed in Paris, so that reinforcements could be rapidly transferred from one gate to another when either should be suddenly attacked, no other passages were left among the houses which would admit of the introduction of wheeled traffic; nor in all the improvements which afterwards occurred, as the city advanced in population and wealth, were any of the original pathways widened and graded sufficiently for this purpose until long after America had been discovered, and the invention of printing and of fire-arms had introduced a new era of social progress.

The labor required for the construction of permanent town walls, and the advantage of being able to keep every part of them closely manned during an attack, made it desirable that they should not be unnecessarily extended. To admit of a separate domiciliation of families within them, therefore, the greatest practicable compactness in the arrangement of dwelling-houses soon became imperative. As families increased, the demand for additional house-room was first met by encroachments upon the passages which had been left between the original structures, and by adding upper stories, and extending these outward so as to overhang the street. Before this process had reached an extreme point, however, the town would begin to outgrow its walls, and habitations in the suburbs would occur, of two classes: first, those formed by poor herdsmen and others who, when no enemy was known to be near at hand, could safely sleep in a temporary shelter, calculating to take their chance in the town when danger came; and, second, those formed by princes, and other men of wealth and power, who could afford to build strongholds for the protection of their families and personal retainers, but who, in times of war, yet needed to be in close vicinity to the larger fighting forces of the town. Neither the castle nor the hovel being placed with any reference to the enlargement of the

town, or to public convenience in any way, streets were formed through the suburbs, as they became denser, in much the same way as they had been in the original settlement; then, as the walls were extended, the military consideration again operated to enforce the idea of compactness in every possible way.

The government of these towns also, however its forms varied, was always essentially a military despotism of the most direct and stringent character, under which the life, property, health and comfort of the great body of their people were matters, at best, of very subordinate consideration.

Thus the policy, the custom and the fashion were established in the roots of our present form of society of regarding the wants of a town, and planning to meet them, as if its population were a garrison, to be housed in a barrack, with only such halls and passages in it, from door to door, as would be necessary to turn it in, to sleep and feed, and turn it out, to get its rations.

It naturally fell out that when at length the general advance of society, in other respects, made it no longer necessary that a man should build a castle, and control, as personal property, the services of a numerous body of fighting men, in order to live with some degree of safety in a house of his own, apart from others, all the principal towns declined for a time in wealth and population, because of the number of opulent citizens who abandoned their old residences, and moved, with servants and tenants, to make new settlements in the country.

The excessive suppression of personal independence and individual inclinations which had before been required in town-life caused a strong reactionary ambition to possess each prosperous citizen to relieve himself as much as possible from dependence upon and duties to society in general, and it became his aim to separate himself from all the human race except such part as would treat him with deference. To secure greater seclusion and at the

same time opportunity for the only forms of out-door recreation, which the rich, after the days of jousts and tournaments, were accustomed to engage in, all those who could command favor at Court, sought grants of land abounding in the larger game, and planted their houses in the midst of enclosures called parks, which not only kept neighbors at a distance, but served as nurseries for objects of the chase.

The habits of the wealthy, under these circumstances, though often gross and arrogant, and sometimes recklessly extravagant, were far from luxurious, according to modern notions, and as, in order to realize as fully as possible the dream of independence, every country gentleman had his private chaplain, surgeon, farrier, tailor, weaver and spinner, raised his own wool, malt, barley and breadstuffs, killed his own beef, mutton and venison, and brewed his own ale, he was able to despise commerce and to avoid towns. The little finery his household coveted was accordingly brought to his door on pack-mules by traveling merchants. The vocation of a merchant, in its large, modern sense, was hardly known, and the trade of even the most considerable towns was, in all respects, very restricted. Thus the old foot-way streets still served all necessary requirements tolerably well.

As the advance of civilization continued, however, this disinclination to the exchange of service, of course, gave way; demands became more varied, and men of all classes were forced to take their place in the general organization of society in communities. In process of time the enlargement of popular freedom, the spread of knowledge by books, the abatement of religious persecutions, the voyages of circumnavigators, and finally the opening of America, India and the gold coast of Africa to European commerce, so fed the mercantile inclinations, that an entirely new class of towns, centres of manufacturing and of trade, grew upon the sites of the

old ones. To these the wealthy and powerful were drawn, no longer for protection, but for the enjoyment of the luxuries which they found in them, while the more enterprising of the lower classes crowded into them to "seek their fortune."

SECOND STAGE OF STREET ARRANGEMENTS

Wagons gradually took the place of pack-trains in the distribution of goods through the country, and, as one man could manage a heavy load, when it was once stowed, as well as a light one, the wagons were made very large and strong, and required the employment of many horses.

In comparatively few town-streets could two of these wheeled merchantmen, with the enormous hamper they carried on each side, pass each other. The seats and hucksteries of slight woodwork with which the streets had been lined were swept away; but, as the population rapidly increased, while the house accommodation was so limited that its density, in the city of London, for instance, was probably three times as great as at present, any attempt to further widen the streets for the convenience of the wagoners had to encounter the strongest resistance from the householders.

Thus, without any material enlargement, the character of the streets was much changed. They frequently became quite unfit to walk in, the more so because they were used as the common place of deposit for all manner of rubbish and filth thrown out of the houses which was not systematically removed from them.

Although London then occupied not a fiftieth part of the ground which it does now, and green fields remained which had been carefully preserved for the practice of archery within a comparatively short distance of its central parts, to which the inhabitants much resorted for fresh air on summer evenings; although the

river still ran clear, and there was much pleasure-boating upon
it, the greater part of the inhabitants were so much confined in
dark, ill-ventilated and noisome quarters, that they were literally
decimated by disease as often as once in every two years, while
at intervals fearful epidemics raged, at which times the mortality
was much greater. During one of these, four thousand deaths oc-
curred in a single night, and many streets were completely depop-
ulated. All who could by any means do so, fled from the town, so
that in a short time its population was reduced more than fifty per
cent. It had not yet filled up after this calamity, when a fire oc-
curred which raged unchecked during four days, and destroyed
the houses and places of business of two hundred thousand of the
citizens. Its progress was at length stayed by the widening of the
streets across which it would have advanced if the buildings which
lined them had not been removed by the military.

Five-sixths of the area occupied by the old city was still covered
with smoking embers when the most distinguished architect of the
age seized the opportunity to urge a project for laying out the
street system of a new town upon the same site. The most novel
feature of this plan was the introduction of certain main channel
streets, ninety feet wide, in which several wagons could be driven
abreast upon straight courses from one end of the city to the other.
It was also proposed that there should be a series of parallel and
intersecting streets sixty feet wide, with intermediate lanes of thirty
feet. The enormous advantages of such a system of streets over
any others then in use in the large towns of Europe were readily
demonstrated; it obtained the approval of the king himself, and
would have been adopted but for the incredible shortsightedness
of the merchants and real estate owners. These obstinately refused
to give themselves any concern about the sacrifice of general incon-
venience or the future advantages to their city which it was shown

that a disregard of Wren's suggestions would involve, but pro-
ceeded at once, as fast as possible, without any concert of action,
to build anew, each man for himself, upon the ruins of his old
warehouse. There can be little question, that had the property own-
ers, at this time, been wise enough to act as a body in reference to
their common interests, and to have allowed Wren to devise and
carry out a complete street system, intelligently adapted to the re-
quirements which he would have been certain to anticipate; as well
as those which were already pressing, it would have relieved the
city of London of an incalculable expenditure which has since
been required to mend its street arrangements; would have greatly
lessened the weight of taxation, which soon afterwards rose to be
higher than in any other town of the kingdom, and would have
saved millions of people from the misery of poverty and disease.

Although in a very few years after the rebuilding of the city,
its commerce advanced so much as to greatly aggravate the incon-
veniences under which street communication had been previously
carried on, the difficulties were allowed to grow greater and greater
for fully a century more before anything was done calculated to
essentially alleviate them. They seem to have been fully realized
and to have been constantly deplored, nor were efforts of a certain
kind wanting to remedy them: the direction of these efforts, how-
ever, shows how strongly a traditional standard of street con-
venience yet confused the judgment even of the most advanced. A
town being still thought of as a collection of buildings all placed
as closely as possible to one centre was also regarded as a place of
necessarily inconvenient confinement, and therefore, of crowding,
hustling and turbulence. An enlargement of the population of a
town could only aggravate all the special troubles and dangers to
which those living in it were subject, add to the number of its idle,
thriftless, criminal and dangerous classes, and invite disease, dis-

order and treasonable tumults. As, therefore, to amplify the street arrangements or otherwise enlarge the public accommodations for trade or residence, would be to increase its attractions, the true policy was generally assumed to be in the other direction. In London, not only its own Corporation followed this policy, but Parliament and the Sovereign systematically did the same.

Once, for instance, a proclamation was issued, to forbid under heavy penalties the erection of any houses, except such as should be suitable for the residence of the gentry, within three miles of the town; another followed which interdicted householders from enlarging the accommodations for strangers within the town; another enjoined all persons who had houses in the country to quit the town within three weeks, while constant efforts were made to ship off those who had none to Ireland, Virginia, or Jamaica.

In spite of all, new houses were built on the sides of the old country roads, the suburban villages grew larger and larger till at length they were all one town with London and the population became twice as great and the commerce much more than twice as great as at the time of the great fire. Even when at last plans of real improvement began to be entertained it was no thought of resisting the increase of disease, pauperism and crime, by other means than fencing it out, that produced the change, but mainly the intolerable hindrance to commerce of the old-fashioned arrangements. Though some refused to see it and still protested against the plans of improvement as wholly unnecessary, hazardous, reckless, and extravagant, and denounced those who urged them, as unprincipled speculators or visionary enthusiasts, the merchants generally could no longer avoid the conviction that their prosperity was seriously checked by the inadequacy of the thoroughfares of the town for the duty required of them. Parliament was therefore induced in the latter part of the last century, to authorize

a series of measures which gradually brought about in the course
of fifty years, larger and more important changes than had occur-
red before during many centuries.

As the definite aim of these changes was to get rid of certain
inconveniences which had previously been classed among the neces-
sary evils of large towns, and as the measure with reference to
which the purpose of their design was limited is thus clearly es-
tablished, it is evident that before we can realize the degree in
which they were likely to approach the ultimatum of civilized re-
quirement we need to know more exactly what the inconveniences
in question amounted to.

It appears then that the imperfect pavements, never having been
adequately revised since the days of handbarrow and pack horse
transportation, were constantly being misplaced and the ground
worn into deep ruts by the crushing weight of the wheels; the
slops and offal matters thrown out of the houses were combined
with the dung of the horses and the mud to make a tenacious pud-
dle through which the people on foot had to drag their way in con-
stant apprehension of being run down or crushed against the wall.
In the principal streets strong posts were planted at intervals be-
hind which active men were accustomed to dodge for safety as the
wagons came upon them. Coaches had been introduced in the time
of Elizabeth, but though simple, strong and rudely hung vehicles,
they were considered to be very dangerous in the streets and their
use within the town was for some time forbidden. Sedan chairs for
all ordinary purposes superseded them and for a long time had
been in common use by all except the poorer classes upon every
occasion of going into the streets. When George the Third went
in the state coach to open Parliament, the streets through which
he passed were previously prepared by laying faggots in the ruts
to make the motion easier. There was little or no sewerage or cov-

ered drainage, and heavy storms formed gullies of the ruts and often flooded the cellars destroying a great deal of merchandise.

This was the condition in which after several hundred years, the town had been left by the transformation of the passages, first occuring between the huts of the entrenched camp of a tribe of barbarians, from the serviceable foot ways of the early middle ages to the unserviceable wagon ways of the generation but one before the last.

THIRD STAGE OF STREET ARRANGEMENTS

To remedy its evils, in the construction of new streets, and the reconstruction of old, the original passage for people on foot was restored, but it was now split through the middle and set back with the house fronts on each side so as to admit of the introduction of a special roadway for horses and wheels, at a lower level. A curb was placed to guard the foot way from the wheels; gutters were used to collect the liquid and floating filth, and sewers were constructed which enabled the streams thus formed to be taken out of the streets before they became so large as to flood the sidewalks. At the same time an effort was made to so straighten and connect some of the streets that goods could be taken from one quarter of the town to another by direct courses, and without the necessity of doubling the horse-power at certain points in order to overcome the natural elevation of the ground.

Thus, just one hundred years after Wren's suggestions were rejected by the merchants, their grandsons began to make lame efforts to secure some small measure of the convenience which his plan had offered them.

A few of the latter improvements had been adopted in other towns at a somewhat earlier period than in London. In the plans of St. Petersburg and of Philadelphia, for instance, directness and unusual amplitude of roadway had been studied, and some of the

free cities of Germany had, at an earlier date, possessed moderately broad and well-paved streets, but the exceptions do not affect the conclusion which we desire to enforce.

To fully understand the reason of this long neglect to make any wise preparation for the enlargement of population which it would seem must surely have been anticipated, we need to consider that while a rapid advance was all the time occurring from the state of things when a town was intended to be governed with little direct regard for the interests of any but a very few of its occupants, at the same time direct responsibility for the care of its interests was being diffused and held for shorter intervals, and was, consequently, less and less felt, as a motive to ingenuity and energy, by any one of the several individuals who partook in it. The theory and form of town government changed more slowly than the character and modes of life of those who were called upon to administer it, but an adherence to the antiquated forms was only calculated to make a personal duty, with reference to the actual new conditions of the people, less easily realized and less effectively operative. What is everybody's business is nobody's, and although of late years experts, with professional training in special branches, are not unfrequently engaged by municipal bodies to study particular requirements of the people, and invent means to satisfy them, still, as a general rule, improvements have come in most cities, when they have come at all, chiefly through the influence of individual energy, interested in behalf of special mercantile or speculative enterprises, by which the supineness of the elected and paid representatives of the common interests of the citizens has been overborne.

ERRONEOUS VIEW OF THE NECESSARY DISADVANTAGES OF TOWN LIFE

What is of more consequence, however, not merely that we may avoid injustice to our ancestors, but that we may realize the changes

which have occurred in the standard of requirement, with reference to which the merits of a street system are now to be judged, is the fact that when these improvements were devised, it was still pardonable to take for granted that the larger the population of a town should be allowed to become, the greater would be the inconvenience and danger to which all who ventured to live in it would necessarily be subject, the more they would be exposed to epidemic diseases, the feebler, more sickly, and shorter their lives would be; the greater would be the danger of sweeping conflagrations; the larger the proportion of mendicants and criminals, and the more formidable, desperate and dangerous the mobs.

EVILS OF TOWN LIFE HAVE DIMINISHED AS TOWNS HAVE GROWN LARGER

We now know that these assumptions were entirely fallacious, for, as a matter of fact, towns have gone on increasing, until there are many in Europe which are several times larger than the largest of the Middle Ages, and in the largest the amount of disease is not more than half as great as it formerly was; the chance of living to old age is much more than twice as great; epidemics are less frequent, less malignant and more controllable; sweeping fires are less common, less devastating and are much sooner [controlled]; ruffians are much better held in check; mobs are less frequently formed, are less dangerous, and, when they arise, are suppressed more quickly and with less bloodshed; there is a smaller proportion of the population given over to vice and crime; and a vastly larger proportion of well-educated, orderly, industrious and well-to-do citizens. These things are true, in the main, not of one town alone, but of every considerable town, from Turkey on the one side to China on the other, and the larger each town has grown, the greater, on an average, has been the gain. Even in Mahomedan Cairo, chiefly through the action of French engineers, the length

of life of each inhabitant has, on an average, been doubled. The question, then, very naturally occurs: What are the causes and conditions of this amelioration? and Can it be expected to continue?

REASON FOR ANTICIPATING AN ACCELERATED ENLARGEMENT OF METROPOLITAN TOWNS

If the enormous advance in the population of great towns which has been characteristic of our period of civilization, is due mainly to the increase of facilities for communication, transportation and exchange throughout the world, as there is every reason to believe that it is, we can but anticipate, in the immediate future, a still more rapid movement in the same direction.

We are now extending railroads over this continent at the rate of more than fifteen hundred miles a year, and before our next President takes his seat, we shall have applied an amount of labor which is represented by the enormous sum of two thousand millions of dollars, to this work, most of it preparatory, and more than half of it directed to the opening up of new lands to profitable cultivation. The productive capacity of the country thus laid open, and the demand upon commerce of its people, [have] scarcely yet begun to be manifested. We have but half made our first road to the Pacific, and we have only within a year begun to extend our steam navigation to Japan and China, where the demands upon civilized commerce of a frugal and industrious population, much larger than that of all Christendom, yet remain to be developed. We are ourselves but just awake to the value of the electric telegraph in lessening the risks of trade on a large scale, and giving it order and system. Thus, we seem to be just preparing to enter upon a new chapter of commercial and social progress, in which a comprehension of the advantages that arise from combination and co-operation will be the rule among merchants, and not, as heretofore, the exception.

CONDITIONS UNDER WHICH THE EVILS OF LARGE TOWNS HAVE DIMINISHED

The rapid enlargement of great towns which has hitherto occurred, must then be regarded as merely a premonition of the vastly greater enlargement that is to come. We see, therefore, how imperative, with reference to the interests of our race, is this question, whether as the enlargement of towns goes on the law of improvement is such that we may reasonably hope that life in them will continue to grow better, more orderly, more healthy? One thing seems to be certain, that the gain hitherto can be justly ascribed in very small part to direct action on the part of those responsible for the good management of the common interests of their several populations. Neither humanity nor the progress of invention and discovery, nor the advancement of science has had much to do with it. It can not even, in any great degree, be ascribed to the direct action of the law of supply and demand.

Shall we say, then, that it has depended on causes wholly beyond the exercise of human judgment, and that we may leave the future to take care of itself, as our fathers did? We are by no means justified in adopting such a conclusion, for, if we can yet trace wholly to their causes, all the advantages we possess over our predecessors, we are able to reach the conviction, beyond all reasonable doubt, that at least, the larger share of the immunity from the visits of the plague and other forms of pestilence, and from sweeping fires, and the larger part of the improved general health and increased length of life which civilized towns have lately enjoyed is due to the abandonment of the old-fashioned compact way of building towns, and the gradual adoption of a custom of laying them out with much larger spaces open to the sun-light and fresh air; a custom the introduction of which was due to no intelligent anticipation of such results.

Evidence of this is found in the fact that the differing propor-

tions between the dying and the living, the sick and the well, which are found to exist between towns where most of the people still live on narrow streets, and those in which the later fashions have been generally adopted; and between parts of the same town which are most crowded and those which are more open, are to this day nearly as great as between modern and ancient towns. For instance, in Liverpool, the constant influx of new-comers of a very poor and ignorant class from the other side of the Irish Channel, and the consequent demand for house-room, and the resulting value of the poor, old buildings which line the narrow streets, has, till recently, caused the progress of improvement to be much slower than in the much larger town of London, so that, while the average population of Liverpool is about 140,000 to the square mile, that of London is but 50,000; the average age at death in Liverpool is seventeen, and that in London, twenty-six. In the city of Brooklyn the number of deaths for each thousand of population that occurred this last year in the closer built parts, was twice as large as in those where the streets are wider and there are many gardens.

Comparisons of this kind have been made in such number, and the data for them have been drawn from such a large variety of localities in which the conditions of health in all other respects have been different, that no man charged, however temporarily and under whatever limitations, with municipal responsibilities, can be pardoned for ignoring the fact that the most serious drawback to the prosperity of town communities has always been dependent on conditions (quite unnecessary to exist in the present day) which have led to stagnation of air and excessive deprivation of sun-light.

Again, the fact that with every respiration of every living being a quantity is formed of a certain gas, which, if not dissipated, renders the air of any locality at first debilitating, after a time

sickening, and at last deadly; and the fact that this gas is rapidly
absorbed, and the atmosphere relieved of it by the action of leaves
of trees, grass and herbs, was quite unknown to those who estab-
lished the models which have been more or less distinctly followed
in the present street arrangements of our great towns. It is most of
all important, however, that we should remember that they were
not as yet awake to the fact that large towns are a necessary re-
sult of an extensive intercourse between people possessing one
class of the resources of wealth and prosperity and those possess-
ing other classes, and that with each increase of the field of com-
merce certain large towns must grow larger, and consequently, that
it is the duty of each generation living in these towns to give some
consideration, in its plans, to the requirements of a larger body
of people than it has itself to deal with directly.

CHANGE IN THE HABITS OF CITIZENS AFFECTING

THE STRUCTURAL REQUIREMENTS OF TOWNS

If, again, we consider the changes in the structure of towns which
have occurred through the private action of individual citizens
we shall find that they indicate the rise of a strong tide of require-
ments, the drift of which will either have to be fairly recognized
in the public work of the present generation or it will, at no distant
day, surely compel a revision of what is now done that will in-
volve a large sacrifice of property.

SEPARATION OF BUSINESS AND DOMESTIC LIFE

In the last century comparatively few towns-people occupied dwell-
ings distinctly separate from their place of business. A large ma-
jority of the citizens of Paris, London and of New York do so
today, and the tendency to divisions of the towns corresponding

to this change of habits must rapidly increase with their further enlargement, because of the greater distance which will exist between their different parts. The reason is obvious: a business man, during his working-hours, has no occasion for domestic luxuries, but needs to have access to certain of his co-workers in the shortest practicable time, and with the smallest practicable expenditure of effort. He wants to be near a bank, for instance, or near the Corn Exchange, or near the Stock Exchange, or to shipping, or to a certain class of shops or manufactories. On the other hand, when not engaged in business, he has no occasion to be near his working place, but demands arrangements of a wholly different character. Families require to settle in certain localities in sufficient numbers to support those establishments which minister to their social and other wants, and yet are not willing to accept the conditions of town-life which were formerly deemed imperative, and which, in the business quarters, are yet, perhaps, in some degree, imperative, but demand as much of the luxuries of free air, space and abundant vegetation as, without loss of town-privileges, they can be enabled to secure.

Those parts of a town which are to any considerable extent occupied by the great agencies of commerce, or which, for any reason, are especially fitted for their occupation, are therefore sure to be more and more exclusively given up to them, and, although we can not anticipate all the subdivisions of a rapidly increasing town with confidence, we may safely assume that the general division of all the parts of every considerable town under the two great classifications of commercial and domestic, which began in the great European towns in the last century, will not only continue, but will become more and more distinct.

It can hardly be thought probable that street arrangements per-

fectly well adapted in all respects to the purpose to be served in one of these divisions are the very best in every particular that it would be possible to devise for those of the other.

RECREATIVE REQUIREMENTS AND DISTANCE OF SUBURBS

Another change in the habits of townspeople which also grows out of the greatly enlarged area already occupied by large towns, results from the fact that, owing to the great distances of the suburbs from the central parts, the great body of the inhabitants cannot so easily as formerly stroll out into the country in search of fresh air, quietness, and recreation. At the same time there is no doubt that the more intense intellectual activity, which prevails equally in the library, the work shop, and the counting-room, makes tranquilizing recreation more essential to continued health and strength than until lately it generally has been. Civilized men while they are gaining ground against certain acute forms of disease are growing more and more subject to other and more insidious enemies to their health and happiness and against these the remedy and preventive can not be found in medicine or in athletic recreations but only in sunlight and such forms of gentle exercise as are calculated to equalize the circulation and relieve the brain. . . .

INADEQUATE DOMESTIC ACCESS TO SUBURBS AND PARKS

The parks are no more accessible than the suburbs, however, from those quarters of the town occupied domestically, except by means of streets formed in precisely the same manner as those which pass through the quarters devoted to the heaviest commercial traffic. During the periods of transit, therefore, from house to house and between the houses and the Park there is little pleasure to be had in driving. Riding also, through the ordinary streets, is often not only far from pleasant, but, unless it is very slowly and carefully

done, is hazardous to life and limb. Consequently much less enjoyment of the Park is possible to those who live at a distance than to those who live near it and its value to the population at large is correspondingly restricted. The difficulties of reaching the Park on foot for those who might enjoy and be benefited by the walk, are at the season of the year when it would otherwise be most attractive, even greater, for they must follow the heated flags and bear the reflected as well as the direct rays of the sun.

But we cannot expect, even if this objection were overcome, that all the inhabitants of a large town would go so far as the Park every day, or so often as it is desirable that they should take an agreeable stroll in the fresh air. On the other hand we cannot say that the transportation of merchandise should be altogether interdicted in the domestic quarters of a town, as it is in a park, and as it now is through certain streets of London and Paris during most hours of the day. On the contrary it is evidently desirable that every dwelling house should be accessible by means of suitable paved streets to heavy wheeled vehicles.

NEW ARRANGEMENT DEMANDED BY EXISTING REQUIREMENTS

It will be observed that each of the changes which we have examined points clearly towards the conclusion that the present street arrangements of every large town will at no very distant day require, not to be set aside, but to be supplemented, by a series of ways designed with express reference to the pleasure with which they may be used for walking, riding, and the driving of carriages; for rest, recreation, refreshment, and social intercourse; and that these ways must be so arranged that they will be conveniently accessible from every dwelling house and allow its occupants to pass from it to distant parts of the town, as, for instance, when they want to go to a park, without the necessity of travelling for any

considerable distance through streets no more convenient for the purpose than our streets of the better class now are.

We may refuse to make timely provisions for such purposes in our suburbs, and we may by our refusal add prodigiously to the difficulty and the cost of their final introduction but it is no more probable, if great towns continue to grow greater, that such requirements as we have pointed out will not eventually be provided for than it was two hundred years ago that the obvious defects of the then existing street arrangements would continue to be permanently endured rather than that property should be destroyed which existed in the buildings by their sides.

The Misfortunes
of New York[18]

THE HON. WILLIAM R. MARTIN, PRESIDENT OF THE BOARD:

Sir: — The undersigned have the honor to present a report introductory to a series of plans for laying out the new wards of the city. The first of these plans can, if desired, be laid before the Board at its next meeting; a second and third are in preparation, and the whole series is in progress of study.

The great advance northward in the building of New York, since 1807, has been strictly according to the street plan which a commission of its citizens then laid down for it. The objections at first hotly urged against this plan (chiefly by property holders whose lands it would divide inconveniently, whose lawns and gardens it would destroy and whose houses it would leave in awkward positions), have long since been generally forgotten, and so far as streets have been opened and houses built upon them, the system has apparently met all popular requirements. Habits and customs accommodated to it have become fixed upon the people of the city. Property divisions have been generally adjusted to it, and innumerable transfers and pledges of real estate have been made under it with a degree of ease and simplicity probably without parallel. All the enormous changes in the modes of commerce, of means of communication, and of the styles of domestic life which the century has seen, have made but one slight local variation from it necessary.

These facts, taken by themselves, may seem to leave little room for doubt that the system was admirably contrived for its purpose, and that, as far as can be reasonably expected of any product of human skill, it remains perfect.

There are probably but a few men in the community who, in

18 Frederick Law Olmsted and James R. Croes, "Preliminary Report of the Landscape Architect and the Civil and Topographical Engineer, upon the Laying Out of the Twenty-third and Twenty-fourth Wards," City of New York, Document No. 72 of the Board of the Department of Public Parks, 1877.

the course of a busy life, have given any slight attention, and but slight attention, to the subject, who are not in the habit of taking this view of it, and in whom, consequently, a pre-judgment is not in some degree deeply rooted in favor of the system. That it should be extended, whenever practicable, over that part of the city not yet laid out, and where this is forbidden by extraordinary difficulties of topography, that no greater variation should be made from it than is necessary to bring the cost of preparing streets within reasonable limits of expense, seems, to all such persons, a matter of course.

All the work of the undersigned will, nevertheless, have been done under the influence of a quite different conviction and its results can only be fairly judged, after a candid and patient balancing of the advantages to be gained, and the advantages to be lost by the adoption of a variety of proposed arrangements always differing, and often differing widely from those with which commissioners and the community are familiar under the regular system.

They, therefore, wish to submit, in advance of any plans, a few general considerations adapted, as they think, to give a different impression of the merits of the system from that which appears to be ordinarily accepted, and by which the Commission has hitherto, to some extent, almost necessarily been influenced.

New York, when the system in question was adopted, though vaguely anticipating something of the greatness that has since been thrust upon her, viewed all questions of her own civic equipment, very nearly from the position which a small, poor, remote provincial village would now be expected to take.

The city had no gas, water or sewer system. The privies of the best houses were placed, for good reasons, as far away from them as possible, in a back yard, over a loose-bottomed cesspool. If the

house stood in a closely built block, the contents of the cesspool, when necessary to be removed, were taken to the street in buckets carried through the house; the garbage of the house was often thrown, with its sweepings and soiled water into the street before the front door, to be there devoured by swine, droves of which were allowed to run at large for the purpose.

Under these circumstances, it was not to be expected that, if the utmost human wisdom had been used in the preparation of the plan, means would be aptly devised for all such ends as a commission charged with a similar duty at the present day must necessarily have before it.

So far as the plan of New York remains to be formed, it would be inexcusable that it should not be the plan of a Metropolis; adapted to serve, and serve well, every legitimate interest of the wide world; not of ordinary commerce only, but of humanity, religion, art, science and scholarship.

If a house to be used for many different purposes must have many rooms and passages of various dimensions and variously lighted and furnished, not less must such a metropolis be specially adapted at different points to different ends.

This it may chance to be if laid out by the old cow-path method, or more surely if laid out in greater or less part with carefully directed intention to the purposes, such as is now being used for instance in London, Paris, Vienna, Florence, and Rome.

There seems to be good authority for the story that the system of 1807 was hit upon by the chance occurrence of a mason's sieve near a map of the ground to be laid out. It was taken up and placed upon the map, and the question being asked "what do you want better than that?" no one was able to answer. This may not be the whole story of the plan, but the result is the same as if it were. That is to say, some two thousand blocks were provided,

each theoretically 200 feet wide, no more, no less; and ever since, if a building site is wanted, whether with a view to a church or a blast furnace, an opera house or a toy shop, there is, of intention, no better a place in one of these blocks than in another.

If a proposed cathedral, military depot, great manufacturing enterprise, house of religious seclusion or seat of learning needs a space of ground more than sixty-six yards in extent from north to south, the system forbids that it shall be built in New York.

On the other hand it equally forbids a museum, library, theatre, exchange, post office or hotel, unless of great breadth, to be lighted or to be open upon streets from opposite sides.

There are numerous structures, both public and private, in London and Paris, and most other large towns of Europe, which could not be built in New York, for want of a site of suitable extent and proportions.

The Trustees of Columbia College sought for years to obtain the privilege of consolidating two of the uniform blocks of the system, into which their own property had been divided, in order to erect sufficient buildings for their purpose, in one unbroken group, but it was denied them.

There is no place under the system in New York where a stately building can be looked up to from base to turret, none where it can even be seen full in the face and all at once taken in by the eye; none where it can be viewed in advantageous perspective. The few tolerable sites for noble buildings north of Grace Church and within the built part of the city remain, because Broadway, laid out curvilinearly, in free adaptation to natural circumstances, had already become too important a thoroughfare to be obliterated for the system.

Such distinctive advantage of position as Rome gives St. Peter's,

Paris the Madeleine, London St. Paul's, New York, under her sys-
tem, gives to nothing.

But, if New York is poor in opportunities of this class, there
is another of even greater importance in which she is notoriously
still poorer. Decent, wholesome, tidy dwellings for people who
are struggling to maintain an honorable independence are more
to be desired in a city than great churches, convents or colleges.
They are sadly wanting in New York, and why? It is commonly
said because the situation of the city, cramped between two rivers,
makes land too valuable to be occupied by small houses. This is
properly a reason why land, at least in the lower part of the is-
land, should be economized, and buildings arranged compactly.
The rigid uniformity of the system of 1807 requires that no
building lot shall be more than 100 feet in depth, none less. The
clerk or mechanic and his young family, wishing to live modestly
in a house by themselves, without servants, is provided for in this
respect not otherwise than the wealthy merchant, who, with a large
family and numerous servants, wishes to display works of art, to
form a large library, and to enjoy the company of many guests.

In New York, lots of 100 feet in depth cannot be afforded for
small, cheap houses. The ground-rent would be in too large propor-
tion to that of the betterments. In no prosperous old city are
families of moderate means found living, except temporarily in the
outskirts, in separate houses on undivided blocks measuring 200
feet from thoroughfare to thoroughfare. It is hardly to be hoped
that they ever will be in New York under the plan of 1807.*

* Various attempts have been made on a small scale to get the better of this difficulty,
the most successful being the introduction of an alley by which a tier of one-hundred-
foot lots is divided into two of forty-two feet each, one tier facing upon the back of
the other. A philanthropic scheme is now under discussion for cutting up a whole
block into short lots for poor men's houses by sixteen-foot alleys. [1876]

The inflexibility of the New York plan, and the nature of the disadvantages which grow out of it, may be better recognized upon an examination of certain peculiarities with which Commissioners must be familiar as distinguishing the city.

These are to be found, for instance, in the position usually occupied by the kitchen and menial offices of even the better class of houses; in the manner in which supplies are conveyed to them, and dust, ashes, rubbish and garbage removed. This class of peculiarities grows out of the absence from the New York system of the alley, or court, by which in all other great towns large private dwelling houses are usually made accessible in the rear.

It is true, that in other cities, as they became dense and land valuable, the alleys and courts come to be much used as streets, that is to say, small houses and shops, as well as stables are built facing upon them, and the dwellings only of people of considerable wealth are carried through to them from the streets proper. But this practice does not do away with the general custom of a yard accessible from the alley by an independent passage, and of placing the kitchen and offices of all large houses in a semi-detached building. Out of this custom come the greater ease and economy with which streets are elsewhere kept in decent order, and the bad reputation which New York has always had in this respect; and again, the fact that New York houses of the better class, much more than those of other cities, are apt to be pervaded with kitchen odors.

Another peculiarity of New York, is to be found in the much less breadth and greater depth of most of the modern dwellings of the better sort. There are many houses not much wider than the hovels of other cities, which yet have sixty or seventy feet of depth, and fifty to sixty feet of height, with sculptured stone fronts and elaborately wrought doors. This incongruity results from the cir-

cumstance that a yard at the back of the house, when no longer needed for a privy and where there is no alley to communicate with it, has little value; consequently, to economize ground-rent, two house lots of the size originally contemplated are divided into three or four, and houses stretched out upon them so as to occupy as much of the space as the Board of Health, guarding against manifest peril of public pestilence, will allow.

The same cubic space is now obtained in a lot of 1,700 square feet, or even 1,300, as formerly on one of 2,500, and the depth between the front and rear windows of houses of corresponding area has been nearly doubled.

That this change has been forced also by the street system, and is not a matter of fashion, nor the result of a caprice in popular tastes, is evident from the fact that no corresponding method has obtained in other cities, new or old, nor however situated; none, for example, in London, Liverpool, Philadelphia, Baltimore, Buffalo, Chicago, or San Francisco.

The practice is one that defies the architect to produce habitable rooms of pleasing or dignified proportions, but this is the least of its evils, for in the middle parts of all these deep, narrow cubes, there must be a large amount of ill-ventilated space, which can only be imperfectly lighted through distant skylights, or by an unwholesome combustion of gas. This space being consequently the least valuable for other purposes, is generally assigned to water closets, for which the position is in other respects the worst that could be adopted.

Still other, and perhaps even graver, misfortunes to the city might be named which could have been avoided by a different arrangement of its streets. The main object of this report will, however, have been secured, if the conviction has been shown to be

justified that an attempt to make all parts of a great city equally convenient for all uses, is far from being prescribed by any soundly economical policy.

"Equally convenient," in this case, implies equally inconvenient. "As far as is practicable," means within reasonable limits of expense. But there are no reasonable limits of expense for such an undertaking. Even on a flat, alluvial site, like that of Chicago, it is essentially wasteful and extravagant. In proportion as a site is rugged and rocky it is only more decidedly so; not simply because in this case it involves greater unnecessary cost, but because variety of surface offers variety of opportunity, and such an undertaking often deliberately throws away forever what might otherwise be distinctive properties of great value.

The important question in dealing with a site of greatly varied topography is, whether, and in what manner, advantage can be so taken of the different topographical conditions it offers, that all classes of legitimate enterprises can be favored, each in due proportion to the interest which all citizens have in its economical and successful prosecution.

It would be easy, of course, to attempt too much in this respect, but the range of practicability is more limited than at first thought may be supposed. The value of a particular situation for a certain purpose may be determined as far as the depth which is left available for building is concerned, by the distance part of two adjoining streets, and as far as aspect, accessibility to the public, and the cost of transportation to and fro, are concerned, by their courses and grades; but as to the breadth of ground that shall be available for any particular purpose, as to the manner in which it shall be graded and otherwise dealt with; whether it shall be cut down or filled up, terraced, or used in a more natural form — these are

questions which the street system must necessarily leave to be settled by private judgment under the stimulus of competition.

Hence, while it is held that the capability of the ground should be studied for purposes more or less distinctly to be classed apart, and that, as topographical conditions vary, it should be laid out with reference to one class or another, an extended, exact, and dogmatic classification for this purpose is not to be apprehended.

A judicious laying out of the annexed territory requires a certain effort of forecast, as to what the city is to be in the future. In this respect, there is as great danger in attempting too much as in attempting too little. Before New York can have doubled its present population, new motive powers and means of transit, new methods of building, new professions and trades, and new departures in sanitary science, if not in political science, are likely to have appeared. If half its present territory should then be built up and occupied as closely as its seven more populous wards now are, the other half would need to lodge but one-seventh of its total population. Assuming that in this other half there should be but a moderate degree of urban density along the river side and near the railway stations, there would remain several square miles of land which could only be occupied by scattered buildings. It is, then, premature, to say the least, to attempt to overcome any topographical difficulty that may be presented to a perfectly compact and urban occupation of every acre of the ground to be laid out.

Respectfully,
Fred. Law Olmsted, Landscape Architect
J. James R. Croes, Civil and Topographical Engineer

Public Parks and the Enlargement of Towns[19]

The last "Overland Monthly" tells us that in California "only an inferior class of people can be induced to live out of towns. There is something in the country which repels men. In the city alone can they nourish the juices of life."

This of newly built and but half-equipped cities, where the people are never quite free from dread of earthquakes, and of a country in which the productions of agriculture and horticulture are more varied, and the rewards of rural enterprise larger, than in any other under civilized government! With a hundred million acres of arable and grazing land, with thousands of outcropping gold veins, with the finest forests in the world, fully half the white people live in towns, a quarter of all in one town, and this quarter pays more than half the taxes of all. "Over the mountains the miners," says Mr. Bowles, "talk of going to San Francisco as to Paradise," and the rural members of the Legislature declare that "San Francisco sucks the life out of the country."

At the same time all our great interior towns are reputed to be growing rapidly; their newspapers complain that wheat and gold fall much faster than house-rents, and especially that builders fail to meet the demand for such dwellings as are mostly sought by newcomers, who are mainly men of small means and young families, anxious to make a lodgment in the city on any terms which will give them a chance of earning a right to remain. In Chicago alone, it is said, that there are twenty thousand people seeking employment.

To this I can add, from personal observation, that if we stand, any day before noon, at the railway stations of these cities, we may

[19] Frederick Law Olmsted, "Public Parks and the Enlargement of Towns," American Social Science Association (Cambridge, Mass.: Riverside Press, 1870), pp. 1–36.

A paper prepared as a contribution to the popular discussion of the requirements of Boston in respect to a public park; read at the request of the American Social Science Association at the Lowell Institute, February 25, 1870.

notice women and girls arriving by the score, who, it will be apparent, have just run in to do a little shopping, intending to return by supper time to farms perhaps a hundred miles away.

It used to be a matter of pride with the better sort of our country people that they could raise on their own land or manufacture within their own households almost everything needed for domestic consumption. But if now you leave the rail, at whatever remote station, the very advertisements on its walls will manifest how greatly this is changed. Push out over the prairie and make your way to the house of any long-settled and prosperous farmer, and the intimacy of his family with the town will constantly appear, in dress, furniture, viands, in all the conversation. If there is a piano, they will be expecting a man from town to tune it. If the baby has outgrown its shoes, the measure is to be sent to town. If a tooth is troublesome, an appointment is to be arranged by telegraph with the dentist. The railway time-table hangs with the almanac. The housewife complains of her servants. There is no difficulty in getting them from the intelligence offices in town, such as they are; but only the poorest, who cannot find employment in the city, will come to the country, and these as soon as they have got a few dollars ahead, are crazy to get back to town. It is much the same with the men, the farmer will add; he has to run up in the morning and get some one to take "Wolf's" place. You will find, too, that one of his sons is in a lawyer's office, another at a commercial college, and his oldest daughter at an "institute," all in town. I know several girls who travel eighty miles a day to attend school in Chicago.

If under these circumstances the occupation of the country school-master, shoemaker, and doctor, the country store-keeper, dressmaker and lawyer, is not actually gone, it must be that the business they have to do is much less relatively to the population

about them than it used to be; not less in amount only, but less in importance. An inferior class of men will meet the requirements.

And how are things going here in Massachusetts? A correspondent of the "Springfield Republican" gave the other day an account of a visit lately made to two or three old agricultural neighborhoods, such as fifty years ago were the glory of New England. When he last knew them, their society was spoken of with pride, and the influence of not a few of their citizens was felt throughout the State, and indeed far beyond it. But as he found them now, they might almost be sung by Goldsmith. The meeting-house closed, the church dilapidated; the famous old taverns, stores, shops, mills, and offices dropping to pieces and vacant, or perhaps with a mere corner occupied by day laborers; but a third as many children as formerly to be seen in the school-houses, and of these less than half of American-born parents.

Walking through such a district last summer, my eyes were gladdened by a single house with exceptional signs of thrift in fresh paint, roofs, and fences, and newly planted door-yard trees; but happening as I passed to speak to the owner, in the second sentence of our conversation he told me that he had been slicking his place up in hopes that some city gentleman would take a fancy to it for a country seat. He was getting old, had worked hard, and felt as if the time had fully come when he was entitled to take some enjoyment of what remained to him of life by retiring to the town. Nearly all his old neighbors were gone; his children had left years ago. His town-bred granddaughters were playing croquet in the front yard.

You know how it is here in Boston. Let us go on to the Old World. We read in our youth that among no other people were rural tastes so strong, and rural habits so fixed, as with those of Old England, and there is surely no other country where the rural

life of the more fortunate classes compares so attractively with their town life. Yet in the "Transactions of the British Social Science Association," we find one debater asserting that there are now very few more persons living in the rural districts of England and Wales than there were fifty years ago; another referring to "the still increasing growth of our overgrown towns and the stationary or rather retrograding numbers of our rural population;" while a third remarks that the social and educational advantages of the towns are drawing to them a large proportion of "the wealthy and independent," as well as all of the working classes not required for field labor.

When I was last in England, the change that had occurred even in ten years could be perceived by a rapid traveller. Not only had the country gentleman and especially the country gentlewoman of Irving departed wholly with all their following, but the very embers had been swept away of that manner of life upon which, so little while ago, everything in England seemed to be dependent. In all the country I found a smack of the suburbs — hampers and packages from metropolitan tradesmen, and purveyors arriving by every train, and a constant communication kept up with town by penny-post and telegraph.

In the early part of the century, the continued growth of London was talked of as something marvelous and fearful; but where ten houses were then required to accommodate new residents, there are now a hundred. The average rate at which population increases in the six principal towns is twice as great as in the country at large, including the hundreds of other flourishing towns. So also Glasgow has been growing six times faster than all Scotland; and Dublin has held its own, while Ireland as a whole has been losing ground.

Crossing to the Continent, we find Paris absorbing half of all the

increase of France in population; Berlin growing twice as fast as all Prussia; Hamburg, Stettin, Stuttgart, Brussels, and a score or two of other towns, all building out into the country at a rate never before known, while many agricultural districts are actually losing population. In Russia special provision is made in the laws to regulate the gradual compensation of the nobles for their losses by the emancipation of the serfs, to prevent the depopulation of certain parts of the country, which was in danger of occurring from the eagerness of the peasantry to move into the large towns.

Going still further to the eastward, we may find a people to whom the movement has not thus far been communicated; but it is only where obscurity affords the best hope of safety from oppression, where men number their women with their horses, and where labor-saving inventions are as inventions of the enemy.

There can be no doubt then, that, in all our modern civilization, as in that of the ancients, there is a strong drift townward. But some seem to regard the class of symptoms I have referred to as those of a sort of moral epidemic, the crisis and reaction of which they constantly expect to see. They even detect already a growing disgust with the town and signs of a back-set towards rural simplicity. To avoid prolonged discussion of the question thus suggested I will refer but briefly to the intimate connection which is evident between the growth of towns and the dying out of slavery and feudal customs, of priestcraft and government by divine right, the multiplication of books, newspapers, schools, and other means of popular education and the adoption of improved methods of communication, transportation, and of various labor-saving inventions. No nation has yet begun to give up schools or newspapers, railroads or telegraphs, to restore feudal rights or advance rates of postage. King-craft and priestcraft are nowhere gaining any solid ground. On the contrary, considered as elements of

human progress, the more apparent forces under which men have thus far been led to gather together in towns are yet growing; never more rapidly than at this moment. It would seem then more rational to prepare for a continued rising of the townward flood than to count upon its subsidence. Examining our own country more particularly, it is to be considered that we have been giving away our public lands under a square form of division, as if for the purpose of preventing the closer agricultural settlement which long and narrow farms would have favored, and that we have used our mineral deposits as premiums for the encouragement of wandering and of forms of enterprise, individual, desultory and sequestered in character, in distinction from those which are organized, systematized and public. This policy has had its day; the choicest lands have been taken up; the most prominent and easiest worked metallic veins have been seized, the richest placers are abandoned to Chinamen, and the only reaction that we can reasonably anticipate is one from, not toward, dispersion.

The same policy, indeed, has had the effect of giving us, for a time, great command of ready money and easy credit, and we have thus been induced to spend an immense sum — say two thousand millions — in providing ourselves with the fixtures and machinery of our railroad system. This system, while encouraging the greater dispersion of our food-producers, has tended most of all to render them, as we have seen, independent of all the old neighborhood agencies of demand and supply, manufacture and exchange, and to educate them and their children in familiarity with and dependence on the conveniences and habits of towns-people.

To touch upon another line of argument, we all recognize that the tastes and dispositions of women are more and more potent in shaping the course of civilized progress, and we may see that women are even more susceptible to this townward drift than men.

Ofttimes the husband and father gives up his country occupations, taking others less attractive to him in town, out of consideration for his wife and daughters. Not long since I conveyed to a very sensible and provident man what I thought to be an offer of great preferment. I was surprised that he hesitated to accept it, until the question was referred to his wife, a bright, tidy American-born woman, who promptly said: "If I were offered a deed of the best farm that I ever saw, on condition of going back to the country to live, I would not take it. I would rather face starvation in town." She had been brought up and lived the greater part of her life in one of the most convenient and agreeable farming countries in the United States.

Is it astonishing? Compare advantages in respect simply to schools, libraries, music, and the fine arts. People of the greatest wealth can hardly command as much of these in the country as the poorest work-girl is offered here in Boston at the mere cost of a walk for a short distance over a good, firm, clean pathway, lighted at night and made interesting to her by shop fronts and the variety of people passing.

It is true the poorer work-girls make little use of these special advantages, but this [is] simply because they are not yet educated up to them. When, however, they come from the country to town, are they not moving in the way of this education? In all probability, as is indicated by the report (in the "New York Tribune") of a recent skillful examination of the condition and habits of the poor sewing women of that city, a frantic desire to escape from the dull lives which they have seen before them in the country, a craving for recreation, especially for more companionship in yielding to playful girlish impulses, innocent in themselves, drives more young women to the town than anything else. Dr. Holmes may exaggerate the clumsiness and dreariness of New England village social parties; but go further back into the country among the out-

lying farms, and if you have ever had part in the working up of some of the rare occasions in which what stands for festivity is attempted, you will hardly think that the ardent desire of a young woman to escape to the town is wholly unreasonable.

The civilized woman is above all things a tidy woman. She enjoys being surrounded by bright and gay things perhaps not less than the savage, but she shrinks from draggling, smirching, fouling things and "things out of keeping" more. By the keenness with which she avoids subjecting herself to annoyances of this class, indeed, we may judge the degree in which a woman has advanced in civilization. Think what a country road and roadside, and what the back yard of a farm-house, commonly is, in winter and spring-time; and what far-away farmers' gardens are in haying time, or most of them at any time. Think, again, how hard it is when you city people go into the country for a few weeks in summer, to keep your things in order, to get a thousand little things done which you regard as trifles when at home, how far you have to go, and with how much uncertainty, how much unaccustomed management you have to exercise. For the perfection and delicacy — the cleanness — with which any human want is provided for depends on the concentration of human ingenuity and skill upon that particular want. The greater the division of labor at any point, the greater the perfection with which all wants may be satisfied. Everywhere in the country the number and variety of workmen, not agricultural laborers, proportionately to the population, is lessening as the facility for reaching workmen in town is increasing. In one year we find fifty-four new divisions of trade added to the "London Directory."

Think of all these things, and you will possibly find yourself growing a little impatient of the common cant which assumes that the strong tendency of women to town life, even though it involves

great privations and dangers, is a purely senseless, giddy, vain, frivolous, and degrading one.

The consideration which most influences this tendency of women in families, however, seems to be the amount of time and labor, and wear and tear of nerves and mind, which is saved to them by the organization of labor in those forms, more especially, by which the menial service of households is simplified and reduced. Consider, for instance, what is done (that in the country is not done at all or is done by each household for itself, and, if efficiently, with a wearing, constant effort of superintendence) by the butcher, baker, fishmonger, grocer, by the provision venders of all sorts, by the ice-man, dust-man, scavenger, by the postman, carrier, express-men, and messengers, all serving you at your house when required; by the sewers, gutters, pavement, crossings, sidewalks, public conveyances, and gas and water works.

But here again there is every reason to suppose that what we see is but a foretaste of what is yet to come. Take the difference of demand upon invention in respect to cheap conveyance for example. We began experimentally with street railways twenty years ago. At present, in New York, one pair of horses serves to convey one hundred people, on an average, every day at a rate of fare about one fiftieth of the old hackney-coach rates, and the total number of fares collected annually is equal to that of the population of the United States. And yet thousands walk a number of miles every day because they cannot be seated in the cars. It is impossible to fix a limit to the amount of travel which really ample, convenient, and still cheap means of transportation for short distances would develop. Certain improvements have caused the whole number of people seeking conveyances in London to be doubled in the last five years, and yet the supply keeps nowhere near the demand.

See how rapidly we are really gaining, and what we have to expect. Two recent inventions give us the means of reducing by a third, under favorable circumstances, the cost of good McAdam roads. There have been sixteen patents issued from one office for other new forms of perfectly smooth and nearly noiseless street pavement, some of which, after two or three years' trial, promise so well as to render it certain that some improvement will soon come by which more than one of the present special annoyances of town life will be abated. An improvement in our sewer system seems near at hand also, which will add considerably to the comparative advantages of a residence in towns, and especially the more open town suburbs.

Experiments indicate that it is feasible to send heated air through a town in pipes like water, and that it may be drawn upon, and the heat which is taken measured and paid for according to quantity required. Thus may come a great saving of fuel and trouble in a very difficult department of domestic economy. No one will think of applying such a system to farm-houses.

Again, it is plain that we have scarcely begun to turn to account the advantages offered to towns-people in the electric telegraph; we really have not made a beginning with those offered in the pneumatic tube, though their substantial character has been demonstrated. By the use of these two instruments, a tradesman ten miles away on the other side of a town may be communicated with, and goods obtained from him by a housekeeper, as quickly and with as little personal inconvenience as now if he were in the next block. A single tube station for five hundred families, acoustic pipes for the transmission of orders to it from each house, with a carriers' service for local distribution of packages, is all that is needed for this purpose.

As to the economy which comes by systematizing and concen-

trating, by the application of a large apparatus, of processes which are otherwise conducted in a desultory way, wasteful of human strength, as by public laundries, bakeries, and kitchens, we are yet, in America, even in our larger cities, far behind many of the smaller towns of the Old World.

While in all these directions enterprise and the progress of invention are quite sure to add rapidly to the economy and convenience of town life, and thus increase its comparative attractions, in other directions every step tends to reduce the man-power required on the farms for the production of a given amount of the raw material of food. Such is the effect, for instance, of every improvement of apparatus or process in ploughing, moving, reaping, curing, thrashing, and marketing.

Another tendency arising from the improvement of agricultural apparatus, which will be much accelerated when steam shall have been as successfully applied to tillage as already to harvesting and marketing operations, is that to the enlargement of fields and of farms. From this will follow the greater isolation of rural homesteads; for with our long-fronted farms, it will be long before we can hope to have country roads on which rapid engine-transit will be practicable, though we may be close upon it whenever firm and smooth roads can be afforded.*

It should be observed that possession of all the various advantages of the town to which we have referred, while it very certainly cannot be acquired by people living in houses a quarter or a half mile apart, does not, on the other hand, by any means involve an unhealthy density of population. Probably the advantages of civilization can be found illustrated and demonstrated under no other circumstances so completely as in some suburban neighbor-

* *Slow freighting* over earth roads is practicable; 500 locomotives are now in regular use on common roads.

hoods where each family abode stands fifty or a hundred feet or more apart from all others, and at some distance from the public road. And it must be remembered, also, that man's enjoyment of rural beauty has clearly increased rather than diminished with his advance in civilization. There is no reason, except in the loss of time, the inconvenience, discomfort, and expense of our present arrangements for short travel, why suburban advantages should not be almost indefinitely extended. Let us have a cheap and enjoyable method of conveyance, and a building law like that of old Rome, and they surely will be.

As railroads are improved, all the important stations will become centres or sub-centres of towns, and all the minor stations suburbs. For most ordinary every-day purposes, especially house-keepers' purposes, these will need no very large population before they can obtain urban advantages. I have seen a settlement, the resident population of which was under three hundred, in which there was a public laundry, bath-house, barber's shop, billiard-room, beer-garden, and bakery. Fresh rolls and fresh milk were supplied to families before breakfast time every morning; fair fruit and succulent vegetables were delivered at house doors not half an hour after picking; and newspapers and magazines were distributed by a carrier. I have seen a town of not more than twelve hundred inhabitants, the streets and the yards, alleys, and places of which were swept every day as regularly as the house floors, and all dust removed by a public dustman.

The construction of good roads and walks, the laying of sewer, water, and gas pipes, and the supplying of sufficiently cheap, rapid, and comfortable conveyances to town centres, is all that is necessary to give any farming land in a healthy and attractive situation the value of town lots. And whoever has observed in the French agricultural colonies how much more readily and cheaply rail-

roads, telegraph, gas, water, sewer, and nearly all other advantages of towns may be made available to the whole population than under our present helter-skelter methods of settlement, will not believe that even the occupation of a farm laborer must necessarily and finally exclude his family from a very large share of urban conveniences.

But this opens a subject of speculation, which I am not now free to pursue. It is hardly a matter of speculation, I am disposed to think, but almost of demonstration, that the larger a town becomes simply because of its advantages for commercial purposes, the greater will be the convenience available to those who live in and near it for cooperation, as well with reference to the accumulation of wealth in the higher forms, — as in seats of learning, of science, and of art, — as with reference to merely domestic economy and the emancipation of both men and women from petty, confining, and narrowing cares.

It also appears to be nearly certain that the recent rapid enlargement of towns and withdrawal of people from rural conditions of living is the result mainly of circumstances of a permanent character.

We have reason to believe, then, that towns which of late have been increasing rapidly on account of their commercial advantages, are likely to be still more attractive to population in the future; that there will in consequence soon be larger towns than any the world has yet known, and that the further progress of civilization is to depend mainly upon the influences by which men's minds and characters will be affected while living in large towns.

Now, knowing that the average length of the life of mankind in towns has been much less than in the country, and that the average amount of disease and misery and of vice and crime has been much greater in towns, this would be a very dark prospect for civilization,

if it were not that modern science has beyond all question determined many of the causes of the special evils by which men are afflicted in towns, and placed means in our hands for guarding against them. It has shown, for example, that under ordinary circumstances, in the interior parts of large and closely built towns, a given quantity of air contains considerably less of the elements which we require to receive through the lungs than the air of the country or even of the outer and more open parts of a town, and that instead of them it carries into the lungs highly corrupt and irritating matters, the action of which tends strongly to vitiate all our sources of vigor — how strongly may perhaps be indicated in the shortest way by the statement that even metallic plates and statues corrode and wear away under the atmospheric influences which prevail in the midst of large towns, more rapidly than in the country.

The irritation and waste of the physical powers which result from the same cause, doubtless indirectly affect and very seriously affect the mind and the moral strength; but there is a general impression that a class of men are bred in towns whose peculiarities are not perhaps adequately accounted for in this way. We may understand these better if we consider that whenever we walk through the denser part of a town, to merely avoid collision with those we meet and pass upon the sidewalks, we have constantly to watch, to foresee, and to guard against their movements. This involves a consideration of their intentions, a calculation of their strength and weakness, which is not so much for their benefit as our own. Our minds are thus brought into close dealings with other minds without any friendly flowing toward them, but rather a drawing from them. Much of the intercourse between men when engaged in the pursuits of commerce has the same tendency — a tendency to regard others in a hard if not always hardening way. Each detail of observation

and of the process of thought required in this kind of intercourse or contact of minds is so slight and so common in the experience of towns-people that they are seldom conscious of it. It certainly involves some expenditure nevertheless. People from the country are even conscious of the effect on their nerves and minds of the street contact — often complaining that they feel confused by it; and if we had no relief from it at all during our waking hours, we should all be conscious of suffering from it. It is upon our opportunities of relief from it, therefore, that not only our comfort in town life, but our ability to maintain a temperate, good-natured, and healthy state of mind, depends. This is one of many ways in which it happens that men who have been brought up, as the saying is, in the streets, who have been most directly and completely affected by town influences, so generally show, along with a remarkable quickness of apprehension, a peculiarly hard sort of selfishness. Every day of their lives they have seen thousands of their fellow-men, have met them face to face, have brushed against them, and yet have had no experience of anything in common with them.

It has happened several times within the last century, when old artificial obstructions to the spreading out of a city have been removed, and especially when there has been a demolition of and rebuilding on a new ground plan of some part which had previously been noted for the frequency of certain crimes, the prevalence of certain diseases, and the shortness of life among its inhabitants, that a marked improvement in all these respects has immediately followed, and has been maintained not alone in the dark parts, but in the city as a whole.

But although it has been demonstrated by such experiments that we have it in our power to greatly lessen and counteract the two classes of evils we have had under consideration, it must be remembered that these means are made use of only with great difficulty —

how great, one or two illustrations from experience will enable us perhaps better to understand.

When the business quarter of New York was burnt over, thirty years ago, there was a rare opportunity for laying out a district expressly with a view to facilitate commerce. The old plan had been arrived at in a desultory way; and so far as it had been the result of design, it had been with reference more especially to the residence of a semi-rural population. This had long since passed away; its inconvenience for commercial purposes had been experienced for many years; no one supposed from the relation of the ground to the adjacent navigable waters that it would ever be required for other than commercial purposes. Yet the difficulties of equalizing benefits and damages among the various owners of the land prevented any considerable change of the old street lines. Every working day thousands of dollars are subtracted from the profits of business, by the disadvantages thus re-established. The annual loss amounts to millions. . . .

Remedy for a bad plan, once built upon, being thus impracticable, now that we understand the matter we are surely bound, wherever it is by any means in our power, to prevent mistakes in the construction of towns. Strange to say, however, here in the New World, where great towns by the hundred are springing into existence, no care at all is taken to avoid bad plans. The most brutal pagans to whom we have sent our missionaries have never shown greater indifference to the sufferings of others than is exhibited in the plans of some of our most promising cities, for which men now living in them are responsible.

Not long since I was asked by the mayor of one of these to go before its common council and explain the advantages of certain suggested changes, including especially the widening of two roads leading out of town and as yet but partially opened and not at all

built upon. After I had done so, two of the aldermen in succession came to me, and each privately said in effect: "It is quite plain that the proposition is a good one, and it ought to be adopted; the city would undoubtedly gain by it; but the people of the ward I represent have less interest in it than some others: they do not look far ahead, and they are jealous of those who would be more directly benefited than themselves; consequently I don't think that they would like it if I voted for it, and I shall not, but I hope it will be carried."

They were unwilling that even a stranger should have so poor an opinion of their own intelligence as to suppose that they did not see the advantage of the change proposed; but it was not even suggested to their minds that there might be something shameful in repudiating their obligations to serve, according to the best of their judgment, the general and permanent interests committed to them as legislators of the city.

It is evident that if we go on in this way, the progress of civilized mankind in health, virtue, and happiness will be seriously endangered.

It is practically certain that the Boston of today is the mere nucleus of the Boston that is to be. It is practically certain that it is to extend over many miles of country now thoroughly rural in character, in parts of which farmers are now laying out roads with a view to shortening the teaming distance between their wood-lots and a railway station, being governed in their courses by old property lines, which were first run simply with reference to the equitable division of heritages, and in other parts of which, perhaps, some wild speculators are having streets staked off from plans which they have formed with a rule and pencil in a broker's office, with a view chiefly to the impressions they would make when seen by other speculators on a lithographed map. And by this manner

of planning, unless views of duty or of interest prevail that are not yet common, if Boston continues to grow at its present rate even for but a few generations longer, and then simply holds its own until it shall be as old as the Boston in Lincolnshire now is, more men, women, and children are to be seriously affected in health and morals than are now living on this continent.

Is this a small matter — a mere matter of taste; a sentimental speculation?

It must be within the observation of most of us that where, in the city, wheel-ways originally twenty feet wide were with great difficulty and cost enlarged to thirty, the present width is already less nearly adequate to the present business than the former was to the former business; obstructions are more frequent, movement are slower and oftener arrested, and the liability to collision i greater. The same is true of sidewalks. Trees thus have been cut down, porches, bow-windows, and other encroachments removed, but every year the walk is less sufficient for the comfortable passing of those who wish to use it.

It is certain that as the distance from the interior to the circumference of towns shall increase with the enlargement of their population, the less sufficient relatively to the service to be performed will be any given space between buildings.

In like manner every evil to which men are specially liable when living in towns, is likely to be aggravated in the future, unless means are devised and adapted in advance to prevent it.

Let us proceed, then, to the question of means, and with a seriousness in some degree befitting a question, upon our dealing with which we know the misery or happiness of many millions of our fellow-beings will depend.

We will for the present set before our minds the two sources of wear and corruption which we have seen to be remediable and

therefore preventible. We may admit that commerce requires that in some parts of a town there shall be an arrangement of buildings, and a character of streets and of traffic in them which will establish conditions of corruption and of irritation, physical and mental. But commerce does not require the same conditions to be maintained in all parts of a town.

Air is disinfected by sunlight and foliage. Foliage also acts mechanically to purify the air by screening it. Opportunity and inducement to escape at frequent intervals from the confined and vitiated air of the commercial quarter, and to supply the lungs with air screened and purified by trees, and recently acted upon by sunlight, together with opportunity and inducement to escape from conditions requiring vigilance, wariness, and activity toward other men, — if these could be supplied economically, our problem would be solved.

In the old days of walled towns all tradesmen lived under the roof of their shops, and their children and apprentices and servants sat together with them in the evening about the kitchen fire. But now that the dwelling is built by itself and there is greater room, the inmates have a parlor to spend their evenings in; they spread carpets on the floor to gain in quiet, and hang drapery in their windows and papers on their walls to gain in seclusion and beauty. Now that our towns are built without walls, and we can have all the room that we like, is there any good reason why we should not make some similar difference between parts which are likely to be dwelt in, and those which will be required exclusively for commerce?

Would trees, for seclusion and shade and beauty, be out of place, for instance, by the side of certain of our streets? It will, perhaps, appear to you that it is hardly necessary to ask such a question, as throughout the United States trees are commonly

planted at the sides of streets. Unfortunately they are seldom so planted as to have fairly settled the question of the desirableness of systematically maintaining trees under these circumstances. In the first place, the streets are planned, wherever they are, especially alike. Trees are planted in the space assigned for sidewalks, where at first, while they are saplings, and the vicinity is rural or suburban, they are not much in the way, but where, as they grow larger, and the vicinity becomes urban, they take up more and more space, while space is more and more required for passage. That is not all. Thousands and tens of thousands are planted every year in a manner and under conditions as nearly certain as possible either to kill them outright, or to so lessen their vitality as to prevent their natural and beautiful development, and to cause premature decrepitude. Often, too, as their lower limbs are found inconvenient, no space having been provided for trees in laying out the street, they are deformed by butcherly amputations. If by rare good fortune they are suffered to become beautiful, they still stand subject to be condemned to death at any time, as obstructions in the highway.*

What I would ask is, whether we might not with economy make special provision in some of our streets — in a twentieth or a fiftieth part, if you please, of all — for trees to remain as a per-

* On the border of the first street laid out in the oldest town in New England, there yet stands what has long been known as "the Town Tree," its trunk having served for generations as a publication post for official notices. "The selectmen," having last year removed the lower branches of all the younger roadside trees of the town, and thereby its chief beauty, have this year deliberately resolved that they would have this tree cut down, for no other reason, so far as appears in their official record, than that if two persons came carelessly together on the roadway side of it, one of them might chance to put his foot in the adjoining shallow street-gutter. It might cost ten dollars to deepen and bridge this gutter substantially. The call to arms for the Old French War, for the War of the Revolution, the war for the freedom of the seas, the Mexican War, and the War of the Rebellion, was first made in this town under the shade of this tree, which is an American elm, and, notwithstanding its great age, is perfectly healthy and almost as beautiful as it is venerable.

manent furniture of the city? I mean, to make a place for them in which they would have room to grow naturally and gracefully. Even if the distance between the houses should have to be made half as much again as it is required to be in our commercial streets, could not the space be afforded? Out of town space is not costly when measures to secure it are taken early. The assessments for benefit where such streets were provided for, would, in nearly all cases, defray the cost of the land required. The strips of ground reserved for the trees, six, twelve, twenty feet wide, would cost nothing for paving or flagging.

The change both of scene and of air which would be obtained by people engaged for the most part in the necessarily confined interior commercial parts of the town, on passing into a street of this character after the trees had become stately and graceful, would be worth a good deal. If such streets were made still broader in some parts, with spacious malls, the advantage would be increased. If each of them were given the proper capacity, and laid out with laterals and connections in suitable directions to serve as a convenient trunk line of communication between two large districts of the town or the business centre and the suburbs, a very great number of people might thus be placed every day under influences counteracting those with which we desire to contend.

These, however, would be merely very simple improvements upon arrangements which are in common use in every considerable town. Their advantages would be incidental to the general uses of streets as they are. But people are willing very often to seek recreations as well as receive it by the way. Provisions may indeed be made expressly for public recreations, with certainty that if convenient they will be resorted to.

We come then to the question: what accommodations for recreation can we provide which shall be so agreeable and so accessible

as to be efficiently attractive to the great body of citizens, and
which, while giving decided gratification, shall also cause those
who resort to them for pleasure to subject themselves, for the
time being, to conditions strongly counteractive to the special
enervating conditions of the town?

In the study of this question all forms of recreation may, in the
first place, be conveniently arranged under two general heads. One
will include all of which the predominating influence is to stimulate
exertion of any part or parts needing it; the other, all which cause
us to receive pleasure without conscious exertion. Games chiefly
of mental skill, as chess, or athletic sports, as baseball, are exam-
ples of means of recreation of the first class, which may be termed
that of *exertive* recreation; music and the fine arts generally of
the second or *receptive* division.

Considering the first by itself, much consideration will be needed
in determining what classes of exercises may be advantageously
provided for. In the Bois de Boulogne there is a race course; in
the Bois de Vincennes a ground for artillery target-practice. Mil-
itary parades are held in Hyde Park. A few cricket clubs are
accommodated in most of the London parks, and swimming is per-
mitted in the lakes at certain hours. In the New York Park, on
the other hand, none of these exercises are provided for or per-
mitted, except that the boys of the public schools are given the
use on holidays of certain large spaces for ball playing. It is con-
sidered that the advantage to individuals which would be gained
in providing for them would not compensate for the general in-
convenience and expense they would cause.

I do not propose to discuss this part of the subject at present,
as it is only necessary to my immediate purpose to point out that
if recreations requiring spaces to be given up to the use of a com-
paratively small number, are not considered essential, numerous

small grounds so distributed through a large town that some one of them could be easily reached by a short walk from every house, would be more desirable than a single area of great extent, however rich in landscape attractions it might be. Especially would this be the case if the numerous local grounds were connected and supplemented by a series of trunk roads or boulevards such as has already been suggested.

Proceeding to the consideration of receptive recreations, it is necessary to ask you to adopt and bear in mind a further subdivision, under two heads, according to the degree in which the average enjoyment is greater when a large congregation assembles for a purpose of receptive recreation, or when the number coming together is small and the circumstances are favorable to the exercise of personal friendliness.

The first I shall term *gregarious;* the second, *neighborly.* Remembering that the immediate matter in hand is a study of fitting accommodations, you will, I trust, see the practical necessity of this classification.

Purely gregarious recreation seems to be generally looked upon in New England society as childish and savage, because, I suppose, there is so little of what we call intellectual gratification in it. We are inclined to engage in it indirectly, furtively, and with complication. Yet there are certain forms of recreation, a large share of the attraction of which must, I think, lie in the gratification of the gregarious inclination, and which, with those who can afford to indulge in them, are so popular as to establish the importance of the requirement.

If I ask myself where I have experienced the most complete gratification of this instinct in public and out of doors, among trees, I find that it has been in the promenade of the Champs Elysées. As closely following it I should name other promenades

of Europe, and our own upon the New York parks. I have studiously watched the latter for several years. I have several times seen fifty thousand people participating in them; and the more I have seen of them, the more highly have I been led to estimate their value as means of counteracting the evils of town life.

Consider that the New York Park and the Brooklyn Park are the only places in those associated cities where, in this eighteen hundred and seventieth year after Christ, you will find a body of Christians coming together, and with an evident glee in the prospect of coming together, all classes largely represented, with a common purpose, not at all intellectual, competitive with none, disposing to jealousy and spiritual or intellectual pride toward none, each individual adding by his mere presence to the pleasure of all others, all helping to the greater happiness of each. You may thus often see vast numbers of persons brought closely together, poor and rich, young and old, Jew and Gentile. I have seen a hundred thousand thus congregated, and I assure you that though there have been not a few that seemed a little dazed, as if they did not quite understand it, and were, perhaps, a little ashamed of it, I have looked studiously but vainly among them for a single face completely unsympathetic with the prevailing expression of good nature and light-heartedness.

Is it doubtful that it does men good to come together in this way in pure air and under the light of heaven, or that it must have an influence directly counteractive to that of the ordinary hard, hustling working hours of town life?

You will agree with me, I am sure, that it is not, and that opportunity, convenient, attractive opportunity, for such congregation, is a very good thing to provide for, in planning the extension of a town.

I referred especially to the Champs Elysées, because the prom-

enade there is a very old custom, not a fashion of the day, and because I must needs admit that this most striking example is one in which no large area of ground — nothing like a park — has been appropriated for the purpose. I must acknowledge, also, that the alamedas of Spain and Portugal supply another and very interesting instance of the same fact. You will observe, however, that small local grounds, such as we have said might be the best for most exertive recreations, are not at all adapted to receptive recreations of the type described.

One thing more under this head. I have but little personal familiarity with Boston customs; but I have lived or sojourned in several other towns of New England, as well as of other parts of the country, and I have never been long in any locality, south or north, east or west, without observing a *custom* of gregarious out-of-door recreation in some miserably imperfect form, usually covered by a wretched pretext of a wholly different purpose, as perhaps, for instance, visiting a grave-yard. I am sure that it would be much better, less expensive, less harmful in all ways, more health-giving to body, mind, and soul, if it were admitted to be a distinct requirement of all human beings, and appropriately provided for.

I have next to see what opportunities are wanted to induce people to engage in what I have termed *neighborly* receptive recreations, under conditions which shall be highly counteractive to the prevailing bias to degeneration and demoralization in large towns. To make clearer what I mean, I need an illustration which I find in a familiar domestic gathering, where the prattle of the children mingles with the easy conversation of the more sedate, the bodily requirements satisfied with good cheer, fresh air, agreeable light, moderate temperature, snug shelter, and furniture and decorations adapted to please the eye, without calling for profound

admiration on the one hand, or tending to fatigue or disgust on
the other. The circumstances are all favorable to a pleasurable
wakefulness of the mind without stimulating exertion; and the
close relation of family life, the association of children, of moth-
ers, of lovers, or those who may be lovers, stimulate and keep
alive the more tender sympathies, and give play to faculties such
as may be dormant in business or on the promenade; while at
the same time the cares of providing in detail for all the wants
of the family, guidance, instruction, reproof, and the dutiful re-
ception of guidance, instruction, and reproof, are, as matters of
conscious exertion, as far as possible laid aside.

There is an instinctive inclination to this social, neighborly, un-
exertive form of recreation among all of us. In one way or another
it is sure to be constantly operating upon those millions on mil-
lions of men and women who are to pass their lives within a few
miles of where we now stand. To what extent it shall operate so
as to develop health and virtue, will, on many occasions, be sim-
ply a question of opportunity and inducement. And this question
is one for the determination of which for a thousand years we
here to-day are largely responsible.

Think what the ordinary state of things to many is at this be-
ginning of the town. The public is reading just now a little book
in which some of your streets of which you are not proud are
described. Go into one of those red cross streets any fine evening
next summer, and ask how it is with their residents? Oftentimes
you will see half a dozen sitting together on the door-steps, or,
all in a row, on the curb-stones, with their feet in the gutter, driven
out of doors by the closeness within; mothers among them anx-
iously regarding their children who are dodging about at their
play, among the noisy wheels on the pavement.

Again, consider how often you see young men in knots of per-

haps half a dozen in lounging attitudes rudely obstructing the sidewalks, chiefly led in their little conversation by the suggestions given to their minds by what or whom they may see passing in the street, men, women, or children, whom they do not know, and for whom they have no respect or sympathy. There is nothing among them or about them which is adapted to bring into play a spark of admiration, of delicacy, manliness, or tenderness. You see them presently descend in search of physical comfort to a brilliantly lighted basement, where they find others of their sort, see, hear, smell, drink, and eat all manner of vile things.

Whether on the curb-stones or in the dram-shops, these young men are all under the influence of the same impulse which some satisfy about the tea-table with neighbors and wives and mothers and children, and all things clean and wholesome, softening and refining.

If the great city to arise here is to be laid out little by little, and chiefly to suit the views of land-owners, acting only individually, and thinking only of how what they do is to affect the value in the next week or the next year of the few lots that each may hold at the time, the opportunities of so obeying this inclination as at the same time to give the lungs a bath of pure sunny air, to give the mind a suggestion of rest from the devouring eagerness and intellectual strife of town life, will always be few to any, to many will amount to nothing.

But is it possible to make public provision for recreation of this class, essentially domestic and secluded as it is?

It is a question which can, of course, be conclusively answered only from experience. And from experience in some slight degree I shall answer it. There is one large American town, in which it may happen that a man of any class shall say to his wife, when he is going out in the morning: "My dear, when the children come

home from school, put some bread and butter and salad in a basket, and go to the spring under the chestnut-tree where we found the Johnsons last week. I will join you there as soon as I can get away from the office. We will walk to the dairy-man's cottage and get some tea, and some fresh milk for the children, and take our supper by the brook-side;" and this shall be no joke, but the most refreshing earnestness.

There will be room enough in the Brooklyn Park, when it is finished, for several thousand little family and neighborly parties to bivouac at frequent intervals through the summer, without discommoding one another, or interfering with any other purpose, to say nothing of those who can be drawn out to make a day of it, as many thousand were last year. And although the arrangements for the purpose were yet very incomplete, and but little ground was at *all* prepared for such use, besides these small parties, consisting of one or two families, there came also, in companies of from thirty to a hundred and fifty, somewhere near twenty thousand children with their parents, Sunday-school teachers, or other guides and friends, who spent the best part of a day under the trees and on the turf, in recreations of which the predominating element was of this neighborly receptive class. Often they would bring a fiddle, flute, and harp, or other music. Tables, seats, shade, turf, swings, cool spring-water, and a pleasing rural prospect, stretching off half a mile or more each way, unbroken by a carriage road or the slightest evidence of the vicinity of the town, were supplied them without charge, and bread and milk and ice-cream at moderate fixed charges. In all my life I have never seen such joyous collections of people. I have, in fact, more than once observed tears of gratitude in the eyes of poor women, as they watched their children thus enjoying themselves.

The whole cost of such neighborly festivals, even when they

include excursions by rail from the distant parts of the town, does not exceed for each person, on an average, a quarter of a dollar; and when the arrangements are complete, I see no reason why thousands should not come every day where hundreds come now to use them; and if so, who can measure the value, generation after generation, of such provisions for recreation to the over-wrought, much confined people of the great town that is to be?

For this purpose neither of the forms of ground we have here-tofore considered are at all suitable. We want a ground to which people may easily go after their day's work is done, and where they may stroll for an hour, seeing, hearing, and feeling nothing of the bustle and jar of the streets, where they shall, in effect, find the city put far away from them. We want the greatest possible contrast with the streets and the shops and the rooms of the town which will be consistent with convenience and the preservation of good order and neatness. We want, especially, the greatest pos-sible contrast with the restraining and confining conditions of the town, those conditions which compel us to walk circumspectly, watchfully, jealously, which compel us to look closely upon others without sympathy. Practically, what we most want is a simple, broad, open space of clean greensward, with sufficient play of surface and a sufficient number of trees about it to supply a vari-ety of light and shade. This we want as a central feature. We want depth of wood enough about it not only for comfort in hot weather, but to completely shut out the city from our landscapes.

The word *park*, in town nomenclature, should, I think, be re-served for grounds of the character and purpose thus described.

Not only as being the most valuable of all possible forms of public places, but regarded simply as a large space which will seriously interrupt cross-town communication wherever it occurs, the question of the site and bounds of the park requires to be

determined with much more deliberation and art than is often secured for any problem of distant and extended municipal interests.

A Promenade may, with great advantage, be carried along the outer part of the surrounding groves of a park; and it will do no harm if here and there a broad opening among the trees discloses its open landscapes to those upon the promenade. But recollect that the object of the latter for the time being should be to see *congregated human life* under glorious and necessarily artificial conditions, and the natural landscape is not essential to them; though there is no more beautiful picture, and none can be more pleasing incidentally to the gregarious purpose, than that of beautiful meadows, over which clusters of level-armed sheltering trees cast broad shadows, and upon which are scattered dainty cows and flocks of black-faced sheep, while men, women, and children are seen sitting here and there, forming groups in the shade, or moving in and out among the woody points and bays.

It may be inferred from what I have said, that very rugged ground, abrupt eminences, and what is technically called picturesque in distinction from merely beautiful or simply pleasing scenery, is not the most desirable for a town park. Decidedly not in my opinion. The park should, as far as possible, complement the town. Openness is the one thing you cannot get in buildings. Picturesqueness you can get. Let your buildings be as picturesque as your artists can make them. This is the beauty of a town. Consequently, the beauty of the park should be the other. It should be the beauty of the fields, the meadow, the prairie, of the green pastures, and the still waters. What we want to gain is tranquillity and rest to the mind. Mountains suggest effort. But besides this objection there are others of what I may indicate as the housekeeping class. It is impossible to give the public range over a

large extent of ground of a highly picturesque character, unless under very exceptional circumstances, and sufficiently guard against the occurrence of opportunities and temptations to shabbiness, disorder, indecorum, and indecency, that will be subversive of every good purpose the park should be designed to fulfill.

Nor can I think that *in the park proper*, what is called gardenesque beauty is to be courted; still less that highly artificial and exotic form of it, which, under the name of subtropical planting, the French have lately introduced, and in suitable positions with interesting and charming results, but in following which indiscretely, the English are sacrificing the simple beauty of their simple and useful parks of the old time. Both these may have places, and very important places, but they do not belong within a park, unless as side scenes and incidents. Twenty years ago Hyde Park had a most pleasing, open, free, and inviting expression, though certainly it was too rude, too much wanting in art; but now art is vexed with long black lines of repellent iron-work, and here and there behind it bouquets of hot-house plants, between which the public pass like hospital convalescents, who have been turned into the yard to walk about while their beds are making. We should undertake nothing in a park which involves the treating of the public as prisoners or wild beasts. A great object of all that is done in a park, of *all* the art of a park, is to influence the mind of men through their imagination, and the influence of iron hurdles can never be good.

We have, perhaps, sufficiently defined the ideal of a park for a large town. It will seldom happen that this ideal can be realized fully. The next thing is to select the situation in which it can be most nearly approached without great cost; and by cost I do not mean simply cost of land or of construction, but cost of inconvenience and cost of keeping in order, which is a very much more serious matter, and should have a great deal more study.

A park fairly well managed near a large town, will surely become a new centre of that town. With the determination of location, size, and boundaries should therefore be associated the duty of arranging new trunk routes of communication between it and the distant parts of the town existing and forecasted.

These may be either narrow informal elongations of the park, varying say from two to five hundred feet in width, and radiating irregularly from it, or if, unfortunately, the town is already laid out in the unhappy way that New York and Brooklyn, San Francisco and Chicago, are, and, I am glad to say, Boston is not, on a plan made long years ago by a man who never saw a spring carriage, and who had a conscientious dread of the Graces, then we must probably adopt formal parkways. They should be so planned and constructed as never to be noisy and seldom crowded, and so also that the straightforward movement of pleasure carriages need never be obstructed, unless at absolutely necessary crossings, by slow-going heavy vehicles used for commercial purposes. If possible, also, they should be branched or reticulated with other ways of a similar class, so that no part of the town should finally be many minutes' walk from some one of them; and they should be made interesting by a process of planting and decoration, so that in necessarily passing through them, whether in going to or from the park, or to and from business, some substantial recreative advantage may be incidentally gained. It is a common error to regard a park as something to be produced complete in itself, as a picture to be painted on canvas. It should rather be planned as one to be done in fresco, with constant consideration of exterior objects, some of them quite at a distance and even existing as yet only in the imagination of the painter.

I have thus barely indicated a few of the points from which we may perceive our duty to apply the means in our hands to ends far distant, with reference to this problem of public recre-

ations. Large operations of construction may not soon be desirable, but I hope you will agree with me that there is little room for question, that reserves of ground for the purposes I have referred to should be fixed upon as soon as possible, before the difficulty of arranging them, which arises from private building, shall be greatly more formidable than now.

To these reserves, — though not a dollar should be spent in construction during the present generation, — the plans of private construction would necessarily, from the moment they were established be conformed.

I by no means wish to suggest that nothing should be done for the present generation; but only, that whatever happens to the present generation, it should not be allowed to go on heaping up difficulties and expenses for its successors, for want of a little comprehensive and business-like foresight and study. In all probability it will be found that much can be done even for the present generation without greatly if at all increasing taxation, as has been found in New York.

But the question now perhaps comes up: How can a community best take this work in hand?

It is a work in which private and local and special interests will be found so antagonistic one to another, in which heated prejudices are so liable to be unconsciously established, and in which those who would be disappointed in their personal greeds by whatever good scheme may be studied out, are so likely to combine and concentrate force to kill it (manufacture public opinion, as the phrase is), that the ordinary organizations for municipal business are unsuitable agencies for the purpose. It would, perhaps, be a bold thing to say that the public in its own interest, and in the interest of all of whom the present public are the trustees, should see to it that the problem is as soon as possible put clean out of its own

hands, in order that it may be taken up efficiently by a small body of select men. But I will venture to say that until this in effect is done, the danger that public opinion may be led, by the application of industry, ingenuity, and business ability on the part of men whose real objects are perhaps unconsciously very close to their own pockets, to overrule the results of more comprehensive and impartial study, is much greater than in most questions of public interest.

You will not understand me as opposing or undervaluing the advantages of public discussion. What I would urge is, that park questions, and even the most elementary park questions, questions of site and outlines and approaches, are not questions to which the rule applies, that every man should look after his own interests, judge for himself what will favor his own interests, and exert his influence so as to favor them; but questions rather of that class, which in his private affairs every man of common sense is anxious, as soon as possible, to put into the hands of somebody who is able to take hold of them comprehensively as a matter of direct, grave, business responsibility.

It is upon this last point far more than upon any other that the experience of New York is instructive to other communities. I propose, therefore, to occupy your time a little while longer by a narration of those parts of this experience which bear most directly upon this point, and which will also supply certain other information which has been desired of me.

The New York legislature of 1851 passed a bill providing for a park on the east side of the island. Afterwards, the same legislature, precipitately and quite as an after-thought, passed the act under which the city took title to the site of the greater part of the present Central Park.

This final action is said to have been the result of a counter

movement, started after the passage of the first bill merely to gratify a private grudge of one of the city aldermen.

When in the formation of the counter project, the question was reached, what land shall be named in the second bill, the originator turned to a map and asked: *"Now where shall I go?"* His comrade, looking over his shoulder, without a moment's reflection, put his finger down and said, *"Go there;"* the point indicated appearing to be about the middle of the island, and therefore, as it occurred to him, one which would least excite local prejudices.

The primary selection of the site was thus made in an off-hand way, by a man who had no special responsibility in the premises, and whose previous studies had not at all led him to be well informed or interested in the purposes of a park.

It would have been difficult to find another body of land of six hundred acres upon the island (unless by taking a long narrow strip upon the precipitous side of a ridge), which possessed less of what we have seen to be the most desirable characteristics of a park, or upon which more time, labor, and expense would be required to establish them.

But besides the topographical objections, when the work of providing suitable facilities for the recreation of the people upon this ground came to be practically and definitely considered, defects of outline were discerned, the incomplete remedy for which has since cost the city more than a million of dollars. The amount which intelligent study would have saved in this way if applied at the outset, might have provided for an amplification of some one of the approaches to the Park, such as, if it were now possible to be gained at a cost of two or three million dollars, I am confident would, if fairly set forth, be ordered by an almost unanimous vote of the tax-payers of the city. Public discussion at the time utterly

failed to set this blundering right. Nor was public opinion then clearly dissatisfied with what was done or with those who did it.

During the following six years there was much public and private discussion of park questions; but the progress of public opinion, judged simply by the standard which it has since formed for itself, seems to have been chiefly backward.

This may be, to a considerable degree, accounted for by the fact that many men of wealth and influence — who, through ignorance and lack of mature reflection on this subject, were unable to anticipate any personal advantage from the construction of a park — feared that it would only add to their taxes, and thus were led to form a habit of crying down any hopeful anticipations.

The argument that certain towns of the old country did obtain some advantage from their parks, could not be refuted, but it was easy to say, and it was said, that "our circumstances are very different: surrounded by broad waters on all sides, open to the sea breezes, we need no artificial breathing places; even if we did, nothing like the parks of the old cities under aristocratic government would be at all practicable here."

This assertion made such an impression as to lead many to believe that little more had better be done than to give the name of park to the ground which it was now too late to avoid taking. A leading citizen suggested that nothing more was necessary than to plough up a strip just within the boundary of the ground and plant it with young trees, and chiefly with cuttings of the poplar, which afterwards, as they came to good size, could be transplanted to the interior, and thus the Park would be furnished economically and quite well enough for the purposes it would be required to serve.

Another of distinguished professional reputation seriously urged through the public press, that the ground should be rented as a

sheep-walk. In going to and from their folds the flocks would be sure to form trails which would serve the public perfectly well for foot-paths; nature would in time supply whatever else was essential to form a quite picturesque and perfectly suitable strolling ground for such as would wish to resort to it.

It was frequently alleged, and with truth, that the use made of the existing public grounds was such as to develop riotous and licentious habits. A large park, it was argued, would inevitably present larger opportunities, and would be likely to exhibit an aggravated form of the same tendencies, consequently anything like refinement of treatment would be entirely wasted.

A few passages from a leading article of the "Herald" newspaper, in the seventh year of the enterprise, will indicate what estimate its astute editor had then formed of the prevailing convictions of the public on the subject: —

It is folly to expect in this country to have parks like those in old aristocratic countries. When we open a public park Sam will air himself in it. He will take his friends whether from Church Street, or elsewhere. He will knock down any better dressed man who remonstrates with him. He will talk and sing, and fill his share of the bench, and flirt with the nursery maids in his own coarse way. Now we ask what chance have William B. Astor and Edward Everett against this fellow citizen of theirs? Can they and he enjoy the same place? Is it not obvious that he will turn them out, and that the great Central Park will be nothing but a great beer-garden for the lowest denizens of the city, of which we shall yet pray litanies to be delivered?

In the same article it was argued that the effect of the construction of the Park would be unfavorable to the value of property in its neighborhood, except as, to a limited extent, it might be taken up by Irish and German liquor dealers as sites for dram-shops and lager beer gardens.

There were many eminent citizens, who to my personal knowl-
edge, in the sixth, seventh, and eighth year after the passage of
the act, entertained similar views to those I have quoted.

I have been asked if I supposed that "gentlemen" would ever
resort to the Park, or would allow their wives and daughters to
visit it? I heard a renowned lawyer argue that it was preposterous
to suppose that a police force would do anything toward preserving
order and decency in any broad piece of ground open to the gen-
eral public of New York. And after the work began, I often heard
the conviction expressed that if what was called the reckless,
extravagant, inconsiderate policy of those who had the making of
the Park in charge, could not be arrested, the weight of taxation
and the general disgust which would be aroused among the wealthy
classes would drive them from the city, and thus prove a serious
injury to its prosperity.

"Why," said one, a man whom you all know by reputation, and
many personally, "I should not ask for anything finer in my pri-
vate grounds for the use of my own family." To whom it was
replied that possibly grounds might not unwisely be prepared even
more carefully when designed for the use of two hundred thousand
families and their guests, than when designed for the use of one.

The constantly growing conviction that it was a rash and ill-
considered undertaking, and the apprehension that a great deal
would be spent upon it for no good purpose, doubtless had some-
thing to do with the choice of men, who in the sixth year were ap-
pointed by the governor of the state, commissioners to manage
the work and the very extraordinary powers given them. At all
events, it so happened that a majority of them were much better
known from their places in the directory of banks, railroads, min-
ing, and manufacturing enterprises, than from their previous ser-
vices in politics; and their freedom to follow their own judgment

and will, in respect to all the interior matters of the Park, was larger than had for a long time been given to any body of men charged with a public duty of similar importance.

I suppose that few of them knew or cared more about the subject of their duties at the time of their appointment, than most other active business men. They probably embodied very fairly the average opinion of the public, as to the way in which it was desirable that the work should be managed. If, then, it is asked, how did they come to adopt and resolutely pursue a course so very different from that which the public opinion seemed to expect of them, I think that the answer must be found in the fact that they had not wanted or asked the appointment; that it was made absolutely free from any condition or obligation to serve a party, a faction, or a person; that owing to the extraordinary powers given them, their sense of responsibility in the matter was of an uncommonly simple and direct character, and led them with the trained skill of business men to go straight to the question: —

"Here is a piece of property put into our hands. By what policy can we turn it to the best account for our stockholders?"

It has happened that instead of being turned out about the time they had got to know something about their special business, these commissioners have been allowed to remain in office to this time — a period of twelve years.

As to their method of work, it was as like as possible to that of a board of directors of a commercial corporation. They quite set at defiance the ordinary ideas of propriety applied to public servants, by holding their sessions with closed doors, their clerk being directed merely to supply the newspapers with reports of their acts. They spent the whole of the first year on questions simply of policy, organization, and plan, doing no practical work, as it was said, at all.

When the business of construction was taken hold of, they refused to occupy themselves personally with questions of the class which in New York usually take up nine-tenths of the time and mind of all public servants, who have it in their power to arrange contracts and determine appointments, promotions, and discharges. All of these they turned over to the heads of the executive operations.

Now, when these deviations from usage were conjoined with the adoption of a policy of construction for which the public was entirely unprepared, and to which the largest tax-payers of the city were strongly opposed, when also those who had a variety of private axes to grind, found themselves and their influence, and their friends' influence, made nothing of by the commissioners, you may be sure that public opinion was manufactured against them at a great rate. The Mayor denounced them in his messages; the Common Council and other departments of the city government refused to cooperate with them, and were frequently induced to put obstructions in their way; they were threatened with impeachment and indictment; some of the city newspapers attacked them for a time in every issue; they were caricatured and lampooned; their session was once broken up by a mob, their business was five times examined (once or twice at great expense, lawyers, accountants, engineers, and other experts being employed for the purpose) by legislative investigating committees. Thus for a time public opinion, through nearly all the channels open to it, apparently set against them like a torrent.

No men less strong, and no men less confident in their strength than these men — by virtue in part of personal character, in part of the extraordinary powers vested in them by the legislature, and in part by the accident of certain anomalous political circumstances — happened to be, could have carried through a policy and a

method which commanded so little immediate public favor. As it was, nothing but personal character, the common impression that after all they were honest, saved them. By barely a sabre's length they kept ahead of their pursuers, and of this you may still see evidence here and there in the park, chiefly where something left to stop a gap for the time being has been suffered to produce lasting defects. At one time nearly four thousand laborers were employed; and for a year at one point, work went on night and day in order to put it as quickly as possible beyond the reach of those who were bent on stopping it. Necessarily, under such circumstances, the rule obtains: "Look out for the main chance; we may save the horses, we must save the guns;" and if now you do not find everything in perfect parade order, the guns, at all events, were saved.

To fully understand the significance of the result so far, it must be considered that the Park is to this day, at some points, incomplete; that from the centre of population to the midst of the Park the distance is still four miles; that there is no steam transit; that other means of communication are indirect and excessively uncomfortable, or too expensive. For practical every-day purposes to the great mass of the people, the Park might as well be a hundred miles away. There are hundreds of thousands who have never seen it, more hundreds of thousands who have seen it only on a Sunday or holiday. The children of the city to whom it should be of the greatest use, can only get to it on holidays or in vacations, and then must pay car-fare both ways.

It must be remembered, also, that the Park is not planned for such use as is now made of it, but with regard to the future use, when it will be in the centre of a population of two millions hemmed in by water at a short distance on all sides; and that much of the work done upon it is, for this reason, as yet quite barren of results.

The question of the relative value of what is called off-hand

common sense, and of special, deliberate, business-like study, must be settled in the case of the Central Park, by a comparison of benefit with cost. During the last four years over thirty million visits have been made to the Park by actual count, and many have passed uncounted. From fifty to eighty thousand persons on foot, thirty thousand in carriages, and four to five thousand on horseback, have often entered it in a day.

Among the frequent visitors, I have found all those who, a few years ago, believed it impossible that there should ever be a park in this republican country, — and especially in New York of all places in this country, — which would be a suitable place of resort for "gentlemen." They, their wives and daughters, frequent the Park more than they do the opera or the church.

There are many men of wealth who resort to the Park habitually and regularly, as much so as business men to their places of business. Of course, there is a reason for it, and a reason based upon their experience.

As to the effect on public health, there is no question that it is already great. The testimony of the older physicians of the city will be found unanimous on this point. Says one: "Where I formerly ordered patients of a certain class to give up their business altogether and go out of town, I now often advise simply moderation, and prescribe a ride in the Park before going to their offices, and again a drive with their families before dinner. By simply adopting this course as a habit, men who have been breaking down frequently recover tone rapidly, and are able to retain an active and controlling influence in an important business, from which they would have otherwise been forced to retire. I direct schoolgirls, under certain circumstances, to be taken wholly, or in part, from their studies, and sent to spend several hours a day rambling on foot in the Park."

The lives of women and children too poor to be sent to the country, can now be saved in thousands of instances, by making them go to the Park. During a hot day in July last, I counted at one time in the Park eighteen separate groups, consisting of mothers with their children, most of whom were under school age, taking picnic dinners which they had brought from home with them. The practice is increasing under medical advice, especially when summer complaint is rife.

The much greater rapidity with which patients convalesce, and may be returned with safety to their ordinary occupations after severe illness, when they can be sent to the Park for a few hours a day, is beginning to be understood. The addition thus made to the productive labor of the city is not unimportant.

The Park, moreover, has had a very marked effect in making the city attractive to visitors, and in thus increasing its trade, and causing many who have made fortunes elsewhere to take up their residence and become tax-payers in it, — a much greater effect in this way, beyond all question, than all the colleges, schools, libraries, museums, and art-galleries which the city possesses. It has also induced many foreigners who have grown rich in the country, and who would otherwise have gone to Europe to enjoy their wealth, to settle permanently in the city.

And what has become of the great Bugaboo? This is what the "Herald" of later date answers: —

"When one is inclined to despair of the country, let him go to the Central Park on a Saturday, and spend a few hours there in looking at the people, not at those who come in gorgeous carriages, but at those who arrive on foot, or in those exceedingly democratic conveyances, the street-cars; and if, when the sun begins to sink behind the trees, he does not arise and go homeward with a happy swelling heart," and so on, the effusion winding up thus: "We regret to say that the more brilliant becomes the display of vehicles and toilettes,

the more shameful is the display of bad manners on the part of the extremely fine-looking people who ride in carriages and wear the fine dresses. We must add that the pedestrians always behave well."

Here we touch a fact of more value to social science than any other in the history of the Park; but to fully set it before you would take an evening by itself. The difficulty of preventing ruffianism and disorder in a park to be frequented indiscriminately by such a population as that of New York, was from the first regarded as the greatest of all those which the commission had to meet, and the means of overcoming it cost more study than all other things.

It is, perhaps, too soon to judge of the value of the expedients resorted to, but there are as yet a great many parents who are willing to trust their school-girl daughters to ramble without special protection in the Park, as they would almost nowhere else in New York. One is no more likely to see ruffianism or indecencies in the Park than in the churches, and the arrests for offenses of all classes, including the most venial, which arise simply from the ignorance of country people, have amounted to but twenty in the million of the number of visitors, and of these, an exceedingly small proportion have been of that class which was so confidently expected to take possession of the Park and make it a place unsafe and unfit for decent people.

There is a good deal of delicate work on the Park, some of it placed there by private liberality — much that a girl with a parasol, or a boy throwing a pebble, could render valueless in a minute. Except in one or two cases where the ruling policy of the management has been departed from, — cases which prove the rule, — not the slightest injury from wantonness, carelessness, or ruffianism has occurred.

Jeremy Bentham, in treating of "The Means of Preventing Crimes," remarks that any innocent amusement that the human

heart can invent is useful under a double point of view: first, for the pleasure itself which results from it; second, from its tendency to weaken the dangerous inclinations which man derives from his nature.

No one who has closely observed the conduct of the people who visit the Park, can doubt that it exercises a distinctly harmonizing and refining influence upon the most unfortunate and most lawless classes of the city, — an influence favorable to courtesy, self-control, and temperance.

At three or four points in the midst of the Park, beer, wine, and cider are sold with other refreshments to visitors, not at bars, but served at tables where men sit in company with women. Whatever harm may have resulted, it has apparently had the good effect of preventing the establishment of drinking places on the borders of the Park, these not having increased in number since it was opened, as it was originally supposed they would.

I have never seen or heard of a man or woman the worse for liquor taken at the Park, except in a few instances where visitors had brought it with them, and in which it had been drunk secretly and unsocially. The present arrangements for refreshments I should say are makeshift and most discordant with the design.

Every Sunday in summer from thirty to forty thousand persons, on an average, enter the Park on foot, the number on a very fine day being sometimes nearly a hundred thousand. While most of the grog-shops of the city were effectually closed by the police under the Excise Law on Sunday, the number of visitors to the Park was considerably larger than before. There was no similar increase at the churches.

Shortly after the Park first became attractive, and before any serious attempt was made to interfere with the Sunday liquor trade, the head-keeper told me that he saw among the visitors the propri-

etor of one of the largest "saloons" in the city. He accosted him and expressed some surprise; the man replied, "I came to see what the devil you'd got here that took off so many of my Sunday customers."

I believe it may be justly inferred that the Park stands in competition with grog-shops and worse places, and not with the churches and Sunday-schools.

Land immediately about the Park, the frontage on it being seven miles in length, instead of taking the course anticipated by those opposed to the policy of the Commission, has advanced in value at the rate of two hundred per cent per annum.

The cost of forming the Park, owing to the necessity of overcoming the special difficulties of the locality by extraordinary expedients, has been very great ($5,000,000); but the interest on it would even now be fully met by a toll of three cents on visitors coming on foot, and six cents on all others; and it should be remembered that nearly every visitor in coming from a distance voluntarily pays much more than this for the privilege.

It is universally admitted, however, that the cost, including that of the original off-hand common-sense blunders, has been long since much more than compensated by the additional capital drawn to the city through the influence of the Park.

A few facts will show you what the change in public opinion has been. When the Commissioners began their work, six hundred acres of ground was thought by many of the friends of the enterprise to be too much, by none too little for all park purposes. Since the Park has come into use, the amount of land laid out and reserved for parks in the two principal cities on the bay of New York, has been increased to more than three times that amount, the total reserve for parks alone now being about two thousand acres, and the public demand is now for more, not less. Twelve

years ago there was almost no pleasure-driving in New York.
There are now, at least, ten thousand horses kept for pleasure-driving. Twelve years ago there were no roadways adapted to light
carriages. There are now fourteen miles of rural drive within the
parks complete and in use, and often crowded, and ground has
been reserved in the two cities and their suburbs for fifty miles of
park-ways, averaging, with their planted borders and inter-spaces,
at least one hundred and fifty feet wide.*

The land-owners had been trying for years to agree upon a new
plan of roads for the upper part of Manhattan Island. A special
commission of their own number had been appointed at their solic-
itation, but had utterly failed to harmonize conflicting interests. A
year or two after the Park was opened, they went again to the
Legislature and asked that the work might be put upon the Park
Commissioners, which was done, giving them absolute control of
the matter, and under them it has been arranged in a manner, which
appears to be generally satisfactory, and has caused an enormous
advance of the property of all those interested.

At the petition of the people of the adjoining counties, the field
of the Commissioners' operations has been extended over their ter-
ritory, and their scheme of trunk-ways for pleasure-driving, riding,
and walking has thus already been carried far out into what are
still perfectly rural districts.

On the west side of the harbor there are other commissioners
forming plans for extending a similar system thirty or forty miles
back into the country, and the Legislature of New Jersey has a
bill before it for laying out another park of seven hundred acres.

I could enforce the chief lesson of this history from other ex-
amples at home and abroad. I could show you that where parks

* The completion of a few miles of these will much relieve the drives of the park,
which, on many accounts, should never be wider than ordinary public requirements
imperatively demand.

have been laid out and managed in a temporary, off-hand, common-sense way, it has proved a penny-wise, pound-foolish way, injurious to the property in their neighborhood. I could show you more particularly how the experience of New York, on the other hand, has been repeated over the river in Brooklyn.

But I have already held you too long. I hope that I have fully satisfied you that this problem of public recreation grounds is one which, from its necessary relation to the larger problem of the future growth of your honored city, should at once be made a subject of responsibility of a very definite, very exacting, and, consequently, very generous character. In no other way can it be adequately dealt with.

3 City Parks and Improved Use of Metropolitan Spaces

Turning from general to specific considerations, we have selections from Olmsted's commentaries on plans for five North American cities, each with distinctive physical and cultural requirements.

The San Francisco of the 1860s was an adolescent city, growing rapidly and awkwardly out of the Gold Rush, and still lacking a mature, urban character. Olmsted's and Vaux's recommendations were not adopted, so the report is largely of historic interest, especially for Olmsted's observations on the life style of nineteenth-century Californians.

The city of Buffalo adopted Olmsted's 1868 proposals for its large North Park but failed to act on his recommendations for a lakeside park south of the city; the present South Park, a compromise site, is inland. The city's choice was unfortunate, for the southern areas have grown without adequate reference to the waterfront. Considering the current condition of Lake Erie, one wonders if the presence of a popular park along its shores might have acted, even in a limited way, to deter the pollution of its waters. The Olmsted plan would have complemented what is, in many respects, quite a good park and parkway system.

CITY PARKS
AND IMPROVED
USE OF
METROPOLITAN
SPACES
102

In Chicago, as in Buffalo, Olmsted had a marshy, lakeshore site for South Park. Since the city officials devoted only half-hearted attention to construction of his program, twenty years later, on his advice, the "Lower Division" of South Park became the site for the World Columbian Exposition in 1893. Olmsted's remarks on exposition architecture are subdued. As a friend and admirer of H. H. Richardson, one suspects he was not entirely happy with the gaudy, eclectic concoctions of D. H. Burnham and R. M. Hunt; yet he withheld outright criticism of what was then the artistic establishment; he could not, however, resist a word or two of dissent. After the Exposition, Olmsted's office rehabilitated the site along the lines of the original 1871 proposals. Since then, however, the city has so encroached upon the area that only vestigial green spaces remain.

After considerable effort and frustration, Olmsted succeeded in convincing Montreal administrators to build the Mount Royal park more or less as he designed it in 1874. The book from which the excerpts in this chapter have been taken was printed at his own expense in defense of his scheme. It is filled with reflections on

CITY PARKS
AND IMPROVED
USE OF
METROPOLITAN
SPACES
103

nature, his art, and with real exasperation at the thought that his plan may be ignored.

The Boston park system, though less famous than Central Park, was probably Olmsted's most ambitious undertaking. His elaborate scheme of parks and boulevards remains intact on a large scale, but subtle attacks upon its integrity — an overpass here, a wider highway there, vandalism, mismanagement — have been effective in breaking the continuity and the resulting sense of generosity that figured so prominently in his design. Current proposals, particularly one for a parking lot in the Fenway, promise to be significantly more devastating.

San Francisco,
1866: A City in
Search of
Identity[20]

A place of public recreation being demanded for the people of San Francisco, I am asked to say in what way I should propose to meet this demand.

Before any discussion can be had with advantage upon this subject, it is necessary that a clear understanding should be arrived at in regard to the special conditions to which the proposed recreation ground should be adapted.

These may be either of a social character, such as the number, and the habits and customs of the people which are to make use of it, or such as are fixed by natural circumstances, as of topography, soil, and climate.

THE WANTS OF A POPULATION MUCH LARGER THAN THE PRESENT TO BE PROVIDED FOR

In regard to the social conditions, it is obvious that San Francisco differs from other towns which have provided themselves with parks, in the incompleteness of its general plan. As soon as the Pacific Railroad is finished, its importance will no longer depend as much as it does at present, upon its position relative to the wants and the productions of the people of the Pacific slope of the American continent, but it will begin to assume relations with the larger part of the population of the whole world, — and the most industrious and productive part, both civilized and uncivilized; — relations more direct, intimate, and profitable, than are now held by any existing town. The magnitude and variety of the field which will thus become tributary to its prosperity, will insure its progress against excessive fluctuations, and its citizens, influenced by a steadily increasing demand for their services, will provide for this demand by a steadily increasing enlargement of their means of

[20] Frederick Law Olmsted, "Preliminary Report in Regard to a Plan of Public Pleasure Grounds for the City of San Francisco" (New York: Wm. C. Bryant & Co., 1866), pp. 7–26, 30–31.

accomplishing business, in the construction of manufactories, shops, warehouses, and otherwise. The present city is but a small section of that which is yet to be formed.

It is, therefore, important to remember, that a public pleasure ground, when once formed within a city, possesses a character of permanency beyond any civic building, and usually becomes the most unchangeable feature in its plan. Consequently, it is necessary, in designing such a work, first of all, to consider how the convenience and pleasure of future generations are to be affected by it, and in the present case, it is more than usually important that this should be borne in mind from the very outset, because a pleasure ground adapted to meet the wants of the population of the City of San Francisco as it exists to-day, will probably be needed to accommodate two or three times that number of people, even by the time it had reached in the growth of plants and other respects, the conditions aimed at in its design, — and, ultimately, a far larger number. Whatever pleasure ground is formed for it in the next ten years, should be laid out with reference to the convenience, not merely of the present population, or even of their immediate successors, but of many millions of people. Obviously this responsibility can not be adequately met without careful prevision of circumstances very different from those with which we have immediately to deal.

The trees in the Regent's Park of London are not yet half grown, yet so rapid has been the enlargement of the city, that since it was formed two new parks have had to be laid out, and another is now called for. It is worthy of remark also, in regard to one of these parks, that as no other conveniently accessible site had been reserved for it on the plan of the city, a swamp, which needed to be drained and filled, was the only point at which it was possible to obtain the required area of land without the destruction of a great

CITY PARKS
AND IMPROVED
USE OF
METROPOLITAN
SPACES
106

amount of property in buildings, and the interruption of important lines of established communication. But neither in this manner, nor any other, can the present generation of Londoners, by any expenditure it would be justified in making, acquire a pleasure ground half as well adapted to its requirements, as those who planned the Regent's Park could have provided for it, with but little additional expense, had they been sagacious enough to properly anticipate the demand that has since arisen, and skillful enough to make a suitable use of the opportunities that were then open to them.

It is less than ten years since a plan of public pleasure-drives was first made for the city of New York, and not half that time since the drives were completed, yet, with an increasing population, so rapidly has their use developed the public demand, that already they have been enlarged and extended, and it has been determined to more than double their length, while projects for still larger undertakings are discussed, and as yet meet with no opposition, the problem being only how and where can these drives be extended without great injury to existing property — a problem which could have been solved even five years ago much more easily than it will be to-day. In like manner, Boston, to extend her public-grounds, is obliged to fill up the back bay, there being no other direction in which such an improvement can be made, without a revolution of existing arrangements of business, and an entire destruction of what has cost the citizens many millions of dollars during the twenty years in which the question has been forgotten or neglected by the corporation. Philadelphia is in a similar quandary; and having eight years ago acquired a small, inconveniently situated, and very incomplete park, is laying over from year to year the question of a more adequate arrangement, although the difficulties and expense of properly responding to the popular demand are constantly increasing.

San Francisco has a future more certain than any of these older towns, and its probable requirements are more easily to be anticipated. It is important, therefore, at the outset, that due attention should be given to the fact that a pleasure-ground planned merely to meet the requirements of the present, or of the next ten or twenty years, will be an uneconomical undertaking, and a neglect of a very important municipal duty.

THE IMMEDIATE DEMAND PRESSING, AND NOT TO BE SLIGHTED

At the same time, the need of a public pleasure-ground for the use of the present population, is a very pressing one; and the immediate demand should not for a moment be set aside on account of the difficulty of providing for the future. While an unusually large proportion of the population of San Francisco is engaged in no useful industry, the more important part of it is wearing itself out with constant labor, study, and business anxieties, at a rate which is unknown elsewhere. This is to a great extent, perhaps, a natural and necessary result of the present circumstances of its commerce; but that there should be so little opportunity and incitement to relief — to intervals of harmless and healthy recreation, as is the case at present — is not necessary, and is not wise or economical. Cases of death, or of unwilling withdrawal from active business, compelled by premature failure of the vigor of the brain, are more common in San Francisco than anywhere else, and cause losses of capital in the general business of the city, as much as fires or shipwrecks. Such losses may be controlled by the corporation to a much greater degree than losses by fires, and it is as much its duty to take measures to control them, as it is to employ means to control fires. Some will not be prepared to receive this as a practical truth, but if they will carefully study the experience of other cities, they will find that it is a simple matter of fact. This, at least, may be demon-

CITY PARKS
AND IMPROVED
USE OF
METROPOLITAN
SPACES
108

strated. If a spacious and attractive public-ground is formed within or close upon a great commercial town, a custom or fashion will soon be established, which compels all the plans and arrangements of business men throughout the day to be controlled by reference to the fact, that, at a certain hour, many of those with whom business is to be done, will want to give themselves up to healthful recreation. Refreshing pictures of beautiful sylvan scenes, and of a multitude of animated, pleasure-seeking men, women, and children, thus crowd in upon the general daily experience of men strained with the eagerness of competition, or anxiously intent upon the means of meeting their engagements and preserving their integrity, and an invitation is constantly made to every man to yield himself to the custom. The more a man needs this invitation, that is to say the harder he is pressed, and the more he is tempted to prolong his attention to his business, the oftener is he reminded that he cannot depend upon finding others so misusing their strength, and thus the oftener does the invitation come to him. The result is conclusively established to be that the daily labor of each man becomes not less in value, but more methodical and regular, and that physicians are compelled, in a much smaller number of cases, to advise those who call upon them to withdraw themselves entirely and prematurely from business.

If this is the case in regard to that portion of the population most pressed by the great interests of the community and of the commerce of the world, the influence and value of a public recreation ground in preserving the health and vigor and especially the moral tone of the larger class, whose labors are of a less intensely intellectual character, is of no less consequence. A small part of the whole population of any town is not attracted to such a ground daily, nor is it necessary that it should be, but of the more steady,

industrious, thrifty men with families, who are generally gaining ground and getting on in the world, there are few who are not induced to take an occasional half-holiday, or now and then at least an hour or two from a working day, to make a visit to the park with their wives and children, with vast advantage to all. This class is, indeed, to be more considered than any other, not because merely of its relation to all profitable production, and, consequently, to all soundly profitable business enterprise, but because out of it are constantly arising the men upon the soundness of whose judgment and the healthy development of whose faculties the destiny of the whole community is pretty sure to be sooner or later mainly dependent.

At present, the people in easy circumstances, and the spendthrifts of San Francisco may be daily seen driving out to the beach, or occasionally to a race course; but this requires not only more money but more time than men engaged in the more confining pursuits of trade can spare, and to be wholly enjoyable and useful, more vigor and hardihood than their wives and infants generally possess. What healthful place of recreation then remains for them? Boys may be turned out into the streets or upon the wharves, but the women and girls will, as a rule, neither find their nerves tranquilized, nor their strength invigorated, nor their tastes improved by any recreation that is open to them in the streets or in any of the public places which have been so far established.

Suppose they take the horse-cars and go to the suburbs, what are the entertainments offered them? The answer is found in the fact that the most popular place of resort for pleasure-seekers of this class is a burial ground on a high elevation, scourged by the wind, laid out only with regard to,the convenience of funerals, with no trees or turf, and with but stinted verdure of any kind, and this with difficulty kept alive. To such a place as this I have, more than once,

CITY PARKS
AND IMPROVED
USE OF
METROPOLITAN
SPACES
110

seen workingmen resort with their families to enjoy a picnic in the shelter of the tombstones, and hundreds every fine day make it the beginning and end of an effort at healthful recreation.

This state of things is not merely disgraceful and shocking to all sense of propriety — barbarous and barbarizing — but it is positively wasteful and destructive of the sources of wealth and prosperity possessed by the city.

While, therefore, in planning any pleasure ground for San Francisco, it is of far more importance than is usually the case to anticipate the special wants of the future; it is a duty not less imperative to so contrive it that it will be enjoyable at an early day and conveniently accessible to the present population.

THE PLAN TO BE LIBERALLY DEVISED AND OF A METROPOLITAN CHARACTER

There are also, in the special circumstances of the city of San Francisco, reasons why no plan of a pleasure-ground should be entertained which is not conceived on a thoroughly liberal scale. These are not found alone in the topographical and climactic conditions which will be hereafter considered, but in circumstances intimately connected with the highest hopes of its future wealth, a fair consideration of which will lead to the conviction that the initiation of a narrow policy in this respect at this time, would inevitably result in a serious obstruction to its prosperity.

An inquiry into the circumstances upon which the prosperity of great towns in the present age of civilization is based, will show that it rests on several conditions. There are, for instance, large towns, the prosperity of which is evidently due mainly to the natural advantages of the positions they occupy for commerce, as where they control important seaports, mines, water-powers, the trade of a large agricultural back-country, etc. There are again others, the prosperity of which is due in a great degree to artificial

advantages for commerce, as where the business of several impor-
tant lines of railroad is concentrated. In the third and last place,
there are towns the prosperity of which is largely due to the fact
that they offer peculiar opportunities for the use of wealth aside
from those which are merely incidental to their commercial char-
acter. Such is the case in any great metropolis, the various intellec-
tual and esthetic privileges of which give pleasure not only to the
citizens themselves but form an attraction to strangers.

New York, built up upon natural and artificial advantages of
commerce, has, in the last twenty years, begun to take on a metro-
politan character, by forming libraries, museums, galleries of fine
art, and more than in anything else, by the acquisition of its Park.
As a metropolis, it is a long way ahead of any other town in
America. Hence the extraordinary attraction it has for people who
are not deeply absorbed in the mere *pursuit* of wealth, and which is
indicated by the fact that the old residents are constantly being in-
duced to let their houses and furniture to new comers and strangers,
by the offer of a rent many times greater than the legal interest on
their cost at gold valuation, and also by the remarkable increase in
the use of luxurious carriages and fine horses. Thus, last year,
16,000 pleasure carriages were driven in the Central Park in a
single day, while only two years before there had been but 6,000 in
any day. Five years earlier not one-tenth of the latter number were
ever seen. During the same period the number of shops for the sale
of flowers and floral decorations has increased nearly a hundred-
fold. The very rapidly increasing demand for articles of fine art,
for artistic decorations of houses and luxurious furniture, for rare
and valuable books and engravings, for musical talent of a high
order, illustrates the same general fact. San Francisco artists send
their works to New York for sale.

In Paris luxurious and well appointed houses have of late

CITY PARKS
AND IMPROVED
USE OF
METROPOLITAN
SPACES
112

readily commanded rents three times as large as they did ten years ago, and this notwithstanding the fact that a much larger number have been built in that time than ever before. Indeed, the demand is so great and so rapidly increasing, that the calculations of capitalists are constantly overrun, and the supply by no means keeps pace with it. There is no similarly increased demand for the simple requirements of people of moderate means, nor does the population or the demand for articles of luxury and the fine arts increase elsewhere as it does in Paris and few other favored towns. Thus, while the population of Paris has increased eighty per cent., that of France as a whole, including all its great seaports and notable manufacturing towns, has increased but six per cent. While the population of England has been doubling, that of six favored English towns has quadrupled.

The explanation is simple. Men who have amassed wealth in the agricultural and mining districts, and in the manufacturing and commercial towns, when they feel able to retire from business, are drawn by the advantages which are offered them — not for making money, but for enjoying the use of it — to one of the towns which have gained a superiority over the many in this respect. There are hundreds of men of large fortune, born in the United States, who are now, with their families, permanent residents of Paris and London, for this reason.

The population of San Francisco is at present of a peculiarly restless and shifting character. The last *City Directory*, which I am able to consult, shows that among 5,500 of the merchants and tradesmen of the more substantial class who were registered in 1861, only 3,400 remained in 1862, and of the smaller dealers it is estimated by the compiler that at least forty per cent had "declined business" during the year. This was during a period of gen-

eral prosperity, and when the business of the city, as a whole, was greatly increased.

Comparatively few of the changes shown by the *Directory* were probably caused by the departure of men from the city, but by their engaging in new speculations, and forming new associations for that purpose. It is nevertheless true, that the manner of life of the large class which is so ready for a change, and its interest in the permanent improvement of the city, differs but little from that of strangers or mere temporary sojourners. It is constantly postponing the best use of life. Its ruling purpose is to make a fortune that will set the maker free from all his present connections. It follows that he cares little for any permanent interests which the citizens have in common, and is ready, whenever satisfied, to seek his enjoyment in a systematic way, to at once dissociate himself from those with whom he has hitherto been living, and fly to those parts of the world where attention has been paid, not only to the art of making fortunes, but also to arrangements for turning them to good account when made.

This applies still more to the State of California at large than to San Francisco, and is a drawback upon its prosperity quite as great and essentially the same as that which curses some parts of the Old World, and which is known as *absenteeism*. It differs from it mainly in this, that the capitalists whose interests in the country are simply to get out of it as much money as possible, instead of living abroad most of the time, and making occasional visits to it, make one long visit, and when they go to live abroad take not merely their rents to spend there, but to a great extent their capital also.

It is however a great mistake to assume, as is commonly done, that, when men who have made fortunes in the interior of California move to San Francisco, the people of San Francisco benefit

CITY PARKS
AND IMPROVED
USE OF
METROPOLITAN
SPACES
114

at the expense of those of the interior. On the contrary, it is the meagre metropolitan character of San Francisco which alone retains in California a great many who would otherwise leave the State, to a great extent withdrawing from it their capital, and their demand for the productions of the interior.

The attractions of San Francisco, however, hold but few. Every steamer takes away some man who has made his pile, who goes with his family to live in an Eastern or European community, which has greater attractions for him and for them than San Francisco, or any part of California.

Still it is by no means in the final abstraction of capital, and the withdrawal from the home market of its manufacturers, mechanics and farmers, of the demand of so many consumers, that this evil bears hardest on California, but in the habitual indifference with which matters of permanent commercial interest are regarded by a large part of its most active and capable citizens, and in their loss of power to make use of the higher productions of civilization.

Even the fortunate speculator himself is apt to find, by the time he has gained the primary object of all his labors, that his uncultivated faculties for enjoyment refuse to perform their office when suddenly called on to do so, and that if he had been reasonably prudent, he would not only have laid up money day by day, but have formed habits that would enable him to enjoy his money when saved. But the case of the children of the city is far more deplorable. These cannot, of course, share in the somewhat coarse excitements of business which occupy the minds of their fathers, and they have no experiences in better organized communities by memories of which the tastes and capacities for healthful enjoyment of their elders may be sustained. San Francisco boasts of her school-houses, but the most important part of education is not that given by the schoolmaster. And it is to be borne in mind that

the new generation is *now* arising, the children are *now* growing up and are yet open to genial influences. In another neglected ten years, a whole generation will have arrived at manhood and womanhood, with habits and tastes full-formed and rigid.

If this is trite and self-evident, it is none the less important with reference to the business under consideration, for a liberally devised public pleasure ground with its accessories, would be the most effective entering wedge that can possibly be conceived of by which to open the way to a better state of things. It can, indeed, never be formed until there is in San Francisco a conservative population really desirous of such an improvement, and not only capable of comprehending the advantage to themselves, their families, and the future welfare of the city which it will secure, but also sufficiently organized to have the necessary power to overcome the dead weight of indifference to all municipal improvements, which is characteristic of the transient speculative class. When the better element asserts itself in a positive way, then the real life of the city of San Francisco will begin. Worthy to be, and destined to be one of the largest, if not the largest city in the world, it must at some time escape from the influences that happen to be associated with the discovery of gold in California, and the consequent adventurous emigration, and it will then begin to take the metropolitan position occupied by New York in the East, and by Paris and London on the other side of the Atlantic. With what degree of rapidity this advance is to be made remains to be proved, but the mere fact of a report being called for on this subject at this time, is in itself a favorable indication.

The conclusion to which these considerations lead, is obviously that whenever a pleasure-ground is formed in San Francisco, it should have a character which the citizens will be sure to regard with just pride and satisfaction. It should be a pleasure-ground sec-

CITY PARKS
AND IMPROVED
USE OF
METROPOLITAN
SPACES
116

ond to none in the world — a promenade which shall, if possible, become so agreeable to its citizens that when they go elsewhere they will remember it gratefully, and not be obliged to consider it a poor substitute for what is offered them by the wiser policy of other cities.

No one doubts now that in this respect it has been a wise economy on the part of the Corporation of New York to incur a debt of more than seven millions of dollars to overcome the great difficulties which stood in the way of its having a park which would compare favorably with those of the European capitals, and the tax-payers of New York do not now object to a great enlargement of this expenditure for the purpose of increasing its advantages as a place of permanent residence.

I do not propose to urge on these grounds that San Francisco should undertake to immediately compete, in the *extent* or the cost of her pleasure grounds, with New York or the great capitals of Europe, but to enforce the prudence of doing nothing of this kind, which, *so far as it goes*, is not done well, while I also desire to establish the conviction that there is no town where a liberal expenditure for this purpose will so surely bring a manifold return in the retention of taxable capital which it will effect, as well as in many other ways.

Hitherto, San Francisco has done nothing through its corporation to place itself in a position to compete with even the most insignificant cities of the Atlantic seaboard, as a place of permanent residence. Of its few public institutions, or monuments of public liberality in any form, there are hardly any, even of the most insignificant character, which have been designed for, or which contribute directly to the enjoyment of the citizens, except as making money to be used elsewhere or to be hoarded, is their enjoyment. To get the better of this, to offer inducements to men of wealth to

remain, and to all citizens to pursue commerce less constantly, to acquire habits of living healthily and happily from day to day, and of regarding San Francisco as their home for life, instead of always looking to the future and elsewhere for the enjoyment of the fruits of their industry, must be a primary purpose of all true municipal economies, and no pleasure ground can be adequate to the requirements of the city, the design of which is not, to a considerable degree, controlled by this purpose.

LIMITATIONS UPON THE SCOPE OF THE PLAN, FIXED BY

PHYSICAL CONDITIONS OF THE LOCALITY

The special conditions fixed by the natural circumstances, to which the plan must be adapted, are so obvious that I need not recapitulate them here. Determining for the reasons already given, that a pleasure ground is needed which shall compare favorably with any in existence, it must, I believe, be acknowledged, that, neither in beauty of green sward, nor in great umbrageous trees, do these special conditions of the topography, soil, and climate of San Francisco allow us to hope that any pleasure ground it can acquire, will ever compare in the most distant degree, with those of New York or London.

There is not a full grown tree of beautiful proportions near San Francisco, nor have I seen any young trees that promised fairly, except, perhaps, certain compact clumpy forms of evergreens, wholly wanting in grace and cheerfulness. It would not be wise nor safe to undertake to form a park upon any plea which assumed as a certainty that trees which would delight the eye can be made to grow near San Francisco by any advantages whatever which it might be proposed to offer them. It is perhaps true that the certainty of failure remains to be proved, that success is not entirely out of the question, and it may be urged that experiments on a

CITY PARKS
AND IMPROVED
USE OF
METROPOLITAN
SPACES
118

small scale should be set on foot at once to determine the question for the benefit of future generations; but, however this may be, it is unquestionably certain that the success of such experiments can not safely be taken for granted in any general scheme that may, at this time, be offered for the improvement of the city.

The question then is whether it be possible for San Francisco to form a pleasure ground peculiar to itself, with a beauty as much superior to that of other such grounds, *in any way*, as theirs must be superior to what it can aspire to in spreading trees and great expanses of turf.

I think that it can.

SPECIAL ADVANTAGES POSSESSED BY SAN FRANCISCO FOR FORMING
AN ATTRACTIVE PLEASURE-GROUND

Strangers, on their arrival in San Francisco, are usually much attracted by the beauty of certain small gardens, house courts and porches, and, if they have any knowledge of horticulture, they perceive that this beauty is of a novel character. It is dependent on elements which require to be seen somewhat closely, and which would be lost or out of place in such expanded landscapes as form the chief attraction of parks and gardens in the East. It is found in the highest degree in some of the smallest gardens in the more closely built and densely populated parts of the town, in situations where park trees would dwindle for want of light and air.

These results of private and unorganized experiments sufficiently indicate the limits within which we can proceed with entire confidence in planning a public pleasure ground, and, omitting a discussion here of the less difficult questions to which my attention has been given, I will now proceed to give the general conclusions of my preliminary enquiry as to the special requirements which the

plan of a public pleasure ground for San Francisco should be adapted to meet.

GENERAL CONCLUSIONS OF DISCUSSION AS TO THE CONDITIONS TO BE OBSERVED IN A PLAN

In any pleasure ground for San Francisco the ornamental parts should be compact; should be guarded from the direct action of the north-west wind, should be conveniently entered, should be rich in detail, close to the eye, and should be fitted to an extensive system of walks, rides, drives and resting places. These latter should also be of such a plan that their public use can be efficiently regulated without cumbrous, unusual, or very expensive police arrangements, and should be easily kept clean and free from dust. No ground should be selected for this improvement which is already of very great value, yet the neighborhood should be of a character which will ultimately invite the erection of the best class of private mansions and public edifices. Entrance to it should be practicable at no great distance from that part of the town already built up; it should extend in the direction in which the city is likely to advance, or should be so arranged that an agreeable extension can be readily made in that direction hereafter. At the same time it should have such a form that when the city shall be much enlarged it may so divide it that, without subjecting the trees and shrubs it contains to destruction during great conflagrations, it shall be a barrier of protection to large districts which would otherwise be imperilled. It is further desirable that it should not make any great change in the present plans of sewerage, lighting and water supply necessary; should not present any insurmountable obstructions to the ordinary ways of passage or business transportation between different parts of the city; should not block the city railroads or other public works; and should not greatly disturb buildings already erected,

CITY PARKS
AND IMPROVED
USE OF
METROPOLITAN
SPACES
120

streets already graded, sewered and paved, or otherwise cause heavy losses or depreciation of value to the existing property of the city, or that of corporations or private citizens.

If there is any scheme by which all these seemingly conflicting requirements can be met, no arrangement which can be proposed, that falls short of it, will long be considered satisfactory. Changes of detail, revisions, repairs, temporary expedients to meet special difficulties, will constantly be suggested, discussed, and from time to time adopted; and thus in the end any less comprehensive plan will prove excessively inconvenient and expensive. It will be much more economical to adopt a plan which comprehends everything that is likely to be wanted at the outset. The whole scheme of improvements should, as far as possible, therefore, be definitely established at the outset, and the plan of the city in all respects adjusted to suit it.

EXPEDIENT PROPOSED FOR OVERCOMING THE CHIEF SPECIAL DIFFICULTIES

The expedient by which I would propose to overcome the chief difficulties imposed by the conditions of the case, will be most readily understood, if it be imagined that there had originally been a creek crossing the site of the city, not far back of that part of it which is at present occupied by buildings of an expensive character; that streets had been formed on the banks with houses facing towards the creek, and that cross streets had, at such intervals as would be required by convenience, been carried over it on bridges. (This may be seen in reality at Stockton, but it will be better to imagine the creek passing through a hilly country, instead of a flat one, and the houses facing toward it to be stately mansions instead of shops and warehouses.) Let it then further be imagined that the course of the stream which formed the creek had been divided, so as to leave its bed dry; that a road had been formed with broad walks

in the middle of the old bed; that the banks had been dressed in agreeable shapes, the lower parts turfed and the slopes planted with shrubs and trees, with a thicket of hardy evergreens all along the top; and that hydrants had been set at proper intervals on the edge of the streets above and the road below, so that, (with hose and punctured pipes, such as are used for watering the lawns and roads of the Bois de Boulogne), the dust could be kept down, and the turf and plantations readily sprinkled as often as necessary. If all this had been done, provided the course of the creek had been originally from southwest to northeast — that is to say, across the sea-wind — it will be seen that a sheltered promenade or boulevard would have been possible within the city limits, which would meet all the prescribed requirements.

As nature has not provided such a creek-bed as has been imagined, what I propose to do is, first, to secure a similar condition by an artificial excavation, and then proceed to obtain a similar result, but of a much higher character.

The citizens of San Francisco would in this way be provided with an extended walk, ride and drive, which would be open at all times to those seeking health, recreation, and social intercourse in the open air but within which the dust, din, and encounters with vehicles, moving in various directions, to which they are subject in all the present public places, streets and roads in and about the town, would be entirely avoided.

MILITARY AND PLAYGROUND; SEQUESTERED GARDEN; MARINE-PARADE AND SALUTING GROUND; PLACES FOR MUSIC, FIREWORKS, AND PUBLIC CEREMONIES

But a mere promenade is not all or nearly all that should be provided in a metropolitan scheme of public grounds. Places are needed where military and athletic exercises can be carried on without conflicting with the pursuit of business and the safety or the

CITY PARKS
AND IMPROVED
USE OF
METROPOLITAN
SPACES
122

quiet of those not interested in them. Civic ceremonies, music and fireworks should also be provided for, and a more secluded, quiet, and purely rural district should be added, in which invalids, and women and children may ramble, or rest in the open air, free from the disturbance of carriages and horsemen. . . .

San Francisco is so situated that it requires arrangements of this kind even more than other great cities, and no system of public grounds will be complete until they are added, even if it should be impracticable to plan them in such a way that they would be attractive and useful in every condition of wind and weather. Obviously, however, they should, as much as possible, be protected from the wind, and as near the present built part of the town as practicable.

To provide a parade ground in such a situation, large enough for the maneuvering of a brigade or division, would cost too much, and it would be otherwise objectionable. For such a purpose the city should secure a large tract of ground some miles distant from the present centre of the town; but for each of the other purposes a smaller area will answer, and suitable positions should, therefore, be found without going far out.

For a municipal landing place and marine parade, suitable to the commercial position of the city and to the duties which it will be proper for it to assume as holding the portal of the republic on the Pacific, where foreign dignitaries and our own national representatives will land and embark, and a port of refuge to which men-of-war of all nations may at any moment be obliged to resort, there seems to be a suitable place on the east side of the ridge of Point San José, between the fort and the Pioneer Woolen Mills. It enjoys considerable protection from the sea wind, as is shown by the growth of shrubs, and there is a good depth of water immediately off shore, with good anchorage. Here there should be a suitable landing quay and a plaza, with a close and thick plantation of ever-

greens on the west side, faced with banks of shrubs and flowers. The plaza or parade should be open and large enough to be used for a drill ground by a battery of artillery or a regiment of infantry, with some standing room and seats for spectators. It should also contain an elegant pavilion for the accommodation of committees of reception and their guests and a band of music, and should be decorated with flagstaffs, marine trophies, and eventually with monuments to naval heroes, discoverers and explorers. It should not, however, be very large or fitted for extended ceremonies, being considered rather as the sea-gate of the city than the place of entertainment for its guests.

The best place for a rural ground, to be retired from the general promenade, that I have been able to find near the city, is in a valley sheltered on the north, west and southwest sides by hills lying north and west of what is designated the "hospital lot" on the city map, and not far from the Orphan Asylum. This valley is not only unusually protected from wind, but the soil is moist, and I have observed that in the driest season the shrubs and herbaceous plants, of which there is a very abundant natural growth within it, retain their freshness and health better than anything else.

There is a considerable extent of low level ground in the same vicinity, suitable for a parade and play ground of moderate size, which being close on Market Street, near the Mission, will be readily accessible from the present town. It is also very centrally situated with reference to all the suburbs of the city, and is just within the lines to which the streets of the city are laid out by the map of 1865. As beyond this point to the westward the rectangular system of streets will probably have to be abandoned, owing to the steepness and ruggedness of the hills, it offers also a convenient point of division between a scheme of grounds intended for the use

CITY PARKS
AND IMPROVED
USE OF
METROPOLITAN
SPACES
124

of citizens during the next ten or twenty years, and a scheme for future improvements.

For these reasons I would propose to place here, as far as practicable, all those parts of the general system of pleasure grounds which require considerable lateral expansion. In European town parks, the more strictly rural portions are generally associated with the parts intended to be used as a promenade, in which but little lateral space is really needed. As by the arrangement already sketched out the social public promenade is provided for elsewhere, and as only a moderate area will be needed for military use here, the parade ground proper being located further out in the country, it will be desirable to bring this area in juxtaposition with the tract to be set apart for the more secluded garden ground, in order to gain a greater general impression of spaciousness than either alone would give. As, however, the purpose of each is quite distinct from that of the other, they should, in the detailed arrangement of the design, be very completely separated. I propose, therefore, to place between them a grand terrace or tribune, readily accessible from each, as well as from the general promenade, and from the common streets of the town. This structure might be formed in two levels, one set apart for persons in carriages, the other for those on foot. On two sides of it might be rich parterres or formal flower gardens with fountains, and the whole might be given a highly architectural character with rich parapets of stone; or it might be cheaply finished with turf banks, bastions and bays, and plain iron or wooden handrails. In connection with this grand central concourse there should be suitable stands for music, for fireworks, and for public speaking. These should face toward the parade ground, in which a crowd of many thousand persons might be assembled without danger of injury to plants or objects of art, and where a regi-

ment might be maneuvered, or a division reviewed in marching column. Additional accommodation for spectators on foot and in carriages should be arranged all around its margin. It should be placed at as low a level as practicable, with higher ground and thick plantations on the windward side.

On the other side of the terrace or tribune, in a still more thoroughly protected position, I would have a small garden formed in a nook of the hills, facing to the southeast, with a grove of trees in the upper part and in that part nearest the tribune, the remainder being thrown into a surface of picturesque form, with rocks and terraces, and planted closely and intricately with shrubs and vines, with walks running among them, and frequent seats, arbors, and small sheltered and sunny areas of turf and flowers. In the lowest part there should be a flatter space, in which there should be laid out and kept up at any expense for maintenance that might be found necessary, a small clear lawn of turf sloping down to the shore of a pool of still water, on the other side of which there should be the finest display of foliage in natural forms which art could command. From within this garden, no carriage road or buildings, except those of a rural character, inviting rest, should be seen, and no pains should be spared to make it a spot of pure and tranquil sylvan loveliness. . . .

For some years to come such a series of grounds and structures as I have suggested near the Orphan Asylum, with a Marine Parade at Point San José, and a spacious promenade between them, would probably suffice.

A line between these two points would be nearly parallel to a line equally subdividing the present population of the city, being within ten minutes' drive of the City Hall and the Lincoln School-house respectively; and the best course for a promenade to be laid out be-

CITY PARKS
AND IMPROVED
USE OF
METROPOLITAN
SPACES
126

tween them, having regard merely to the beauty and fitness of the promenade itself, would be a moderately direct one, carried in a succession of easy curves, generally in the depression of the hills.

If, however, the value of the land which would need to be purchased, and the disarrangement of the present lines of streets and properties which would be required to carry out this plan, should be thought a very great objection to it, it would be practicable to make use of Van Ness Avenue, from the water line to Eddy Street, and I think it best to presume that this would be deemed advisable.

THE GENERAL PROMENADE

Taking Van Ness Avenue, I should add to it one tier of building lots on each side, which gives a space 390 feet wide. Fifty-five feet of this space on each side might be appropriated to streets, into which the cross streets now falling into Van Ness Avenue would lead, without there being necessarily any change in the present plans for their grading, paving, sewering or piping. The present middle tier of lots of the blocks on each side of Van Ness Avenue would then be front lots on these two streets, which would be in all respects formed in the usual manner, except that it might be considered best not to lay any walk on the sides opposite the houses. There would remain a space to be given up to the promenade and ornamental ground 280 feet wide. Within this an excavation would be made, varying in depth a little, according to the shape of the surface, but everywhere at least twenty feet deep. The sides of the excavation should slope so as to have a nearly level space at the bottom 152 feet wide. In the centre of this might be formed a mall 24 feet wide, flanked on each side by a border, to be used as will hereafter be described. Between the borders and the foot of the slopes might be two roadways, each 54 feet wide, 15 feet being made of loose sifted gravel, as a pad for saddle horses, and the remaining 39 feet finished with

hard rolled gravel for carriages. Immediately outside the road-
ways, the surface should usually rise very gently and be occupied
by beds of turf or flowers, which should be carried up irregularly
until lost under plantations of shrubs and trees. The upper part of
the slopes adjoining the streets should be everywhere planted with
coniferous trees set closely and trimmed so as to form a lofty hedge
or thick screen sufficient to break off the wind from the less sturdy
plants within.

At such intervals as might from time to time be deemed advis-
able, bridges, to carry streets across the promenade grounds, would
have to be constructed, and at each of these bridges entrances
should be arranged by which persons on foot could reach the mall.
Access to the parks may be obtained by carriage approaches de-
scending the slopes in lines diagonal to the general course, starting
midway between the bridges.

After crossing Eddy Street, the promenade might fork into two
branches, that to the left going straight to the south-west corner of
the present Yerba Buena Park, where the Pioneer monument is to
be placed, which would form the vista-point of the mall. Here it
would terminate with an entrance on Market Street, six blocks out
from Montgomery Street. The fork to the right would be at right
angles to the first, and run parallel to Market Street until it reached
the vicinity of the low ground near the Orphan Asylum, where it
would connect with the terrace before described. Here it would be
divided, one branch of the roadway being carried around the
garden, following the hills; the other making the circuit of the
parade ground; the mall being arranged to branch out into the
garden walks, and also to lead around the parade.

The system of roads and walks after leaving this point, would
resume more or less of the original restricted form, and would be
carried on as far as might be thought advisable, as an extension of

CITY PARKS
AND IMPROVED
USE OF
METROPOLITAN
SPACES
128

the general promenade. Between the Pioneer Monument and the old Spring Valley Reservoir near the Orphan Asylum, little having been done toward the carrying out of the existing plan of the city streets on the west side of Market Street, I think it would be best to revise the city map, both to secure greater convenience for business purposes, and to increase the dignity of the approaches and surroundings of the parade and garden. The small pieces of ground now reserved in this vicinity for public squares, may as well be thrown into streets and lots, and the streets at present laid out to divide the property between Market Street and the proposed promenade, be given up, and a more simple and symmetrical plan adopted. . . .

To the present time the street plan of San Francisco has been contrived with scarcely any effort to adapt it to the peculiar topography of the situation. On a level plain, like the site of the city of Philadelphia, a series of streets at right-angles to each other is perfectly feasible, and the design is as simple in execution as it appears on paper; but even where the circumstances of site are favorable for this formal and repetitive arrangement, it presents a dull and inartistic appearance, and in such a hilly position as that of San Francisco, it is very inappropriate. If the present site, as it was in 1850, had now to be laid out for a large city, it would be desirable to adopt a different arrangement in many respects.

If hills of considerable elevation occur within the boundary of a site marked out for a city, this salient difficulty should be met at the outset, and a series of main lines of road should be arranged that will ascend these hills *diagonally*, in such a way as to secure sufficiently easy grades. The skeleton lines being thus determined on, a series of transverse and connecting streets should next be provided that will divide the whole into sections of moderate size, and each of these intermediate districts should then be planned separately, and with as much regularity as the circumstances of the case admit.

The city of San Francisco is unquestionably in a very different degree of advancement from what it was in 1850; but even now it is evident that by far the larger portion of the city remains to be built up. Although, therefore, very much has been done that it would be impossible to think of changing, and the interests involved in the portions that are not improved, are, doubtless, so numerous as to make a change anywhere difficult and troublesome; still the future advantage to the city of a judicious reconsideration of the whole subject at this time can hardly be over estimated, especially with reference to that portion of the city that remains entirely unoccupied by buildings of a permanent character.

The first cost of constructing the streets upon such a plan as has been suggested, would probably be less than upon the present; and the advantage in the saving of wear and tear to horses and vehicles, to say nothing of fatigue to persons on foot, would be incalculable.

There are many side questions in connection with the general scheme I have presented, to which I have given the consideration necessary to satisfy myself that any difficulty likely to arise in carrying it out might be satisfactorily overcome; but the whole matter has already been laid before you in a more detailed form than properly belongs to a preliminary report, and I now leave it in your hands, sincerely hoping that you will be as strongly impressed as I am with the commercial, social, and moral importance to your state of an early attempt to develop on a liberal scale some such plan of metropolitan improvement as I have here sketched out.

Respectfully,
Fred. Law Olmsted.
Olmsted, Vaux, & Co.,
Landscape Architects.

110 Broadway,
New York, March 31, 1866.

Buffalo: A Lakeshore
Park and Pleasing
Parkways[21]

Sirs, — We have the honor to submit drawings showing a plan
for a park adapted to a site on the shore of Lake Erie, south of the
city, as contemplated in a resolution of the Common Council of
February, 1887, and in subsequent action of your Commission,
recorded in its last Annual Report. For distinction's sake, we shall
refer to the proposed park as the South Park, and to your present
park as the North Park.

It is believed that many citizens of Buffalo are of the opinion
that discussion of the subject of this report might better be deferred
until it has been more maturely considered whether the city just now
wants to engage in another park enterprise, and whether if it does
so, the required park had better be in a place naturally so unat-
tractive within itself as that which you have had in view. Mature
consideration can be given to neither of these questions, without a
much more definite statement of the project than has hitherto been
possible, and a better knowledge than has hitherto been had by the
public, of what could be made of the conditions of the locality.
What is thus wanting to open a profitable discussion, it is hoped
that this report may supply. . . .

Twenty years hence Buffalo will be not only a city of much
larger trade, much larger wealth and much larger population, but
it will be a city of much more metropolitan character, than, not-
withstanding its recent rapid advance in this respect, it has yet come
to be. The currents of civilization, which in all metropolitan centres
have, in modern times, been increasingly manifest, will have been
growing correspondingly stronger. The drift of these currents in
relation to parks is indicated by the fact that eleven cities of Europe

[21] Frederick Law Olmsted and J. C. Olmsted, "The Projected Park and Parkways on
the South Side of Buffalo," City of Buffalo, Park Commission, 1888, pp. 3–18, 20–23,
27, 28, 30, 31, 36–46.

and America have, during the last thirty years, added twenty thousand acres of land to their park properties, and that towns which a few years ago were thought to be particularly well provided, have been recently adding largely to what they had; as London, 6000 acres, New York, 3000, Boston, 700.

The drift being as thus indicated, the question upon which this report bears, is not whether the people of Buffalo require just now more and other park provisions than they have, but whether the people of Buffalo twenty years hence will have required no more and no other? It is wholly probable that in less time than that a considerable additional park will have been required and will have been provided for. If so, it is not to be questioned that going about the business now in a deliberate way, pursuing the same steady, methodical, frugal but efficient methods that have distinguished the proceedings of your Commission from its origin, such additional park provision as will be required may be obtained of a much more valuable character and at much less outlay than it will be, if all effective action toward the result is now staved off indefinitely. This consideration, rather than a conviction of any immediate urgent necessity for an additional park, accounts for such favor as the project has hitherto received from conservative citizens. . . .

Your present North Park is rarely well adapted to certain quiet forms of recreation, favoring a contemplative or musing turn of mind and restful refreshment. It is not in the least larger than it should be for a park designed to that end, and in a single park of its size, provision for no other end is more desirable for a city. But it is not always that merely soothing, out-of-door refreshment is wanted. Occasionally by all, but oftenest by those who pass most of their time in monotonous occupations and amid sombre surroundings, tranquilizing natural scenes are less demanded than those by which gayety, liveliness, and a slight spirit of adventure

CITY PARKS
AND IMPROVED
USE OF
METROPOLITAN
SPACES
132

are stimulated. This being the case, it is inevitable that an inclination will arise, and year by year increase, to have better provision made for the purpose on the North Park. It will follow that unless comprehensive provision for it is soon undertaken elsewhere, you will be constrained to meet the requirement by a succession of small, feeble, imperfect and desultory interpolations upon the design of the North Park. An unconsciously indulged tendency in that direction has, we think, already been manifest in the minds of some of your number. If it should continue and spread, the North Park will come in time to lose the character in which otherwise it will, year after year, be gaining, and by which it would take a more and more distinguished position among the parks of the world, while, because not having been broadly designed for anything else, it can be made respectable in no other character. Thus the question now to be decided may be this:

Twenty years hence shall Buffalo have one park, of a poor, confused character, or two, each of a good, distinct character?

Assuming that it is wise that the City should soon enter upon proceedings looking to the acquisition, in good time, of another park, and of a park which shall have a character essentially different from that of the park which it set about obtaining twenty years ago, argument will hardly be needed to make the following conclusions acceptable: —

1st. Buffalo owes its importance as a city to its position on Lake Erie. It has in Lake Erie really great natural scenery. It has no other, and can have no other to be compared with it in value. It has no work of art and can have no work of art that will compare with it in value. Having made no use of its good fortune in this particular for the aggrandizement of its first large park, it ought not, except for absolutely conclusive reasons, to fail of making use of

it in its second. The new park should be in a position to annex to itself the grandeur of Lake Erie.

2d. The situation of the first park having secured much greater advantages of access and use to those who would visit it in carriages upon common roads, than those who could come to it only by other means of transit, it will be better, in fixing the place and determining the plan of the second park, that special regard should be given to the point of providing inexpensive, convenient and agreeable means of access to it and conveyance within it, independently of ordinary road vehicles.

The site which we were specially invited by your Board to consider, has the following obvious advantages: —

1st. It looks upon the Lake.

2d. There is navigable water and there are four lines of railway already in operation, and others contemplated, between the place and the heart of the City.

3d. To acquire the site, nothing of importance would have to be paid for buildings or other improvements. The land as a whole has little productive value, and probably none as near the heart of the city has had as little commercial or speculative value.

There are, however, serious objections to the locality, — serious difficulties to be overcome before a park can be made of it. They may be indicated as follows:

Of the area proposed to be taken, the surface of nine-tenths is almost perfectly flat. Upon this larger part there are no trees growing, no rocks, no natural features of value for a park. Its surface is but a little above the ordinary surface of the water in Lake Erie. It is below the level to which the Lake occasionally rises. It is consequently imperfectly drained and not only half swampy at all times, but liable at intervals to be completely submerged. The diffi-

CITY PARKS
AND IMPROVED
USE OF
METROPOLITAN
SPACES
134

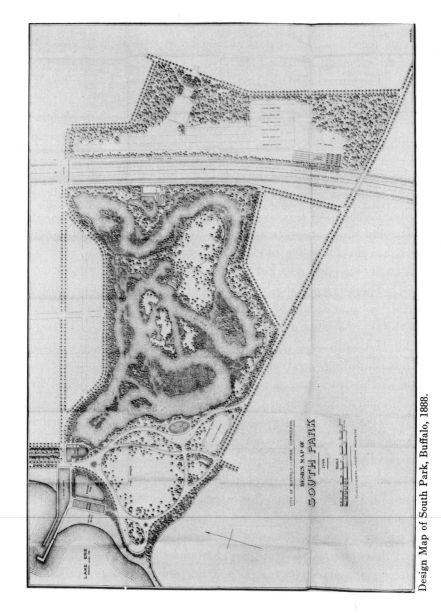

Design Map of South Park, Buffalo, 1888.

culties growing out of these circumstances are aggravated by the fact that below the gravel beach and the low shifting sand dunes that form the apparent lake shore, there is a stratum two feet thick or more of rotten vegetation in the form of black muck, which is easily washed out, undermining the beach. On this account the shore is rapidly wasting and the lake encroaching upon the land. Finally, there is no natural protection or facility of any kind for landing from boats on the Lake.

The weight of these objections to the site being realized, it will be seen that the first question in a discussion of a plan must be this: — By what devices, if any, can the objections to the site be so far overruled that a result of any attempted improvement of it can be looked for, that shall not have cost more than it will be worth?

This was found to be so difficult a question, that we were for a period in doubt whether we ought not to advise you to give up the idea of a lake shore site, and we accordingly took upon ourselves the duty of examining all the southerly borders of the city in search of a site that we might recommend you to consider in place of it.

Our conclusion, however, at last came to be, that unless an excessive price would have to be paid for the site on the lake shore, it would be wise to adopt it, and undertake to overcome its disadvantages by means, the general nature of which will presently be indicated. We believe that a park can be made upon this site which, for all time, will be of greater value to the city than any park possible to be made in any other situation as near to the city's centre. . . .

For the present, only that part between the railroads and the lake is to be considered. The extent of this part is about 240 acres, and about nine-tenths of it lies below the surface of the lake at high stages. There is, however, a narrow strip of ground on the south side, and a larger space on the west side, where the surface is several feet higher, and these elevations, with the embankment already

CITY PARKS
AND IMPROVED
USE OF
METROPOLITAN
SPACES
136

constructed for the railroads on the east, leave the tract subject to flooding from without only on the north and a short distance on the west side. A levee four and a half feet high along this unprotected line will, therefore, shut the lake water out of the entire area. Suitable material for its construction is found in a stratum of clay two feet below the surface, on and adjoining the line of required protection. Looking at the map it is to be supposed that the planted sidewalk of the street adjoining the northern border of the park, is made upon such a levee.

With reference to the difficulty of landing from boats on the lake, adequate provision for very large boats is not important; frequent trips of numerous boats of a smaller class being more desirable than trips of large boats at longer intervals. This for the reason not only that less time will be wasted by visitors at the starting point, but that a large throng thrown all at once from a boat into a pleasure ground, is a dangerous and inconvenient occurrence. For boats of the length of those now mostly used for public pleasure excursions from Buffalo, an artificial haven is proposed to be formed; entrance to it being between two parallel piers extending to a point on the lake, where at low stages, there can be had without dredging, a depth of water of seven feet. Such a structure, to be thoroughly secure, will be costly but well worth its cost.

With regard to inroads of the lake, a firm sand bank may be expected to form on the south side of the piers, which, so far as it extends, will protect the wasting shore. How far such bank will extend cannot be accurately determined in advance. If it is inadequate for the protection of the entire shore of the park, it may be supplemented by a riprap wall, the boulders for the construction of which can be gathered near by. If this is insufficient the method can be adopted which has been successfully used for the protection of

the property of the Lehigh Valley Railway Company nearer the city.

We shall now describe other parts of the plan.

As before stated, there is a body of land in the southwest part of the tract, the surface of which is several feet above high-water level of the lake. The old Hamburg Turnpike passes through it; there are several dwellings upon it, the soil is good and much of it is cultivated as a market garden. It is proposed to make as much of this ground as practicable, into a single park-like body of turf, with scattered trees upon its margin. It is designated The Green, will be about twenty acres in area, and is expected to be commonly used as a general playground. Upon occasions it will be a good place for parades, exhibitions, balloon ascensions, and public ceremonies. Near it, where the upland is narrower, there is to be an athletic ground, with a running and bicycling track and an out-of-door gymnasium, three acres in extent.

Between the athletic ground and the Green there is a pleasant dwelling house, the old Crocker Mansion, which it is proposed to retain and improve. In this would be rooms for the deposit of dressing and playing gear and other conveniences, for those using the Athletic Ground and the Green. Near the house the map shows, also, a range of public horse-sheds.

A road for general traffic across the park, is shown on the eastern limit of the Green. It will take the place of the Hamburg Turnpike, the line of which it nearly follows.

A proper pleasure road, with broad bordering walks mainly in the shade of trees, will be seen making a circuit of the Green, with liberal curves and liberal turning places. On one side of the circuit this road will command a broad view up Lake Erie, on the other a broad view over the park water. Where these views will be seen to

CITY PARKS
AND IMPROVED
USE OF
METROPOLITAN
SPACES
138

the best advantage, there are expansions of the drives, and places arranged for people both in carriages and on foot to congregate. On the west side of the Green a minor circuit road is introduced, and the junctions are made so large that there can be a circulation of carriages about the point where the lake and the breeze from over the lake can be best enjoyed. On the east side, where the best lines of view over the park water are to be had, there is a standing place for carriages, and near it a large aquatic garden, for growing choice water plants.

Where the lake beach is likely to be finest, owing to the packing of sand to the windward of the pier, a bathing establishment is provided for. From its dressing rooms, bathers would pass on one side to the surf beach of the lake; as at the Newport and Long Branch bathing places, or that of Rochester on Lake Ontario, and Detroit on Belle Isle; on the other side they would pass to the beach of a still-water bathing pool. In the latter, the water being shallow and brought from the shallow waters of the park, although constantly flowing, would be heated above the temperature of the lake, by the sun, and it is intended for the use of delicate persons and children, and as a swimming school. But about this feature of the plan, until the effect of building the pier is determined, there must be some doubt. At present the material of the peaty stratum before referred to, washing out from the shore makes the beach unattractive for bathing. It is confidently hoped that the defect may be remedied. If it cannot, surf-bathing as a feature of the park must be abandoned, but a still-water bathing place can, by a slight modification of the plan, be provided in the interior park waters.

All the arrangements of the plan thus far considered are situated at the west end of the site and either upon the naturally high

ground, or upon ground in connection with the beach which is to
be protected and kept above the lake level by the pier.

There remains to be laid out about 180 acres of the low, flat,
more or less swampy land to be protected by embankment from
being occasionally submerged by the lake. What we propose for
this is that it shall, in the first place, be thrown into ridges and fur-
rows, mounds and hollows, the material taken from the depressions
forming the elevations, being heaped for the purpose upon intervals
of flat land left between them. The ridges being often discontinued,
so that the furrows will wind round the ends of them, and water
being then let in to a suitable height, the result will be a body of
water nearly a mile in length and a third in breadth, within which
the elevations will form islands, savannas, capes and peninsulas.

The required water is expected to be drawn from Cazenovia
Creek by gravity, either through the canal which has been pro-
jected for the relief of the Thirteenth Ward from floods, or if that
and all similar schemes should be abandoned, by two miles of tile
pipe laid for the purpose. The water thus brought would flow first
through the park, then into the still-water bathing pool, and thence
between the piers into the lake. The islands of the park water are
to be of varied form and extent, and it has been a principal part
of our study to so contrive them, that when overgrown by suitably
designed verdure and foliage, they will, with the waters upon their
borders, form pleasing landscape compositions of a natural charac-
ter.

The half-decayed vegetable matter which forms the surface of
the ground, having been thrown up, exposed to frost and aerated,
will make the principal part of a deep, rich mould on the surface
of the islands. This mould kept moist by the adjoining water, and
the water shallow and heated by the sun, the conditions will be

CITY PARKS
AND IMPROVED
USE OF
METROPOLITAN
SPACES
140

favorable to types of vegetation, such as it is rare to see profusely displayed in nature except at much inconvenience to the observer and in close association with disagreeable elements, and which it is still rarer to see exhibited in a large and intricate way in works of gardening. By varying the conditions, so that the water will at points be comparatively shallow and at others deep, and the land at points low and at others high, the shores here abrupt, there gently inclined; giving them, sometimes the form of beaches, at others of banks, and the banks being at some places shaded by trees, at some overgrown by bushes, at some dressed with turf, at some hidden by rushes, flags, irises and other waterside plants, an extended series of interesting passages of scenery will result. At intervals there will open long vistas over water under broad leafy canopies; there will be coves completely overarched with foliage, forming verdant grottoes; some of the islands will be large enough to have within them spacious forest glades; some will be low and densely wooded, their shores so shallow that boats can not land upon them, and their skirts so hedged with thickets as to be impenetrable. These will be nurseries for song birds, where their nestlings will have protection from natural enemies. The waters will everywhere abound with water-fowl, for the breeding of which other islands, unapproachable by visitors, will be set apart. They will be navigated largely by a special class of boats gaily painted and gilded, decorated by day with bright awnings and bunting, and at night with colored lights. Small electric lights will also at night mark out the shores, the electricity to be supplied from storage batteries charged by dynamos to be run by windmills, for the use of which the locality has special advantages.

The largest of the islands shown on the drawing is to be reached in a two minutes' walk from the entrance of the park, over a short foot bridge. It will be twenty acres in area, or more than twice as

large as that portion of the North Park hitherto used for picnics, and is intended to be used in a similar manner. Its surface is to be mainly four or five feet above the level of the water; it is to be planted with large-growing umbragious trees, chiefly near the shores, and its central parts are to be open spaces of turf. There is to be a refectory upon it with the usual conveniences for picnic parties. There are to be swings and other resources of recreation; sand parks and means of amusement for infants and little children. There is to be a landing for boats bringing passengers entering the park from the lake side.

The three islands near the centre of the map, being the largest of all except that last described, are to be of the same general character. Each is to have a landing, and to be entered upon only at the landing, bars below the surface preventing boats from coming elsewhere to the shores. The landings are also to be barred at will. These three islands vary from one and a half to two and a half acres in area, and are to be assigned as there may be occasion, on application in advance, each for the exclusive use for a day, or a part of a day, of picnic parties that may prefer to be secured from intruders. Thus family and club entertainments may be given upon them, or a charitable society may take one as a place for a day's outing of a body of children or the convalescents of a hospital. They may be used, as parts of the parks of Paris are much used, for wedding parties, or for the anniversary festivals of all manner of associations. The outlooks from these picnic islands will be particularly attractive, and quite unlike anything to be had from the places which have usually to be accepted for such occasions.

But it is impossible to convey much idea of what it would be sensible to expect in respect to the local scenery to be enjoyed from them, or in any part of the park waters or their shores. No example

CITY PARKS
AND IMPROVED
USE OF
METROPOLITAN
SPACES
142

of a realized design of such a character can be pointed to. Growing largely out of the peculiar conditions of the locality and the distinctive requirements upon the designers, the result would be a park of unique character. To judge the plan in this respect, free play must therefore be given the imagination. The bird's-eye view and the sketches we set before you, are designed to give a general direction to the imagination, but even in this respect they must be regarded as but crudely and distantly suggestive.

Looking upon the ground as it now appears, there may be a doubt whether what we have said does not represent a day-dream of impracticably romantic character? As to this we may reasonably take it upon ourselves to say, that if twenty years ago, one standing at a certain great piggery, slaughter and pork packing house, and looking over a nauseous and dismal swamp on the northern outskirts of your city, had read a description of what was actually to be seen from the same place ten years afterwards, such a doubt would have been much more reasonable. In truth, the processes to be used for realizing the design which we are now trying to suggest, so far as the production of effects of natural scenery is concerned, will be simpler and surer, and, in this sense, of a more practical character, than those used to bring about the existing water-side scenery of the North Park. . . .

We shall make a separate report to you on the question of approaches to the park. For the purpose of this report it is only necessary to say, the plan takes into account probable approaches in the future by inside and outside boats, carriage-road and street railroad at the northwest corner. It is presumed that many people will come to one of these entrances, pass through the park by boat and return to the city from the other; also that many will come by one of them, make the tour of the park by boat and return from the same entrance at which they arrived. In either case, their chief

enjoyment of the park would be while afloat, and the designed boat-
ing arrangements of the park are of critical importance. . . .

It has been a surprise to us that Lake Erie is no more used than
it is by Buffalonians for this manly and wholesome form of recrea-
tion; we believe that the reason must be the lack of places pleasant
to visit by boat within convenient distance of the creek. The use of
the row boats on the North Park, shows that under favorable cir-
cumstances there is as much fondness for boating in Buffalo as in
any city.

In the South Park plan, land, water and plantations have been
disposed not only with regard to landscape beauty to be best en-
joyed from boats, but with a view to prevent any swell from oc-
curring, so that boats can never run out of still water. The islands
are so disposed that, without much appearance of it to those in
boats, they will practically be kept to water-roads, a hundred and
fifty feet wide, and in navigating them the ordinary rule of land
roads, "keep to the right," will apply. For an additional precaution
against collisions, care is taken in the plan that where bends of the
channel occur between one reach of water and another, the point
of land to be turned will bear no foliage that will prevent the boat-
men from seeing over it. The water is expected to be nowhere be-
yond a man's depth. The course of the channels is such, that while
a direct line from the northeast to the southwest landing would
measure but 1000 yards, the route to be taken by a boat would be
4000 yards. The length of the round trip would be nearly four
miles. Rapid movement of the boats would not be desirable; the
time occupied in a round trip of a steam launch, including stop-
pages at five landings, might be three-quarters of an hour.

Row boats, canoes and small steam yachts for private parties
are expected to be used. For the conveyance of the public in gen-
eral, however, regular lines of packet boats are had in view. For

CITY PARKS
AND IMPROVED
USE OF
METROPOLITAN
SPACES
144

the propulsion of these, the circumstances are particularly favorable to the use either of electric or of compressed air engines, but steam or naptha engines will be available.

The packet boats would be broader, roomier and stiffer than ordinary steam launches. Making but short trips they would carry little fuel. Never running out of still water they would need no decks. Boats of twenty-five feet length accordingly, would be spacious for the conveyance each of sixteen passengers under an awning. Each boat would be well managed by one man, who would have police authority, and the boat police thus provided, constantly reviewing as it would, all the waters, would see that suitable regulations were observed in other boats as well as in the packets.

The cost of a water carriage of the class proposed, with efficient machinery, will be less than that of any style of land carriage fitted to convey the same number of passengers with anything like equal comfort and luxury; it would be half the cost of a good hackney coach that would carry a fourth part of the number. Its ordinary running expenses would be but a trifle more than the pay of the boatmen. Plying in the manner of omnibuses or street cars, with five-cent fares, a numerous fleet of such water carriages would be profitably employed. . . .

REPORT ON THE SOUTH PARKWAY QUESTION

. . . Comparatively little anxiety has been evinced by any citizens of Buffalo as to your decision of any questions of the park, but in regard to possible routes for a parkway, much evidence of warm interest and of a divided opinion has appeared. Parties favoring each a different route, have been represented in argument before you with so much earnestness, that it is plain that any conclusion to which you shall come, will be grievously disappointing to most of them.

To the site, which from the launching of the project has been had in view for the park, there are, as in our report upon it has been pointed out, several serious objections, but the only wish that we have heard expressed to have it changed, has been based, not on those objections, but on a supposition that an inland site would be more favorable to a settlement upon a particular route favored for the parkway.

Yet to the people of Buffalo as a body, the matter of the parkway is one of really trifling consequence compared with that of the park. The explanation of the more active interest apparent in the parkway, we understand to be this:

The value of real estate in the southern outskirts of the city is much less than in the northern outskirts. The degree in which it is so, is largely due to the fact that between these southern outskirts and the main body of the city, there is a district so crossed by railroads, creeks, canals and swamps, that communication across it by ordinary street conveyances can only be had in a way which, to those who have not become habituated to it, is frightfully perilous, besides being extremely tedious and disagreeable. At times, even such communication as has been thus characterized, is impossible because of floods.

If a single road could be made which by sufficient causeways and bridges on almost any line would provide good, safe passage across this intermediate district, all property over a large space to the southward of it would be greatly benefited. But as the law stands, the cost of making such a road would not be distributed among all, or even any large number, of those to be thus specially benefited but would be concentrated upon the owners of property abutting upon it. If, however, a road of precisely the same character were to be made with a purpose more especially of giving general access to a park, and which was, therefore, to be classed as a parkway, ac-

CITY PARKS
AND IMPROVED
USE OF
METROPOLITAN
SPACES
146

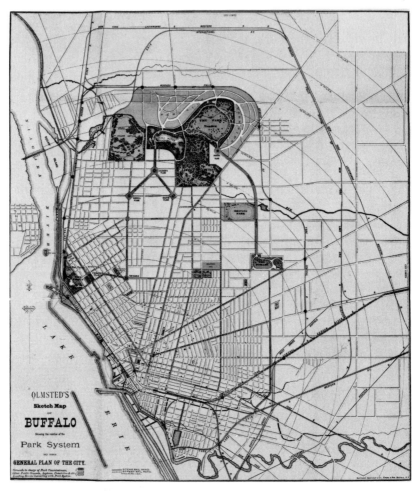

Olmsted's Sketch Map of Buffalo Showing the Relation of the Park System to the General City Plan.

cording to a precedent established when the North Park was laid out, one-half its cost would be defrayed by general taxation. . . .

The parkways stretching out from the North Park may be taken as a sufficient illustration of what, in this discussion, is to be understood by the term parkways. They plainly serve, not simply as branches or outworks of the park with which they connect but as a part of the general street system of the city. Streets of similar character much used for pleasure driving and as public promenades, having no connection with a park, are to be found in many of our cities. Euclid street in Cleveland is a notable example. Why, then, should it be expected in Buffalo that the Park Commissioners will take the duty of laying out this particular class of streets? The answer to this question is that the Park Commissioners have the duty of providing for the wants of the people in respect to open air refreshment. With this duty they have to choose ground for a park which because of natural circumstances is adapted to the purpose. But suppose such ground to be so situated that access to it for the greater part of the people of a city by existing streets would be inconvenient, fatiguing and unpleasant to that degree that it would hardly be compensated by the refreshment that they would obtain while in the park. In that case it becomes the duty of a Park Commission to consider and advise the city what improvement of its street system may desirably be undertaken in order to make the proposed park more valuable to its entire people. Out of this duty grows that class of public streets properly called parkways.

If this reasoning is sound, parkways are not to be dealt with on the principle that they are local affairs any more than the parks with which they connect. They are to be laid out primarily even with less regard for people who are to live in quarters of the city near the park than for those at a distance, because the fatigue and inconvenience of an approach to the park independently of any

CITY PARKS
AND IMPROVED
USE OF
METROPOLITAN
SPACES
148

new ways to it would be of much less consequence to those living near it than to the main body of citizens. . . .

Before proceeding, however, to work out a plan for such a road, a clear understanding should be secured of the advantages of access by rail to the South Park which are already essentially provided, not only for those dwelling near the heart of the city, but to those dwelling in quarters far to the east and west of it, toward which there is now the most rapid and sure progress of house building.

Especially it should be realized that one steam railroad line from the eastern quarter connects with another from the western quarter, at a point which is but ten minutes' walk from the centre of population of the whole city; that there are several lines of street railroad from intermediate districts, by which the same point can be approached, and that from this converging point there is a line of steam railroad leading in a nearly straight line to the nearest point at which the South Park can be entered. This advantage, added to those of access to be provided by steamboat, makes directness and amplitude of approach to the South Park by ordinary carriages a matter of no pressing importance to the people of any part of the city. Make the best approaches for carriages that you possibly can, even with lavish outlay; even make a number of them radiating from the South Park to all quarters of the city and it would be extremely unlikely that a tenth part of those resorting to the South Park for recreation would make any use of them.

What you as Park Commissioners, acting impartially in behalf of all those who may wish to drive to and from the South Park, can reasonably suggest to the city, we believe to be this: —

That from the point on the southern border of the district within

which the city may be expected, as the outcome of movements now
in progress, to speedily provide for streets clear of railroad tracks,
one broad thoroughfare should also be speedily provided by which
the remaining obstacles would be bridged to a safe passage from the
central parts of the city, not only for pleasure carriages going to the
South Park, but for all ordinary street traffic between the central
parts of the city and the country to the southeastward of the point of
departure.

As to the plan and courses of this thoroughfare we advise that it
be given the general character of Fillmore Avenue; that its breadth
be nowhere less than ninety nor more than a hundred and twenty
feet; that its centre line shall follow the centre lines of Abbott's
Corners Road, Triangle Street, White's Corners Roads and Ridge
Road to the entrance to the park at Hamburg turnpike shown on our
design-map.

Among the reasons favoring this proposition are these: — By
no other route less indirect would the borders of the road, for years
to come, be as pleasing. By no other, less indirect, would the diffi-
culty of drainage and of forming a good road bed be as little
important. By no other, less indirect, would as many dwellings of
the people of the Thirteenth Ward be closely approached. By no
other would a common artery of travel be provided equally central
to the Ward, or which by lateral branches would as well accom-
modate the larger number of the people of the Ward not living
directly upon it. By no other is the co-operation of the abutting
property-owners in the construction of a permanent roadway as
likely to be obtained.

The reason for proposing so wide a margin of breadth in the
thoroughfare, is that a wise discretion may be exercised by your
Commission in adjusting lines for wheelways, gutters, planted

CITY PARKS
AND IMPROVED
USE OF
METROPOLITAN
SPACES
150

borders and sidewalks to certain of the existing trees already ir-
regularly planted along the sides of the present roads, some within,
some without the fence lines.

It is understood that the owners of land adjoining the present
roads proposed to be followed, are willing to enter into an agree-
ment under which the city would acquire the land needed for the
operation without cost.

In our opinion, a parkway better adapted than such a one as we
have thus advised to serve the general interests of the whole body
of the people of the city, cannot at present be discreetly laid out in
connection with the South Park. At the same time it is our opinion
that no other route for a parkway, would incidentally as soon and
as much benefit the whole body, on an average, of the residents
and land owners of the Thirteenth Ward.

This is all that we have to advise in respect to approaches to the
South Park, to be so soon put under construction that early con-
sideration should be given to legislation with respect to them.

But we cannot think that in recommending legislation for this
measure, the duty of your Commission in respect to the question
of parkways will be fully done.

On one of its margins Buffalo is beginning to be built out upon
a flat region with no constant drainage outlets; often water-soaked
to the surface; more or less swampy; and at times completely over-
flowed. The tendency to build in this direction has greatly increased
of late years. It will be much accelerated by the intended improve-
ments to be made by the city in co-operation with the railroads and
by the development of the grand commercial undertaking, now far
advanced, of the Lehigh Valley Railroad Company. Founderies,
factories, storehouses, coal docks, lumber yards, shipyards, and
the like will be established, and not far from them, nor long after-

wards, there will be dwellings for those employed in them and shops for supplying their domestic wants. As long as such progress of building continues without the adoption of comprehensive, systematic, scientific measures for providing drainage and sewerage outlets; for determining the courses and grades of streets; and for the regulation of building upon and between them with reference to drainage and sewerage, another great evil will be growing upon the city; an evil that like the present railroad evil will in time become intolerable. It will be brought to an end, if not sooner, when the whole city is in mourning and its business suspended because of disease of which this region will have been the propagating ground. The longer the task of fixing upon, at least, a skeleton scheme of preventive measures is put off, the more difficult it will be to plan them, the more difficult to secure the adoption of a plan, and the greater the cost both to citizens personally and to the city as a whole, of carrying it out. The necessary cost of soon preparing a plan under which there will be the minimum of evil and the minimum of inconvenience attending the growth of the city southward, is infinitesimal compared with the cost that will result from a long delay in preparing, adopting and enforcing it.

The cost of carrying it out is another matter. If not too long delayed, the plan once adopted, the carrying out of the city's part in it would not necessarily proceed faster than its building of streets and sewers upon incomprehensive, improvident, scrappy and time-serving plans. The value of the comprehensive plan and of regulations requiring conformity to it, would be that citizens would be prevented by it from proceeding individually to build, in a manner which would add egregiously to the cost of the work which the city would ultimately have to do.

Under these circumstances your Commission ought not to pro-

CITY PARKS
AND IMPROVED
USE OF
METROPOLITAN
SPACES
152

ceed upon the assumption that the city will for many years neglect to provide that such progress as may occur in building over the low country, shall be upon a well considered and provident system.

In devising the skeleton lines and grades of such a system one of two ways must be had in view for discharging drains and sewers. The surface of the land as it stands is much too low for suitable outlets into the creek or the lake. To obtain outlets there must either be a large filling to bring up the grades of all streets, and the lower floors of houses must be set several feet above the present surface, or the whole region must be defended from overflows by a levee, and its sewerage and drainage be removed by pumping in the well-known manner adopted by the cities of Holland. Between these two methods that one must be expected to be adopted which on the whole will be least costly. . . .

The line of the dyke or levee had in view by Mr. [George] Mann, [City Engineer,] would vary little from the old line of the Hamburg turnpike from the point where it crosses the Lehigh Valley Company's ship canal to the point where, in our plan, it enters the South Park. The levee already made by the Lehigh Valley Company would form a part of it, and the other part would be of similar construction. The short levee along the lake shore that we have proposed as a necessity of the park, would also form a part of it. The Hamburg turnpike abreast of the Lehigh Valley property, is now carried on the company's embankment. Make the levee broad enough, and you will have upon it a site for a parkway continuous to the South Park, from the street had in view in the report of the Board of Engineers, between the heart of the city and the north end of the Hamburg turnpike.

To obtain a part of the material required, the least costly process would be that used by the Lehigh Valley Company, namely, to

dredge a canal on the eastern side of the line of road, and form the
levee of the material (a stiff clay), that would be excavated, lifted
and carried to the place by the steam power of the dredge boat.
Plantations having been grown on the borders of the canal, there
would, by this process, have been prepared a pleasant water-avenue
providing a direct inside passage for boats between the park and
the lower wharves of Buffalo Creek. The western slope of the levee
would be everywhere washed by the waters of the lake, and in
passing along the parkway upon it, the full expanse of the lake,
clear to the horizon, would be open to view. It would thus form a
superb promenade, and as it would be crossed by no streets, but
be bordered by a belt of wood on one side and by the lake on the
other, it would in effect bring the park a mile and a half nearer
the city; that is to say, within two miles of City Hall.

At some time not so dimly in the future that consideration of
the wants of the city when it arrives should now be indefinitely put
off, more direct and spacious parkways than we have thus far
suggested will certainly be desirable east of the railroads. It would
plainly be prudent, also, for the city to acquire one or more sites
for local recreation grounds — spaces, say, of from five to twenty
acres — in the eastern part of Ward Thirteen.

Here is a region within the city limits as at present defined, over
which suburban building is already advancing, in spite of the bar-
barity of a great number of deadly grade railroad crossings, within
which no provision has as yet been made for a single open space.
In an area of half the same extent of the more compact part of the
city there have been provided eight open places and local pleasure
grounds. Get the better of the railroad difficulty; get a suitable
street plan, and there will soon be a large population here. . . .

With respect to additional parkways, we have to propose three
short lines. It is not desirable that they should be formed in ad-

CITY PARKS
AND IMPROVED
USE OF
METROPOLITAN
SPACES
154

vance of a general street plan, because only as the result of comprehensive study of a general street system could their grades or their crossing of railroads be safely determined. But even at this time your Board may well suggest them.

One would supply a more direct approach to the east end of the South Park from the central parts of the city than that which we have advised to be soon constructed by way of White's Corners and the Ridge Roads. Abby Street will form a suitable and probably the best line for this parkway for a distance of a mile and a half from the park. At the point that would then be reached difficulties with railroads begin, which it is not unlikely will disappear before any general public utility will be served by the parkway. If they should not disappear then, by a slight deviation from a continuous direct line, at a distance of a quarter of a mile, junction may be made with the parkway we have advised on the line of Abbott's Corners Road. Thence the way will be clear to the heart of the city.

If a small park should be determined on in the eastern part of Ward Thirteen, at either of the sites to which we have referred as offering advantages for the purpose, a branch from half to three quarters of a mile in length, of the parkway on the line of Abbott's Corners Road would offer direct access to it from the central parts of the city. There would be no railroad crossing needed and the ground is comparatively favorable for its economical construction. Another short branch-parkway will be desirable whenever a bridge shall be thrown over the railroad tracks as contemplated on our plan for the South Park. It would leave the line of the proposed parkway on the White's Corners Road at the junction of Marilla Street and follow the line of Marilla Street to the bridge. The distance is about three quarters of a mile.

Our advice as to each of these short parkway projects is, that an intention to adopt it as a part of the parkway system should be

formed and made public, but that further action should be suspended until such time as the preparation of a general street, sewer and drainage system for the Thirteenth Ward shall be determined upon.

As to the proposed local park for the eastern part of the Thirteenth Ward, we recommend that one of the sites to which we have referred, which can be bought lowest, be acquired for it as soon as practicable, it being probable that if this is not done, the special value of each for the purpose will soon be destroyed. We have examined the piece of ground offered to be presented to the city, on condition that it shall be made a park. It is not well adapted to the objects of a local park, and much better sites being available near by, could not be suitably improved except at extravagant cost. . . .

Respectfully,
F. L. & J. C. Olmsted,
Landscape Architects

Chicago: Taming
the Waterfront[22]

Gentlemen: We present for consideration at this time a design, prepared under your instructions, for laying out the three tracts of land which are comprised under the title of the South Park, and before proceeding to describe the special features of our plan, we wish to draw your attention to the leading considerations which have determined its general character.

There are two broad types of public parks, by reference to which the discussion of a plan may be most readily opened. Richmond Park is, for instance, a very useful adjunct of the park system of London, and Fontainebleau of that of Paris, but both are useful in a quite different way from St. James's or the Parc de Monceau; the first being great roaming grounds, to which people go out by railway, generally spending a day in the excursion; the other, garden-like enclosures into which people are constantly strolling in great numbers for a short diversion from the ordinary occupations of the day.

Your territory lies at the distance of six miles from the center of business of Chicago, and quite beyond its corporate limits. Its neighborhood is mainly an uncultivated country, much of it un-enclosed and sparsely inhabited — the thousand acres of the park site having included not more than a dozen small dwellings.

Under these circumstances, it may be thought that the park to be formed upon it will not be much used by the citizens of Chicago, except as a distant suburban excursion ground. The population of the city might indeed be doubled several times, and if it should be built as compactly as most great towns hitherto have been, and the advance of building should spread equally to the North, South and

22 Olmsted, Vaux & Co., "Report Accompanying Plan for Laying Out the South Park," Chicago South Park Commission, 1871 pp. 3–10, 12–19, 31–36, 38–40, 116–142.

West, the South Park would, undoubtedly, still be in the midst of a rural district.

Against any such presumption, however, stands the fact that in all large and flourishing cities throughout the world, there has been manifest of late, a strong and steadily increasing tendency to abandon the old, cramped manner of building, and to adopt a style of dwellings with individual and villa-like characteristics that involve a greater ground space, and a corresponding tendency at the same time to widen streets and public places, and separate domestic more and more distinctly from commercial quarters. This tendency is especially strong where it has free play in American communities, and except where it goes so far as to lead people to dispense with appliances of health, which, on account of their costliness, require a certain degree of density of building, there is abundant evidence that it is, in the long run, economical, beneficent and favorable to the prosperity of the whole community. This being the case, it may be observed incidentally, that in designing a park in the environs of a rapidly growing town, it is proper to have in view, as a secondary purpose, the general improvement of the neighborhood with reference to its healthfulness as a residence, as, for instance, by facilitating its drainage.

In Chicago the banks of the navigable streams are unattractive for domestic purposes and cannot fail to be required for commerce. Special business quarters may hereafter grow up in some directions at a considerable distance from them, but if so a more or less complete connection of business streets will soon follow between the two, and under the operation of the tendency to separate domestic from commercial life, the intermediate districts will become less and less valuable for dwellings. The most desirable domestic quarters therefore in the early future are likely to be those in which

CITY PARKS
AND IMPROVED
USE OF
METROPOLITAN
SPACES
158

building has never been compact and which are in no danger of being invaded for commercial purposes.

In regard to the district about your site there are, in the first place, nowhere near it any special inducements to the rise or extension of a commercial quarter; in the second place, the interpolation of the large closed spaces of the Park, turning transportation out of direct channels, will be obstructive to business, and finally, the advantage which will come with the Park for securing domestic comfort can hardly fail to soon establish a special reputation for the neighborhood and give assurance of permanence to its character as a superior residence quarter.

There are other circumstances which it is unnecessary to specify here which add weight to these considerations, and it thus becomes highly probable that before any proper plan of a park designed at the present time shall be fully realized, not only will a large number of the citizens of Chicago be living much nearer to your site than now, but it will be in the center of a really populous and wealthy district. In addition then, to its holiday use by the whole body of citizens, a large number must be expected to resort to it for their daily exercise and recreation. To be well adapted to such habitual use, it will need to have a much greater variety of features and much larger and more varied accommodations than if it were so remote to the population of the city on an average, that few would see it except occasionally and it were only rarely to be used by great numbers, and then as a picnic and roving ground.

If it were now to be improved with a view to the latter use only, it would be impossible at a later period to change its character, by the introduction of much enlarged accommodations and new landscape features of interest, without destroying and wasting much of what had first been prepared, and this consideration would

probably prevent any but feeble and insufficient changes being made.

Regarding it on the other hand as an urban park, that is to say, as a ground to which large numbers of people will resort every day, rather than as a remote or holiday park, it has to be considered that it will be but one of a series of such grounds and will be further from the present town center than any of the others. It is then a question how far it should be treated purely as a local park.

It is clearly most undesirable that the existing territorial divisions of interest and policy by which all comprehensive improvement of your city are embarrassed should be unnecessarily perpetuated, and with whatever motives the choice has been made of the park sites now fixed in its general plan, present duty is first of all to the whole city. We are bound, that is to say, to look upon the park to be formed on your site simply as one member of a general system of provisions upon which as a whole the health of the city, its attractiveness as a residence and its prosperity will in all future time be largely dependent. In the process of design, therefore, one of the first duties is to study the comparative value of one or another possible function, or class of features or source of interest of each site.

The marked circumstances of the South Park site when compared with the others are, first, the groves of comparatively large trees which it contains; second, the greater spaciousness of two of its divisions; and, third, the longer frontage and greater depth of that division of it which looks upon the Lake.

The first, though it makes the Park more available for certain purposes at an early day, is of little importance with reference to a plan except as it may be an indication that the natural conditions are more favorable than elsewhere for the growth of large trees.

CITY PARKS
AND IMPROVED
USE OF
METROPOLITAN
SPACES
160

and we are of the opinion that with skillful management very much better trees than any on the South Park may be grown upon each of the other park sites of the city.

It is an advantage of great space that one part of those who resort to a park for recreation can be engaged in a class of exercises which, in order to be pursued by different parties without clashing, require much breadth of open ground, that another part can look upon the first from a suitable distance with convenience and safety, while a third, interested neither as participants nor spectators, can seclude themselves completely from both and straying into other parts of the Park pursue entirely different methods of recreation. Another advantage is that, without any sacrifice of convenience for the class of exercises first referred to, elements of interest may be multiplied and yet, if the natural features oppose no obstacle, a larger, simpler and more tranquil landscape character be given to the Park as a whole.

Of the other park sites reserved for the future benefit of Chicago but one offers this class of advantages in any degree to compare with that of the South Park, and that, as it should be, is the one which is at the greatest distance from it. The two outer divisions of the South Park being connected more directly, however, and by a division considerably wider than any connecting any other two park divisions of the whole series, it is possible to associate them much more intimately in design than any other two, so that each may in many particulars complement the other and the whole be classed together as one park. If we add to this possibility those which grow out of its situation with reference to the lake, there can be little room for doubt that you have the opportunity, and consequently the duty, of adopting a scale of scenery and at certain points a scale of public accommodations larger than can elsewhere be attempted, without a restriction upon design with reference to

depth and variety of sylvan elements of interest, which would be unfortunate.

By a course of reasoning thus barely indicated, but which will be more evident as we proceed with the consideration of details, we are led to think that, while the local urban use of the South Park will not be unimportant, its availability for general purposes in which the city as a whole will be interested is considerably greater than that of any other of the sites which have been reserved for parks.

It follows that the South Park should belong to a third class, of which the type in London is found in Hyde Park with Kensington Gardens, and in Paris in the Bois de Boulogne; a class which should not be a compromise between the two extremes first named, but in which the advantages of each should be completely reconciled and united.

That some one park will be required to assume this position and will be more or less satisfactorily adapted to it, may, from the experience of other cities, be assumed and that neither of the others is as well suited to the purpose, must, we believe upon a comparison of situations, outlines and topographical conditions, be admitted. . . .

The general class, scope and character of the proposed park having been thus approximately determined, we may proceed to consider the limitations fixed by the conditions of the site upon the design.

The first obvious defect of the site is that of its flatness. That this is to be regretted is undeniable, yet it is a mistake to suppose that a considerable extent of nearly flat ground is inadmissable or undesirable in a great park, or that it must be overcome, at any cost, by vast artificial elevations and depressions, or by covering all the surface with trivial objects of interest.

CITY PARKS
AND IMPROVED
USE OF
METROPOLITAN
SPACES
162

The Central Park of New York, having been laid out for the most prodigal city in the world, is one of the most costly constructions ever made for public, open air recreation. The view just expressed may then be thought to be strengthened by the fact that one of the largest items in its cost, and unquestionably, one of the most profitable, was that for reducing considerable portions of its surface to a prairie-like simplicity. In our judgment, it still comes far short in this particular of what is chiefly desirable in the principal recreation ground of a large city, in a temperate climate.

It should especially be considered that where there is a broad meadow with ever so little obvious play of surface, an irregular border formed by massive bodies of foliage will in a great degree supply the place in landscape of moderate hills and particularly will this be the case if it contains water in some slight depression, so situated as to double these masses.

Chicago in the future would no doubt be glad if there should have been provided for it, somewhere within the thousand acres of its principal park, a considerable district of a highly picturesque character, a mountain glen with a dashing stream and cascades, for example, but, agreeable as this might be if it were to be obtained by the simple appropriation and development of conditions already existing; as in the valley of Wissahickon at Philadelphia, it would, after all, in a thoroughly well ordered park, be an episode, not essential, and far less useful than a district of low rolling prairie.

There is but one object of scenery near Chicago of special grandeur or sublimity, and that, the lake, can be made by artificial means no more grand or sublime. By no practical elevation of artificial hills, that is to say, would the impression of the observer in overlooking it be made greatly more profound. The lake may,

indeed, be accepted as fully compensating for the absence of sublime or picturesque elevations of land.

There are three elements of scenery however, which must be regarded as indispensable to a fine park to be formed on your site, the first being turf, the second foliage, the third still water. For each of these you are bound, at the outset, to make the best of your opportunities, because if you do not, posterity will be likely to lay waste what you have done, in order to prepare something better. . . .

If it should be undertaken to form a large market garden in such a district as this, the first thing to be done would be, if possible, to secure a free outlet through the beach, so that water flowing in from the west would, under no circumstances, be so checked in its outflow as to rise appreciably higher than the lake. This would be accomplished, if at all, by building out a crib upon the beach, and then opening a channel, the mouth of which would be on its south side. A series of cross channels would then be laid out mainly parallel with and equidistant from one another, the breadth, depth, and distances between them being so adjusted that the material excavated, when thrown out, should be sufficient to raise the surface of all the intermediate ground just so far above the level of the lake as should be thought necessary for the thrifty growth of the crops proposed to be cultivated.

The same process may be adopted for your purpose, with such modifications as the difference between a park and a vegetable garden requires, the difference being, that in the park the divisions of land and water should have a natural appearance and be interesting in landscape effect, and that they should be adapted to the convenient movement of a large number of persons pursuing recreation in a variety of ways.

Searching for a natural type of what is thus desirable, we look

CITY PARKS
AND IMPROVED
USE OF
METROPOLITAN
SPACES
164

first for local suggestions. The present formation is the result of an encroachment of the shore upon the lake, and this appears to have occurred first by the formation of a large outer bar, and of minor bars within it, the outer bar rising gradually more and more above the surface, and finally completely separating the water behind it, except perhaps at one or two inlets, from the main lake. In subsequent storms the outer bar has been more or less broken down, and sand, driven by wave and wind, mixed with some wash from the land side, has gradually filled up the inner basins.

Had the situation been less bleak, had the outer bar been firmer and composed of different material, had the streams flowing in been more rapid and the country swept by them richer in vegetation, and had the climate been hot and moist certain plants would have taken root upon the shallows, silt would have been caught by them and drift stuff lodged upon them; fish, birds, insects would have made contributions and soil would accumulate, other plants would in time overgrow the first, and, the process continuing, scenery would finally result of a most interesting and fascinating character, that, namely, of the wooded lagoons of the tropics.

You certainly cannot set the madrepore or the mangrove at work on the banks of Lake Michigan, you cannot naturalize bamboo or papyrus, aspiring palm or waving parasites, but you *can* set firm barriers to the violence of winds and waves, and make shores as intricate, as arborescent and as densely overhung with foliage as any. You can have placid and limpid water within these shores that will mirror and double all above it as truly as any, and thus, if you cannot reproduce the tropical forest in all its mysterious depths of shade and visionary reflections of light, you can secure a combination of the fresh and healthy nature of the North with the restful, dreamy nature of the South that would in our judgment be admirably fitted to the general purposes of any park, and which cer-

tainly could nowhere be more grateful than in the borders of your city, not only on account of the present intensely wide-awake character of its people, but because of the special quality of the scenery about Chicago in which flat and treeless prairie and limitless expanse of lake are such prominent characteristics.

Taste and convenience would require that some portions of the lagoon waters should be broader than the economy of a mere market garden would prescribe, but to avoid great length of haul in filling over the marshy ground, the water spaces would need to be distributed from end to end and from the beach to the rear of the Lower Division.

This course of thought leads towards two important conclusions, viz.: 1st. By any feasible and moderately economical plan of making a public pleasure resort on your Lower Division, water must be so distributed through it that the land will be broken up into comparatively small areas and no great breadth of green landscape will be available. 2d. Command of the lake upon a shore line of more than a mile and a half in length, accessibility from the heart of the city by water-passage, and the great extent and necessary ramifications of its interior waters would give such marked distinctions to this part of the Park, that, so long as they were in view, a comparison of it with parks elsewhere, more fortunate in other respects, would be out of the question. For beauty of hill and dale your ground certainly will never be distinguished; it may never be for the grandeur of its trees, but it may have a beauty and an interest of its own such as we have partly indicated, in which the citizens of Chicago for generations to come, shall take a just pride, and all the more so that it has been the result of their fathers' work upon a sandbar.

In every distinct field of design, however multitudinous the intentions to be served in its details, some one source of interest

CITY PARKS
AND IMPROVED
USE OF
METROPOLITAN
SPACES
166

should dominate, and either by contrast or harmony, all details should be auxiliary to this central interest. In a work of the kind before us there may be — almost necessarily must be — several more or less distinct fields of design, but it is desirable that there should be a studied artistic relation of support by harmony, and of emphasis by contrast of character between the different fields. The element of interest which undoubtedly should be placed first, if possible, in the park of any great city, is that of an antithesis to its bustling, paved, rectangular, walled-in streets; this requirement would best be met by a large meadowy ground of an open, free, tranquil character. The necessity of sub-dividing the ground by the ramifications of the water system, and of generally planting the shores, if you would gain the beauty or reflections, half-lights, and shaded coves of foliage over water, as we have proposed, will prevent your realizing any considerable breadth of open landscape within your Lower Division. It will be equally impossible within your Middle Division, on account of its narrowness. Fortunately, there is no similar objection to the realization of this desideratum in the Upper Division, the proper general landscape character of which, as well as that of the Lower Division, may thus be considered as determined.

We proceed to consider what is required more specifically in the Lower Division. It naturally divides into two fields of landscape, the exterior lake expanse with its necessarily simple, raw, storm-lashed foreground, and the interior lagoon scenery, intricate, sequestered, sylvan and rich in variety of color and play of light and shade, both having the common and continuous element of water. Still, considering this park as the principal recreation ground of the city and one in which more than any other a general attendance from all parts of the city should be expected, invited, and prepared for, the fact remains that the distance to it from the centre

and more northern quarters is so long that the access to it by land will be often uninteresting and tedious. Were it to be very much more so, mere approach by land to the Park wholly impracticable, as from Venice to the Lido, the means of access by water and the connection of the Park by water with the heart of the commercial part of the city would be so admirable that under ordinarily favorable conditions of weather, there would be thousands of the very class of citizens whose convenience most needs to be considered, to whom the Park would practically begin at the mouth of the Chicago river. Where great numbers are to be carried short distances, there is no transportation so cheap or so agreeable as that by water, and the time should be expected when the toiling population of Chicago, relieved from work at an early hour on the last of the week, will be carried to the South Park by many tens of thousands at the cost of a few cents. Its advantages in this respect will correspond to those of the Haga Park of Stockholm, one of the most popular and delightful public grounds in the world.

Aside from the actual advantages of access which it thus offers, it is most desirable that whatever sources of interest there may be in the lake should be as closely as possible associated with those of the Park and be made to appear, as much as possible, part and parcel of the Park. The introduction of artificial water with natural outlines and no perceptible current, so near the great lake, is, as a matter of art, not a little hazardous, and to fully insure it against a paltry and childish aspect it is indispensable that the character of the lagoon as an arm of the lake should be distinctly manifest. For this reason the channel between the water of the lake and the water within the Park should be given importance in the design, so that at all times, even when few or no boats are passing, this privilege of the Park will be felt by land visitors as an important distinction.

CITY PARKS
AND IMPROVED
USE OF
METROPOLITAN
SPACES
168

The channel must be cut through the beach, the break in it being guarded against the drift of sand from the northward by a pier, which should be fully two hundred feet in length, in order to create a strong eddy at the mouth of the inlet. It must be presumed that in any case the channel will need occasional dredging.

Such a pier would be the most prominent object connecting the Park with the lake, and experience shows that where an offset into the water from a tame coast has been thus formed people are strongly drawn to gather upon and near it. So well established is this attraction that at many of the places of resort on the English and French coasts, long piers have been built simply for the gratification of visitors.

For these reasons the pier and inlet must be treated as most important members of the design; they should not be thrust into a corner, but located as near to the heart of the Park as possible, and as visitors will inevitably be drawn to the pier special provision should be planned for the comfortable coming together of a large number in connection with it. From the view of the lake which these would command, the transition should be made easy and natural to some other point, also adapted to the coming together of large numbers, which will have a like central position with reference to the lagoon.

We wish to present one other class of preliminary considerations before referring to our plans. Among the purposes for which public grounds are used is that of an arena for athletic sports, such as baseball, football, cricket, and running games, such as prisoner's base, and others which are liable to come again much more in fashion than they have been of late. Another is that of a ground for parades, reviews, drills, processions and public meetings and ceremonies in which large spaces are required. Experience shows that neither upon fields used for these purposes nor on ground

where large numbers of people are liable to come together strongly interested in them, is it practicable to guard shrubs and low branching trees from injury. For all these purposes turf is much more favorable to the skill and comfort of those engaged in the exercises and more agreeable to the eye of spectators than gravel; it is also generally much less costly. If at any particular point, however, it is much used it wears out and leaves unsightly and slippery ground in its stead. Consequently it is impossible to keep grounds used for these purposes in decent order unless the open fields of turf are very large and the plantations about them are of an open character, and composed almost wholly of strong, clean trunked trees.

It is also impossible to keep grounds in good order in which the breadths of turf are smaller and decorated with shrubbery and low foliage, if the same freedom of movement and action is permitted in them which it is desirable to allow upon the larger open grounds. Consequently an entirely different scheme of regulations needs to be applied to them. To enable these to be enforced the line between one class of grounds and the other must be sharply defined so that it cannot be passed unconsciously even under excitement.

The distinction between grounds to be used by day only, and grounds to be open night and day, needs also to be considered. It is impossible to make grounds in the midst of large towns which offer numerous places of complete obscurity, safe places of general resort after nightfall. Wherever it has been attempted in Europe or America, decent people have soon been driven from them, and they have become nurseries of crime and immorality. . . .

Disregarding here very small places we thus show a necessity for two classes of grounds, one characterized by broad, nearly level spaces of turf suitable for reviews and athletic exercises, and open plantations offering no coverts, and which may be artificially lighted and safely resorted to after nightfall; the other, not de-

CITY PARKS
AND IMPROVED
USE OF
METROPOLITAN
SPACES
170

signed to be artificially lighted nor to be used at night, adapted only to quiet and moderate exercises; in which shrubbery, underwood and brooding trees may be common elements of scenery, and if circumstances admit of it, what is technically styled the picturesque in distinction from the simply beautiful in nature may be cultivated.

The scenery of the first class of grounds is distinctively "park scenery," because the private parks of Europe are generally pastured by deer or cattle, and consequently, up to a distinct browsing line, are clear of foliage. The scenery of the second class is that of what is usually distinguished from the park as the "pleasure ground" or "kept ground," being managed in a more garden-like way. We shall term the first "OPEN," and shall apply the old word "PLAISANCE" to such as is intended to be enclosed with a high fence and used only by day.

Your territory is so extensive and so large a population may be expected eventually to resort exclusively to it for out-door recreation that it is clear that provision of both classes should be found in it, and its extreme points being three miles apart (exclusive of the parkways), it should not even be necessary for a boy who has reached one end to go half around it to find himself free to run upon the turf, or that a man living near it and going out after dusk with his wife and daughters, should find no better place in which to stroll than an ordinary street side-walk. For these reasons there should be enough "open" ground at least for local use, night and day, near each of the extreme parts of your plan.

It is impracticable to close any ground at night through which important thoroughfares are carried unless by the expedient of carrying one line of transit under another as in the New York Park. This is a costly arrangement and can rarely be used so that land-

scape opportunities shall not be marred by it; it should only be adopted therefore under considerations of special necessity.

We are instructed that your Upper Division must be crossed by a thoroughfare near its middle from east to west. It is not to be hoped and there is no reason to believe that there ever will be a business quarter on the east side of this ground, nor at least very near it on the west. As the space in the east is quite limited and is likely to be occupied almost exclusively with dwellings of people of wealth, and therefore not densely, there is not likely to be much need for driving through the park except with pleasure carriages. Coal, building materials, hay, and most market supplies will be brought in from the north, and the principal occasion for crossing with business wagons will be early in the morning, as of milkmen and bakers. Under these circumstances the movement of pleasure carriages is not likely to be so unpleasantly interfered with as at all to justify the construction of a sunken traffic road across the park. . . .

If it were not for the experience of other cities where the cost of forming parks has been more than met by the increased taxable valuation of real estate benefited by them, and for the rise in the value of certain property which has already accrued on account of the South Park undertaking, the excavation for water required by the plan would probably be thought too costly to be soon entered upon. Even as it is, it may be questioned whether the delay which will be involved by it in meeting the expectations upon which the present value of property depends, will not, after a time, be so disappointing as to render advisable some different plan of dealing with the Middle and Upper Divisions, dispensing with the water connection, and giving the public the use of the ground sooner in a finished condition.

CITY PARKS
AND IMPROVED
USE OF
METROPOLITAN
SPACES
172

We shall give some reasons for thinking that nothing would really be gained by such a course.

The expectations upon which the rise in the value of real estate has depended and will depend, are partly of a definite and partly of a very indefinite character. A few years ago the district more especially affected by the undertaking of the South Park was commonly regarded as waste land and as hardly susceptible of much improvement. Whatever change has occurred in the public judgment in this respect is due, in the first place, to the results of private enterprise by which it has been proved that it can generally be relieved of surface water, be clothed with fine greensward, and that trees can, up to a certain point at least, be made to flourish upon it. These experiments give definite and tangible ground of expectation as to its future. But beyond this, secondly, there is a blind faith that your Commission, having larger proportionate means at command, and being able to direct a business-like study to the question of the possibilities of improvement, will find a way to do more on a large scale than private enterprise has yet done even on a small scale. Suppose, then, that after several years work, a finish shall have been given to the whole of the Upper and Middle Divisions, but that the character of this finish does not vary materially from that of the adjoining door yards as they are now seen, the improvements by drainage, manuring, greensward and tree planting having been essentially the same. The result would be that nothing more would be found in the park than the realization of the defined and experimentally grounded expectations of the present, and it may be doubted whether this would not really be somewhat disappointing.

But suppose, on the other hand that, with less extent of superficial finish, it should be evident that the operations in progress were to result in much more substantial far-reaching improvements than

had been definitely imagined — improvements of a really organic character, directly affecting the whole region — it is clear that it would not only satisfy, but induce a strong advance upon, present expectations.

The great increase in the value of real estate produced by the construction of the New York Park did not begin until sometime after it was commenced, nor until the public began to see that the ground had much greater capabilities than had at first been imagined. The President of the Brooklyn Park Commission, in a public address two years ago, quoting a statement that the opening of a small part of the park the previous year had caused an advance of real estate in that city to the amount of ten millions of dollars, observed that it was not because the public then first realized that the city was to have a park, but because the character of the first improvements which had been made for the purpose really advanced the rank of the city in the public estimation and suddenly caused a new class of expectations to be formed of its future.

Looking again at the Baltimore and Philadelphia parks, the natural advantages of the sites of which are much greater than those possessed in New York and Brooklyn, and where the improvements thus far made though quite extensive, have been of a more superficial and commonplace class, we find that they have produced no very extraordinary increase of value in neighboring real estate.

Among the advantages of the plan we propose, which would be permanently barred by the substitution for it of any plan which could be executed very much more cheaply and quickly, are the following:

First. It secures a deep thorough drainage of the Upper and Middle Divisions, and thus adds greatly to the chances of making trees flourish upon them.

Second. It locks the three divisions of the Park into one obvious

CITY PARKS
AND IMPROVED
USE OF
METROPOLITAN
SPACES
174

system, so that their really disjointed character will be much less impressed upon the minds of observers passing through them than would be the case if the connecting element of a common body of water were lacking.

Third. It practically places the Upper or Inland Division of the Park upon a navigable arm of Lake Michigan and thus makes it accessible by boats from the heart of the commercial part of the city. The aquatic character of the Park will thus be more remarkable. It will also be an advantage that the water fowl and fish may swim freely between the Upper Plaisance and the lake. The skating advantage is also obvious.

Fourth. It offers to those coming by rail, in public carriages, or on foot, a means of traveling through nearly all parts of the Park quietly, agreeably and without fatigue, and by a method much less expensive than that of wheeled carriages. This will be of great value to invalids, convalescents, and mothers with children in arms. There is a very limited extent of water in the New York Park, yet it is found that from four to six thousand persons use the small boats daily, in fine weather, and at a charge of ten cents they yield a satisfactory profit.

Fifth. The material excavated from the basins and mere will, if skillfully used upon the banks, overcome, to a certain extent, the chief landscape defect of all the Chicago pleasure grounds, namely, their nearly level surface. Presuming that the work will be done by steam dredges, in no other way can so considerable an improvement in this respect be made as cheaply. Here, therefore, if anywhere, the city can afford a little luxury in undulation.

Sixth. By offering upon the Midway and Upper Plaisances to the view of those who come to the Park in boats, generally, much higher banks than it will be practicable to form upon the lagoon, the

value of the boating privileges of the Park, and consequently of its lake approach, will be greatly increased.

Seventh. The incidental effect of this operation upon all the country surrounding the Park as well as that within it will be most valuable. It will gradually bring about a change in its character equivalent to that which would be gained by lifting its surface several feet above its present level. It will make gardens practicable where otherwise nothing but swamp plants will grow. It will at once make a considerable district suitable for residences which will otherwise remain not only unwholesome for that purpose within itself, but a source of ill health to others until a costly system of sewers has been constructed. In connection with the better growth of trees which will result, the climate of the whole south part of the city will be essentially improved by it, so much so, for instance, that there will be appreciably less liability to rheumatic and pulmonary complaints and the epidemics of children.

In view of the advantages thus promised, it would, in our judgment, be prudent and politic to enter at once upon the necessary works, even though, to carry them on, all other improvements had to be postponed until they were completed. We judge, however, that this would not be at all necessary. The process of excavation and embankment should be mainly by steam apparatus, and when once begun should go steadily on at a nearly regular per diem rate, otherwise idle capital would be charged upon the park. The total amount of the outlay which would thus be required per annum, would not, we suppose, exhaust your resources. The construction of the Southopen Ground being an undertaking by itself, need wait for nothing. It nowhere involves very heavy work, and the chief need for discretion will be in regard to the means and methods to be used for improving the soil. We should recommend that the outer parts

CITY PARKS
AND IMPROVED
USE OF
METROPOLITAN
SPACES
176

be dressed heavily with soil, clay, and well-rotted manure, and trees planted of much larger size than we should advise to be used under other circumstances, but that for the sake of economy The Green should be improved more slowly by the process already suggested. Before it was ready to be seeded for turf the pavilion might be built, and the grove to the north of it being fitted up as a temporary picnic ground, it would probably be found at once a source of income equivalent to the interest on its cost.

At the same time the Park Haven pier should be built and there would be nothing in the way of the construction of the shore road, the concourse on the pier, and the Belvedere. By the time these had been completed, the dredging would be so far advanced that boats could run from the city into the harbor and finishing operations could be begun on the Belvedere lawn and other parts of the interior Park.

We make these suggestions as to the course of operations simply to show that if the construction of the lagoon and Midway Basin should be immediately undertaken, it would not necessarily involve a delay in making the Park fully available in certain important particulars for public use.

In speaking of the depth of the lagoon, and generally in referring to the depth of excavations, we have had in view the minimum requirements of the plan. It is to be expected that roads and walks throughout the park will generally be graded as low as shall be consistent with efficient drainage, and a graceful continuity of parts, and by this means material will be obtained for a slight modulation of adjoining surfaces. By the occasional introduction in the shores of a surface but a few inches above high water level, and in which only rushes and water plants will grow, the average elevation of the filled ground may be made higher at other points, and a variety attained altogether desirable. Adjoining the basin and the Mere,

occasional elevations of at least twenty feet can be easily managed
with long flowing contours and without any appearance of being
artificially mounded. The excavation of two feet, which we have
before said is required in the Southopen Ground, and which should
be extended from the central point in long shallow depressions to
the north-west and north-east, and to the south-west beyond the pool,
together with the deeper excavation required for the pool itself, will
yield sufficient material to give a perceptible play of surface upon
the lower part of the Southopen Green, and in grading the drives
and walks something may be cheaply added.

By slight and inexpensive changes of the surface, such as we have
thus advised, provided always that trees of a satisfactory character
can be insured, the scenery of this part of the Park may be
rendered appropriate and pleasing. We do not say that it would
under no circumstances be desirable to vary the surface much more,
but only that it is not indispensable to do so, and as any consider-
ably increased modulation beyond what we have indicated, would
be expensive, the question of undertaking it may be regarded as
one of detail, to be determined when necessary with fair considera-
tion of resources which shall then be available. . . .

It only remains for us to refer to some suggestions which we have
offered in the plan, in regard to approaches and exterior streets.

The important line of communication which we call the South-
open Parkway, does not, at present, connect properly with the
Southopen Ground, but it may be made to do so by the acquisition
on the part of your Commission, of a comparatively small piece of
land, and we have therefore thought it desirable to show on our
design how a satisfactory adjustment may thus be arrived at.

The difficulty in regard to the Southgrove Parkway, as at present
laid down on the maps, is of a more serious character. It turns
abruptly at right angles, a few hundred feet away from the Park,

CITY PARKS
AND IMPROVED
USE OF
METROPOLITAN
SPACES
178

and the actual provision for entrance when it reaches its extreme corner, is so wholly inadequate that some considerable improvement will inevitably be required.

A close study of all the circumstances of this case, has led us to avoid any attempt to solve the difficulty by direct addition to the Park territory, and we have been led to think on the other hand that the necessary improvement should be made in the form of an extension of the parkway on a scale commensurate with the importance of its position and having a marked artistic character of its own.

About fifty years ago the Quadrant leading from Pall Mall to Regent Street was made one of the finest thoroughfares in London. No such connection had been originally contemplated, but the demand for some adequate means of communication in this direction having become imperative, the new street was at length cut through a quarter of the city that had been solidly built up with expensive structures. We suggest the adoption of a somewhat similar expedient in your case, before any houses are erected in the neighborhood, and if the Parkway Quadrant can be carried out as shown on our plan, the curved line of approach will, we think, have a sufficiently bold sweep to be easy and agreeable in connection with the long, straight line of the Southgrove Parkway, and the main Park entrance to which it leads will be relieved of any appearance of awkwardness.

An unusual volume of traffic will naturally be accumulated on the boundary streets of the Park, and we propose, for this reason, and also to improve their promenade character, that they should be somewhat widened on each side of the present centre line. The suggestion [is] to increase the width of two of these streets to eighty-six feet, and the others should, we think, be at least a hundred feet wide, and their walks on the Park side continuously shaded. Improvements of this character are almost invariably called for sooner

or later in the vicinity of urban parks, and their costliness increases with every year they are postponed. We have seen many hundred thousand dollars saved in a few years by prompt action on similar advices in other cases, and many more lost by inattention to it.

In the progress of a public improvement like that of the Chicago South Park, undertaken with so much reference to the distant future as its justification necessarily predicates, and the completion of which, in all its parts, must must be so far off, the introduction of subsidiary elements of design of greater or lesser importance will undoubtedly from time to time be proposed. It is not to be expected that a plan will be made at the outset so complete, that no additions to it or modificatons of it in detail will be admissable, but it is of the utmost consequence that the essential ends should be clearly seen before the work is organized, and that from the moment it begins to the end, be that five or fifty years hence, and under whatever changes of administration and changes of fashion, these great ruling ends should be pursued with absolute consistency. Work of the character designed constantly requires ability of high order in its supervision, and it is undesirable that the exercise of this ability should be hampered by unnecessarily specific instructions.

Under the influence of these considerations our object has been simply to develop a series of the most desirable features practicable of realization under the very peculiar conditions of your site and circumstances, and we have endeavored to carry the design of these only so far as to establish the characteristic end of each, whether it be an artistic effect on the imagination or simply an accommodation for convenience and comfort.

The plan having, after due deliberation, been adopted as the constitutional law of the park construction, no proposition involving change or addition in any locality, should be entertained, however attractive in itself, which is not harmonious with the purpose in-

CITY PARKS
AND IMPROVED
USE OF
METROPOLITAN
SPACES
180

tended to rule in that locality. All propositions on the other hand, intelligently designed to strengthen and emphasize its main purposes, may be heartily welcomed, and their adoption be simply a question of practical business expediency.

Trusting that the plan which we have now presented may meet with your approval and that time will justify the confidence with which you have honored us.

We remain, gentlemen,

Yours respectfully,
Olmsted, Vaux & Co.,
Landscape Architects
March, 1871.

THE COLUMBIAN EXPOSITION[23]

This paper has been written at the request of the American Institute of Architects, with the object of briefly accounting for such part of the preparation of the Exposition of 1893 as has come within the responsibility of the landscape architects, and as a contribution in this respect to a record of its genesis and development as a work of design.

In the *Quarterly Review* of 1820, page 303, there is an article written by Sir Walter Scott, from which it appears that this master of words did not approve of the term "landscape gardening," which was then coming into popular use. His objection to it was that it tended to confusion between two classes of purposes, or motives of art, which could not well be blended together. To make this objec-

[23] Frederick Law Olmsted, "A Report Upon the Landscape Architecture of the Columbian Exposition to the American Institute of Architects," *American Architect and Building News*, 41 (September 1893). This paper was read before the World's Congress of Architects at Chicago.

tion clear, it may be observed that the word garden comes to us from the same root with girdle, girth, garth and others to be found in every European tongue, all of which imply something limited, restrained and separated from what exists beyond or about it, or that is the cause of such limitation, restriction or separation. From remote times, the word in its various forms — English, Spanish, French, Italian, Scandinavian — has carried with it this idea of limitation and exclusion. We yet speak of "garden flowers," meaning certain flowers exclusive of others. Taking up a book with the title, "*A Garden of Verse*," we should understand it to be a selection of verse. Being told at a farmhouse that one of the family is "in the garden," no countryman would think that this meant either simply out-of-doors, or in a stable-yard, or an orchard, or a common cultivated field, a grove, a park or a pasture. The word implies reference to a limited, defined and exclusive space, and it may be used in this way antithetically to the word landscape, the application of which is so comprehensive that it may take in houses, lawns, gardens, orchards, meadows, mountains and even the sky, with the stars to the remotest nebulæ.

The word landscape is often used by accurate writers interchangeably with the word scenery, as, for example, by Gilpin in his series of works on the scenery of Great Britain; also by Hamerton in a recent treatise on landscape written from the point of view of a landscape painter.

A distinction implied by the word landscape unfitting it to be compounded with the word garden is indicated by Hamerton when he says that: "Much of the comprehensiveness of natural scenery depends upon the degree in which mass appears to predominate over detail. In perfectly clear weather, a mountain does not look nearly so grand as when . . . its nearer details are only partially revealed amidst broad spaces of shade. So it appears with other

CITY PARKS
AND IMPROVED
USE OF
METROPOLITAN
SPACES
182

elements of landscape — they lose in comprehensiveness as the details become more visible." Thus, for the enjoyment of landscape beauty, we are to regard the detail of what we see mainly as it affects the character and expression of masses, these masses being considered as elements of composition and perspective. On the other hand, for the enjoyment of garden beauty as such, we must scrutinize objects of detail discriminatingly. We must see roses as roses, not as flecks of white or red modifying masses of green.

Lastly, to understand aright the term "landscape architect," we must bear in mind that the word architecture is not limited in application to works of building. The Almighty is referred to as the Architect of the Universe. Plutarch writes of the architecture of a poem, meaning the plotting of it. "The architect of his own fortune" is an old proverbial term yet commonly used in our newspapers, and it is applicable as well to a banker or a miner as to one whose fortune has been made by directing works of building.

In view of the considerations thus presented, when the office of landscape architects to the Exposition was created, what, in the absence of specific instructions, was to be understood as the leading duty of that office? The answer assumed by those to whom the title was applied was that their leading duty must be to reconcile the requirements of the problem which the directors had before them in respect to buildings, and means of access to, and means of communication between, buildings, with the requirements of pleasing scenery and of scenery which would be pleasing, not because of the specific beauty of its detail, but because of the subordination and contribution of its detail to effective composition of masses as seen in perspective.

Adopting such a view, the first thing to be noted in an account of the landscape architecture of the Exposition is this:

Immediately after the settlement in the Directory of the question

of its own organization and rules, the question of a choice of sites came up, and it soon appeared that the debate of it was likely to be inconveniently prolonged. Thereupon the suggestion was made that expert counsel upon it might be desirable, and an inquiry was addressed to our office as to the terms upon which counsel could be had. Upon receipt of our reply by telegraph, we were asked to come to Chicago as soon as practicable. We did so by the next train, and upon arrival, were presently taken to examine, in succession, seven proposed sites, three on the Lake and four inland. . . .

Of the seven sites to which our attention was called, there was not one the scenery of which would recommend it if it had been near Boston, New York or Philadelphia. After our first general review of the premises, we adopted the opinion that nothing was to be found in any of the inland sites that could be weighed against the advantages, in respect to scenery, of the Lake Shore. Next, as to the sites on the shore, we concluded that, provided suitable means of transportation for goods and passengers between the town and the place could be secured, the northernmost of those proposed would be the best. By comparison with the most nearly competing site, it would require less outlay to prepare the ground and establish suitable means of interior transportation, water supply, drainage and sewerage; the great marine commerce of Chicago would be passing in review before it at a suitable distance for spectator effect; an arrangement of buildings simpler and much grander than elsewhere would be practicable, and the buildings would have a much better setting and framing of foliage provided by standing woods, fairly vigorous, and of sufficient height to serve as a continuous background.

But a committee of the Directory, taking up the question of transportation between this site and the central parts of the town, advised us that the railroad companies concerned could not be induced to

CITY PARKS
AND IMPROVED
USE OF
METROPOLITAN
SPACES
184

make the outlay of capital required for such arrangements of trans-
portation as we thought needful. Thereupon we fell back on the
southernmost of the sites proposed on the Lake, which went by the
name of Jackson Park.

Our report favoring this place excited much remonstrance. Op-
position to it was concentrated in favor of an inland site near by,
known as Washington Park, the advantages of which were thought
to be so great and so obvious that a leading member of the National
Commission assured us that after an inspection of the two sites in
question, not one vote in ten could be got for our proposition. In the
few days that intervened before the Commission met, we gave the
reasons of our choice as well as we could in private conversation,
but I do not think we accomplished much. In the end the Commis-
sion accepted our advice, not because a majority of its members
understood the grounds of it, but because they could not be led to
believe that we should have given this advice without having, as
experts, sound reasons for doing it. The result was due to respect
for professional judgment. Comparing this experience with some in
my earlier professional life, I can but think that it manifests an
advance in civilization.

Unquestionably, to common observation, the place was forbid-
ding. At different periods in the past, sand-bars had been formed
in the lake and a few hundred feet from, and parallel with the
shore. The landward one of these, gradually rising, would at length
attain an elevation above the surface of the water. There would then
be within this bar a pool accurately definable as a lagoon. Gradu-
ally, in this case, lagoons thus formed had been filled nearly to the
brim with sand drifting from the outer bar, and had been turned
into marshes. Thus nine-tenths of the surface of the site, or, in fact,
all of it that had not been artificially made otherwise, consisted of
three ridges of beach sand, the swales between which were more or

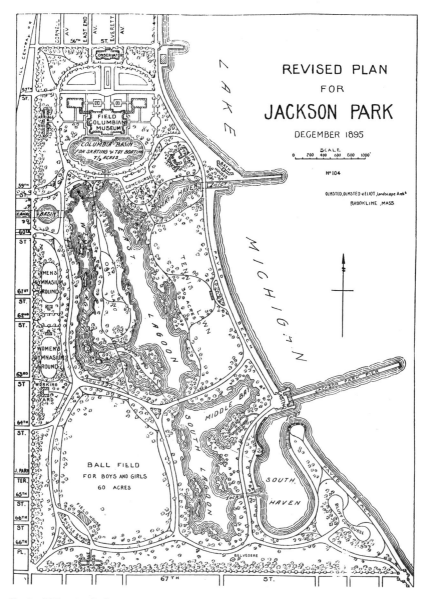

Revised Plan for Jackson Park, Chicago, 1895.

CITY PARKS
AND IMPROVED
USE OF
METROPOLITAN
SPACES
186

less occupied by boggy, herbaceous vegetation. Upon the innermost two of the ridges vegetable mould had gathered and trees had sprung up in scattered groups. The most important of these trees were oaks. The situation being extremely bleak, the soil subject to be flooded, and the sandy sub-soil water-soaked, these had had an extremely slow growth. The largest were about forty feet in height. They were very feeble and many of them dilapidated through loss of limbs broken off by gales from the lake.

A more serious difficulty than any involved in this consideration was found in the circumstance that the level of water in the lake, and consequently in the marshes, was fluctuating, and this not only from day to day, as would be determined by winds at a distance drawing it off or backing it up, but its average level varied from year to year. An engineer who had been in charge of operations upon the lake shore, and who had had occasion to study the matter with accuracy, advised us that the probabilities were that in 1893, the average elevation of the surface of the lake would be four feet higher than it was at the time when we were studying the plan, or than it had been during the year before. It will be readily understood how difficult it became to forecast landscape effects in a region of low shores, without knowing within four feet what the level of the water was to be by which these shores were to be washed.

The Jackson Park site, had, twenty years before, been selected as a site to be reserved for a public park. If a search had been made for the least park-like ground within miles of the city, nothing better meeting the requirement could have been found. It will, then, naturally be asked: Why was such a place fixed upon for a park? I have not the specific knowledge required for an answer, but I may mention that it is a common thing for town governments when they find bodies of land which, because of their special topographical

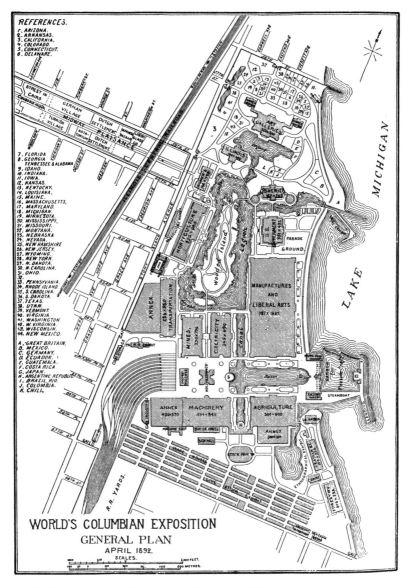

World's Columbian Exposition General Plan, April 1892, Chicago.

CITY PARKS
AND IMPROVED
USE OF
METROPOLITAN
SPACES
188

condition, are not favorable to the ends of dealers in building-lots, to regard them as natural reservations for pleasure-grounds; to label them accordingly on their maps, and to refrain from ordering streets to be laid across them. This is not peculiarly a Western custom. The sites for Central Park, for the Morningside Park, for the Riverside Park, for the Mount Morris Park, for Tompkins Square, and, no doubt, for other public grounds in the City of New York, were thus selected. So was the site of the public ground in Boston, officially called the Fens, but popularly known as the Back Bay Park. Sites having been thus obtained, landscape architects are asked to contrive how pleasure-grounds can be made of them. It has been so, I believe, in London, conspicuously in the case of Battersea Park. And it may be remembered that the opportunity of making the Tuileries Garden in Paris occurred because, while the city had been building out about the place, the necessary ground had been held in reserve while the clay which it contained was being removed to be used for making roofing-tile. In the millennium it may be hoped that landscape architects will be employed to select land with regard to the specific purpose for which it is to be used. When that is the case, the making of a park will be less costly than it is at present. . . .

When Jackson Park was chosen as the site for the World's Fair, the general landscape design of no part of the plan, of which the expedient I have described was the germ, had been carried out. In the Washington Park part of the scheme, a good deal had been done following the leading outlines of the plan, but with a modelling of surfaces and a choice of material and disposition of foliage looking to conditions of detail rather than of masses, and with entire disregard of the elements of mystery through effects of aerial perspective, and the complicated play of light and shadow and of reflected tints in extended composition.

In the nominal carrying out of plans in the preparation of which I have had part there have often been sacrifices of the designs of those plans which have been mortifying and disappointing. In no other case, however, had the disappointment been so great as in this. Nowhere else had the opportunity for forming agreeable scenery been so lost. But, in the lagoon district, what little had been done had not been done unwisely.

Coming to consider what might yet be done with this same lagoon district suitably for the purposes of the Exposition, the question at once came up how far the general theory of the old plan for a public pleasure-ground to be formed upon it could be made available to the special purpose of the Exposition.

As a result of this consideration, we came to the conclusion that the element of the water-ways in the original plan being carried out, retaining-walls being built in various places for holding up the excavated material to be piled upon the shores, so that in this place terraces would be formed, the necessary buildings for the Fair could be advantageously distributed upon the surrounding sandy ridges.

Before making their formal report favoring the choice of Jackson Park for the site of the Exposition, the landscape architects took counsel with Messrs. Burnham & Root, presenting their views of the manner in which, this site being adopted, it should be used, and obtaining confirmation of them, more especially with reference to the expediency of distributing the needed large buildings upon the sandy ridges, and of spreading out these ridges suitably for the purpose by retaining-walls to be backed by the excavated material from the lagoons. It may be observed that, to accomplish this purpose in various localities where otherwise lagoons with shores of a natural character would become unsuitable for boats, it was thought best to give them the character of canals; that is to say, to make

CITY PARKS
AND IMPROVED
USE OF
METROPOLITAN
SPACES
190

them formal and give their banks, which would necessarily be walls, an architectural character in harmony with the buildings to which, in a near perspective view, they would form foregrounds.

Mr. Burnham, in his report of the operations, addressed to the President of the Exposition on the 24th of October, 1892, thus describes the process of forming the first complete graphic sketch illustrative of the design:

"After consideration of sketches made on the ground, . . . a crude plot, on a large scale, of the whole scheme was rapidly drawn on brown paper, mostly with a pencil in the hand of Mr. Root, whose architectural prescience and coördinating talent was of invaluable service to the result. The plot, formed in the manner described, contemplated the following as leading features of design: That there should be a great architectural court with a body of water therein; that this court should serve as a suitably dignified and impressive entrance-hall to the Exposition, and that visitors arriving by train or boat should all pass through it; that there should be a formal canal leading northward from this court to a series of broader waters of a lagoon character, by which nearly the entire site would be penetrated, so that the principal Exposition buildings would each have a water as well as a land frontage, and would be approachable by boats; that near the middle of the lagoon system there should be an island, about fifteen acres in area, in which there would be clusters of the largest trees growing upon the site; that this island should be free from conspicuous buildings and that it should have a generally secluded, natural, sylvan aspect, the existing clusters of trees serving as centres for such broad and simple larger masses of foliage as it would be practicable to establish in a year's time by plantations of young trees and bushes. Because the water in the lagoons would be subject to considerable fluctuations, it was proposed that their shores should be occupied

by a selection of such aquatic plants as would endure occasional submergence and yet survive an occasional withdrawal of water from their roots. Time pressing, the pencil, large-scale, brown-paper plot above prescribed, with a brief written specification, almost equally sketched, was submitted to the Corporation, and, after due consideration, on the 1st of December, 1890, was adopted as the plan of the Exposition."

The question may be asked: In what degree at this early period was the result forecast, which has since been attained in respect to the effect of boats, bridges and water-fowl and overhanging foliage on the lagoons? The answer is that it was quite fully anticipated in a general way. The effects of the boats and water-fowl as incidents of movement and life; the bridges with respect to their shadows and reflections, their effect in extending apparent perspectives and in connecting terraces and buildings, tying them together and thus increasing the unity of composition — all this was quite fully taken into account from the very first, and the style of boats being adapted to the purpose became, at once, a topic of much anxiety and study.

The next important step in the progress of the enterprise to which reference is here necessary was taken by Mr. Burnham which resulted in the meeting at Chicago of the Advisory Board of Architects, with Mr. Hunt as Chairman. The landscape architects were made members of this board, and their general plan came up for critical review. Many suggestions for its amendment were made by the building architects, but in nearly all cases counter-suggestions were offered by others of them, and, the balances of advantages being weighed, the result was at length a cordial and unqualified approval of the plan as originally presented, and this was duly expressed by a resolution and report to the Commission.

The general plan was, however, afterwards modified in certain

CITY PARKS
AND IMPROVED
USE OF
METROPOLITAN
SPACES
192

particulars. These particulars were the abandonment of a proposed outer harbor for which the landing pier now seen was substituted: the introduction of the Peristyle, and of the Colonnade at the end of the south transept of the main court. All of these changes resulted from suggestions of the building architects, cordially welcomed by the landscape architects.

The general plan was later modified in one matter, to its great injury. Two of our firm had visited the last World's Fair in Paris while it was in preparation, under the guidance of its landscape architect. The third of our number, Mr. Codman, had passed several months in Paris, while the Fair was in progress. We all thought, and Mr. Codman was particularly strong in the conviction, that it was an unfortunate circumstance that visitors so generally entered the Paris Exposition at points and by ways not adapted either to give them a grand impression or to provide a convenient point of dispersal for systematic observation. This in Paris grew largely out of the situation of the Exposition. There was no similar difficulty in the Chicago situation and the very first step in our revision of the old park plan in adaptation to the requirements of the Fair was to fix upon a focal point of interest to be regarded as the centre of design, and to so place this centre that conveyances of all kinds, by land and by water, the railways and the boats, both those of the interior and those of the exterior, should conveniently discharge visitors into it and receive visitors from it. That it should thus be made a place of general exchange, a place for obtaining information and guidance, as well as a place of departures and returns, a spacious court was designed; the Administration Building was placed in this court; the buildings likely to be most frequented were placed so that they would open from it; the intramural railway was to have its principal station in it; the whole

interior water system was planned with a view to easy connection with and through it by the small boats.

All railways and all steamboats were to conveniently receive and discharge passengers through it. A union station was provided for with the latter object in view. We intended that the Administration Building which stands in this court, and this railway station should contain the principal provision of guides and wheel-chairs and the central office of a system of offices of "public comfort" to be in telephonic communication with it. We did all in our power to have this arrangement carried out. The failure to carry it out has added, in my opinion, to the cost of the Exposition and deducted much from its value. In reporting to you professionally, I have thought it necessary to say this, not in the least in a complaining way, but that it may go on record for the benefit of those who may have to deal hereafter with a similar problem. You will ask why we were unsuccessful? I do not fully know. I can only answer that our failure took the form of a failure of prolonged negotiations with the Illinois Central Railway.

At the period when the general plan was formed it was impossible to have building masses definitely in view except in the case of a few of the larger ones. Our instructions as to these were that a classification similar to that of the last Paris Exposition was to be contemplated, but that the buildings required under the classification would be a third larger than the corresponding buildings in Paris. We presumed that additional buildings would be wanted and that they would be of smaller but of varying size. For these presumed, but as yet undetermined, smaller buildings, we held three large spaces in reserve. First, for such as would be wanted for the livestock exhibits, an area at the south end; second, for the distinctive office and "headquarters" buildings of the National and State

CITY PARKS
AND IMPROVED
USE OF
METROPOLITAN
SPACES
194

Committees, an area at the north end; third, for miscellaneous exhibition buildings of a smaller class, the strip of land called the Midway. We calculated that restaurants would be established in the great Exposition buildings, and that the terraces of some of these buildings would be occupied to a considerable extent with refreshment tables and chairs, under awnings. We did not suppose that there would be many small buildings scattered about between the main great buildings, nor do I think that it was at the outset contemplated by those in direction that there would be. Afterwards they were seen to be financially desirable.

Also, it is to be noted that it was our original intention and that this intention was fully set forth, to have what has since been called the Wooded Island, occupying a central position, held free from buildings and from all objects that would prevent it from presenting, in connection with the adjoining waters, a broad space in contrast with the artificial grandeur and sumptuousness of the other parts of the scenery. After a time demands came for the use of the island for a great variety of purposes, and at length we became convinced that it would be impossible to successfully resist these demands. When we reluctantly reached this conclusion, the question with us was which of all the propositions urged, if adopted, will have the least obtrusive and disquieting result? Probably we were fortunate in securing the occupation of the island only by the temple and garden of the Japanese, and for the display of horticultural exhibits. Nevertheless, we consider that these introductions have much injured the island for the purpose which in our primary design it was intended to serve. If they could have been avoided, I am sure that the Exposition would have made a much more agreeable general impression on visitors of cultivated sensibility to the influence of scenery.

With regard to the subsequent occupation of ground by smaller

structures, especially such as are of the class called pavilions and concession buildings, many of these have been inserted without consulting us; places being often given them in which they intercepted vistas and disturbed spaces intended to serve for the relief of the eye from the too nearly constant demands upon attention of the Exposition buildings. As a caution to those who will manage the next affair of a similar class, it is best to record the opinion that the effect of these little structures among the larger has been bad. I can best show our judgment of it by saying that it had been our original intention to use on the grounds a great deal more of gardening decoration in various forms than we have. We had, at considerable expense, provided materials for the purpose, largely in the form of plants propagated and kept last winter under glass. But at last when the time approached for making the intended use of this material, the spaces of the Exposition grounds not occupied by the larger building masses and trees appeared to us to be everywhere already a great deal too much divided and disturbed by little features intended to be more or less of a decorative character. So much was this the case that, after consideration, and with reluctance, we concluded that our intended floral decorations would add so much disquiet to the already excessive disquiet of the scenery, and so detract from the effect of the more massive elements, that they must be abandoned.

One other modification of the original plan must be referred to. The administration at one time contemplated the introduction of a branch railway, by which Illinois Central trains would be taken from the Midway to the station upon the main court through the Fair ground. To give room for this branch road, we were required to change the position assigned to the Horticultural Building, reduce the breadth of the lagoon, and modify the outlines of the island. Afterwards the railway project was abandoned, but in the

CITY PARKS
AND IMPROVED
USE OF
METROPOLITAN
SPACES
196

meantime work had been done compelling adherence to the unfortunate revision of the shores. It will readily be seen that the cramping of the water at this point has been a considerable loss, and that, had the advances and recesses of the foliage masses opposite the Horticultural Building been much greater than they are, a more picturesque effect would have been obtained.

Montreal:
A Mountaintop Park and
Some Thoughts on
Art and Nature[24]

To the Owners of Mount Royal:

In 1874 you had bought this property and were wishing to begin its improvement. To do so prudently, you needed a fixed design and policy, and to forward this, I had the honor to be engaged to aid you, with the special duty of drafting a plan for laying out the ground.

It was presumed that my draft would be matured, discussed, and, if necessary, revised in time to serve as the basis of operations to be prosecuted the following summer; and I have no reason to doubt that I could easily have supplied a drawing in a few months, which would have been accepted as the fulfilment of my duty.

The matter, however, gave me a great deal of labor, and was a source of constant and increasing anxiety for nearly three years, and when, at last, under repeated urgings, I reluctantly reported the result, it was with the conviction that my work had, with reference to its principal object, been vainly expended.

Having a strong, abiding sense of its importance, I have not been able to acquit myself of accountability to you and your heirs, and have deferred a formal ending of my engagement, pending conditions less unfavorable than those of the late extreme hard times, to solicit a consideration from you for views which it will be my aim in this writing to commend.

I cannot but think that a certain dead weight of passive public opinion, which, rather than an actively intelligent resistance, I have seen to stand in their way, is partly to be attributed to an overlooking of certain aspects of the business which I have had a special duty to keep before me.

For example, I just now referred to your heirs, which to some

[24] Frederick Law Olmsted, *Mount Royal* (New York: G. P. Putman, 1881), pp. 1, 2, 16–17, 19–21, 26, 27, 29, 30, 32–35, 50–52, 58–64.

CITY PARKS
AND IMPROVED
USE OF
METROPOLITAN
SPACES
198

may have seemed superfluous; but with a little reflection it will be apparent that the property could not have been justly purchased with regard only for the profit to be got from it by a few thousands of the generation ordering it; and that I was bound, in suggesting a plan, to have in view the interests of those to inherit it as well as yours; and to bear in mind that, before the first planting of the plantations which I was to outline should reach their full growth, these inheritors would begin to be counted not by the thousand but by the million; and also to remember that, if civilization is not to move backward, they are to be much more alive than we are to certain qualities of value in the property which are to be saved or lost to them, as shall presently be determined. . . .

A Wall Street property was visited by a mining engineer who found capital pumping and hoisting works, efficiently operated; a shaft and gallery skillfully timbered; a busy tram, and, at the end of a long drift, miners hard at work. "But," said he, "I see no metal." "No, sir." "I see no vein." "No, sir." "I see no signs of a vein." "No, sir." "What are you working here for?" "Two dollars a day, sir." And his visit resulted in the abandonment of an enterprise lacking but one thing of perfect business management, — an adequate purpose.

Without constant reference to a fixed leading purpose, you can not spend a dollar on the mountain with any assurance that it is not wasted. If your leading purpose is trivial, or of but temporary consequence, you have already spent more than you can afford upon it. It is childish to go further. Every dollar you appropriate will be a dollar more of inexcusable extravagance.

To open discussion upon the question, What purpose is adequate to justify your purchase of the property, the outlay you have made, and any further outlay you may choose to make for better turning it to account? Suppose the following proposition were offered for

your consideration — a proposition I do not mean to sustain, but which, I doubt, will for a moment be very unsatisfactory to many of you to whom the business is new:

The value of this city property is to depend on the degree in which it shall be adapted to attract citizens to obtain needful exercise and cheerful mental occupation in the open air, with the result of better health and fitness in all respects for the trials and duties of life; with the result also, necessarily, of greater earning and tax-paying capacities, so that in the end the investment will be, in this respect, a commercially profitable one to the city. . . .

The first step toward a safe conclusion as to the general purpose to be had in view will be, in this, as it would in any other business, to determine what the situation puts economically out of the question.

Suppose that the owners of a vacant lot with a narrow frontage on an important business street were about to determine what to build upon it. These stated conditions of space, frontage, and situation would at once rule out two large classes of buildings: first, such as would be inadequate to the value of the ground — a cottage, for example; second, such as the ground would be inadequate to sustain, as a hotel, an iron foundry, or a theatre.

So, as to the site for a park. If a city has a large area of level prairie it can, without excluding or cramping provisions for other park purposes, provide great breadths of tranquil scenery with parade, lacrosse, cricket, archery, tennis, and croquet grounds, all in excellent fashion at small cost, the landscape motives, and others in which the whole community has a direct interest, harmonizing with the special motives of recreation of particular classes.*

But any attempt to form picturesque scenery through abrupt

* In the New York park the number of people who come to it in summer for special forms of recreation is not one in several hundred of those who come for walking, riding, driving, and the enjoyment of the scenery in a broad way, and this, I believe, is true of all well-ordered parks.

CITY PARKS
AND IMPROVED
USE OF
METROPOLITAN
SPACES
200

variations of surface, not to be puerile in its results, will be costly and to aim at having an outlook comparable with that you have already obtained on the mountain will be, if not impossible, ridiculously extravagant.*

Having chosen ground everywhere broken and with but scanty breadths of thin soil at any point between its rocks your case is the reverse. Economy begins with fixing upon a plan and a permanent policy in the business which looks to nothing which could be better accomplished at much less cost on less rugged ground. True, this restricts the value of your park. But consider the compensation: for example, in this one respect.

In parks at Liverpool, London, Paris, Milan, Genoa, and other cities, there is a good deal of rock brought with cost from a distance, or of artificial rock made of materials brought from a distance, set as facings to mounds laboriously built up so as to obtain scraps and ravellings of scenery which will seem, under the circumstances, to have a flavor of this same quality of ruggedness. The rock, in itself, is generally ugly; the mounds are hills suitable for a doll's plea-sure-ground, but, when aided by adequate vegetation skillfully selected and disposed, the comparatively insipid *picturesquishness* of the result is generally regarded by those who pay for the work as economically purchased.

Of raw material of this quality you have already on your ground a wealth beside which all that these older cities have accumulated is poverty. At slight cost you may soon obtain results of the same class beside which theirs will be backwoods makeshifts.

* "Every one knows how flat is the surface of Holland. Their parks may have plenty of still-water views, and grass, trees, and flowers all grow well there; but in Leyden they were determined to have a hill too. Great labor, no doubt, was spent, and enough sticky clay has been scooped out of the neighboring canals and piled up in the centre of their park to make a mound, perhaps twenty feet high." — Professor S. E. Baldwin.

/

I know that there is a prevalent notion that you must make the best of such opportunities as you find upon your site for purposes to which it is not generally well adapted, but you cannot build a policy on this basis *without bringing aims in which success can never be satisfactory into conflict with aims through which any adequate return for your total outlay must mainly come.*

In short, the conclusive objection to the entire tendency of management with which I am now contending, and the drift to which may perhaps be deeper and stronger and more insidious than you can readily realize, is that it favors a constant waste of what, if preserved, will unquestionably be, in the long future of the city, the two most important elements of value in this property. For, if you think of it, the reasoning out of which it grows, while allowing some value to natural objects of beauty (trees, for example) with reference to the purpose of air and exercise, first, wholly disregards the pervading charm of natural scenery (scenery in distinction from scenes) with reference to this purpose, and the result of pursuing it would, by the interposition of a variety of objects appealing to a different exercise of taste, greatly restrict if not wholly pervert such charm; then, second, it wholly leaves out of account an element of value much more important to be borne in mind than inducements to take air and exercise — more important because much less available to the city by other means than the improvement of the mountain — the *intrinsic* value of charming natural scenery.

That this last element of value in the mountain is one for practical consideration, that it is a matter of dollars and cents to you quite as much as air and exercise, I will show in the next chapter.

Here it remains to be affirmed that the opportunities and advantages for producing certain charms of natural scenery which you hold as yet *inert and unproductive* in the mountain, are such as are

CITY PARKS
AND IMPROVED
USE OF
METROPOLITAN
SPACES
202

possessed by no other city in any ground held for a public park. To allow it to be so used and dealt with as that these elements of value shall be lost, will be a scandalous extravagance.

Soon after you bought the property a friend of mine said to one of your citizens, whose experience should make his counsel valuable in your debates: "You are going to improve the mountain?" "No," was the reply; "we are going to spoil it." This gentleman may have had a greater degree of foresight in one respect than many of you. Possibly you would not have made your purchase if you had all as plainly seen that much of what made the property attractive to you depended upon the wildness and seclusion of its natural elements.

If it is to be cut up with roads and walks, spotted with shelters, and streaked with staircases; if it is to be strewn with lunch papers, beer bottles, sardine cans and paper collars; and if thousands of people are to seek their recreation upon it unrestrainedly, each according to his special tastes, it is likely to lose whatever of natural charm you first saw in it.

It is true, moreover, that when the mountain is suitably fitted for public use and traversed by gaily-dressed throngs of ladies and children, polished carriages, and highly groomed and caparisoned horses, that much of its original nature will appear comparatively rude, harsh, incongruous, and dreary.

What follows? Surely not that you should abandon your purpose; surely not that the more money you spend on improvements the less value for your purpose the mountain will have.

It follows only that all that you have seen and admired of the old work of nature must be considered as simply suggestive of what that is practicable, suitable, and harmonious with your purposes of large popular use, nature, wisely entreated, will give you in place of what must be abandoned.

You need to have new mountain ideals in view; ideals with more not less, of poetic charm; and your roads and other artificial constructions must be made with studied regard to that which you thus have before you, not to what you are necessarily putting behind. To accomplish this transition skilfully and gracefully requires, it must be admitted, an exercise of judgment and taste in a direction not often followed with commercial purposes; and it must be further admitted that if you secure this and yet cannot, as a community, find satisfaction in anticipating, forecasting, and watching the development of the new charm, and in seeing it gradually emerge from and overgrow the ruin of the old, then the gentleman I have quoted was in the right, and the policy was sound which I presume him to have since followed, of opposing every measure of pretended improvements upon the mountain as, in. truth, a measure for spoiling it. Indeed, no man should account himself a gentleman to whom any other course is not only repugnant, but in whom such measures do not stir up a disposition to something more than idle grumbling.

In short, it is not to be denied that you cheated yourselves when you bought the mountain for a park, unless you were prepared to have it managed on principles applicable to WORKS OF ART.

I have been urging you to regard the work to be done in your behalf on the mountain as primarily a work of art, and to insist that in this respect you shall have the fair value of what you pay for it.

I have used the term with some reluctance, because there is so much quacking and silly affectation afloat about art, that with many sensible people the simplest mention of it kindles prejudice. I know also that to speak of the work before you on the mountain as a work of art will again seem "unpractical," as looking to something above the heads of the people and opening channels of lavish expenditure.

CITY PARKS
AND IMPROVED
USE OF
METROPOLITAN
SPACES
204

I beg all who feel about it in this way to let me ask, first, are you sure that if you oppose art ever so much you are going to get on without it? Are you sure, that by a method which compels an off-hand, slapdash way of going to work you escape quackings and affectations? Is it not smart, shallow, Jack-of-all-trades art that is most of all contemptible to you? Can you despise or wish to put away art, of which the chief condition is a sincere, devoted, and devout application of judgment to the purpose upon which it is engaged?

Please reflect also whether it may not be a teaching of snobbishness and vulgarity against which every true man should rebel, that good art is above the heads of the common people. Those whom all accept as the highest authority regard the highest art to be that which was made for public places and for the use of all.

Psalms and hymns are works of art, and to this day, in the degree that they rank high or low in the scale of art, are they consoling and cheering to generation after generation of the poor and needy.

Among thousands of college-bred Scotchmen not one has shown as high poetic sensibility as the ploughboy Burns, and this sensibility is strongly exhibited in respect to the charm of natural scenery formed largely by art.

This may seem a contradiction of terms. It is not. When an artist puts a stick in the ground, and nature in time makes it a tree, art and nature are not to be seen apart in the result.

In verses called out by an enjoyment of a brawling stream under trees, the ploughboy begs for the planting of more trees, that the poetic charm by which he has been inspired may be deepened by art.

But, third, as to the economy of art. You know that the market-value of a literary work of art (the psalms of David, the novels of Scott, the idylls of Tennyson) does not depend on the amount of

paper and ink used in them; that a work of the painter's art is not valued by counting the cost of the canvas, pigments, and day's labor which has been spent on it, or a statue by the cost of the marble and its cutting. You know also that of the works of two men, given the same subject to draw, paint, or carve, one representing no more school-knowledge, industry, faithfulness, or hand-labor, only higher art, will sell at once for ten times as much as the other, and that this difference in market value instead of lessening will increase century after century.*

There is this, then, about good art; it is not, like bad art, to go out of fashion. Let your work upon the mountain be directed by sound art, and the older the results the more they will be valued; the oftener and more familiarly they are seen the more wholesome pleasure will be taken in them.

Again, then, in your choice of what to do, have some regard for your heirs.

An incident occurred in the early work upon the mountain which gave rise to some discussion in which a proposition was more or less definitely advanced or its soundness assumed, which may be thus stated:

"Suppose a road is to be made along a naturally wooded and otherwise attractive hillside, and it is an object to give those who pass over the road as much as practicable of the enjoyment of its natural scenery, then the simpler the means taken to obtain desirable courses and grades; the more strictly operations are confined to the space necessary to obtain them; and the less cutting and covering of the adjacent ground, the better. The highest art consists, un-

* The city of Amsterdam possesses a little picture, and I have seen laboring men smiling before it, of which it has been lately written that "it was sold in 1766 for 8,000 francs, and in 1808, for 35,000, and that certainly a cypher added to the last sum would not be sufficient to buy it now." — HOLLAND, by E. de Amicis. New York: Putnam's Sons.

CITY PARKS
AND IMPROVED
USE OF
METROPOLITAN
SPACES
206

der such circumstances, in making the least practicable disturbance
of nature; the highest refinement in a refined abstinence of effort;
in the least work, the most simple and the least fussy and potter-
ing."

To see the crudity of this dictum, consider first, what must neces-
sarily result from proceeding upon it, and, to make the principle
plainer, suppose that the hillside is a little steeper and a little more
perfectly furnished with old wood than was the case on the moun-
tain.

You lay out as an engineering affair what is the most direct, con-
venient, and economical route with reference to the purposes of
transportation. You begin construction by removing the trees in
the way of a road of the prescribed breadth. You then have two
broken lines of spindling trunks supporting sprawling limbs, which
sustain meager tufts of feeble foliage, not at all natural, for if the
opening had been a natural one, such as might have been caused,
for example, by a watercourse, or a long narrow outcrop of rock,
the trees would have grown beside it in a way much more effective
for your purpose; a much more beautiful way.

Next, to obtain a plane surface for your road, you break into the
slope of the mountain on one side, and bank out on the other. You
then have two steep, formal, unnatural banks, one above your
wheelway, the other below it. Next, as you will have cut off a
third of the roots of the trees growing above, and banked over a
third of the roots of those growing immediately below, and estab-
lished conditions favorable to a constant waste of the natural vege-
table mould, the change from the circumstances to which the
bordering trees are habituated in respect to moisture, food, frost,
and light, will lessen their vitality.

It may happen that in process of time, by the death of some of
them, the decay of their roots, and through the effect of freezing,

thawing, washing, and vegetable growth and decay, your banks will take natural forms more or less agreeable. Of the trees that do not soon die, some will sprout out in an eccentric new growth; suckers will be thrown out from the roots of others; and, here and there, young trees and bushes will grow up from seed in front of the old ones.

In this way the first rude aspect of your work will be partly obliterated, partly obscured, and a degree of natural charm obtained; if the circumstances are favorable it may even be accounted a high degree of charm. And yet it will have been folly, worse than the folly of gambling, to take your chance in this way of the value of the results, for, even with the same inconsiderate grades and courses for your wheel-way, you can shape the banks at once in such desirable forms as frost, and rain, and root growths might chance to give them after many years. You can do more. You can, by a little forecast, make them at one point bolder and more picturesque in contour by a fitting buttress of rock than nature, working alone, would be able to do. By inserting little pockets of leaf-mould about this rock, and proper seeds or plants, you can then prevail upon nature to dress it with characteristic mountain forms of foliage and bloom, more interesting than nature would, in a century, otherwise provide. You can put in the way of immediate growth behind this rock a broad dark mass of low mountain pine, or a pensive, feathery and brooding hemlock, educated to a character which nature, left alone, gives to one of its species in a thousand, to supply the degree of canopy and shadow which will be most effective for your purpose. And, this being done, you are finally relieved of the nuisance and expense which the natural washing down of your abrupt bank would have otherwise entailed.

Then, at another point, you can cut back on the crest of your bank and make it gentle and graceful, with long double curves of

CITY PARKS
AND IMPROVED
USE OF
METROPOLITAN
SPACES
208

the surface, dressed with low, soft verdure and decked with modest wild flowers.

You can cut out the feebler and uglier of the old trees (their ugliness is due in many cases to the falling of others upon them and other unhappy accidents); shorten in the tops of others more promising, but which have been strained upward in feeble forms to avoid suffocation in the crowd. You can enrich the soil and induce a lower growth upon them; and you can everywhere plant at once such trees, shrubs, and herbage as will best harmonize with what you select to stay of this old wood, and best carry out, grace, and enrich the necessary inanimate detail of the immediate road border.

Thus, you can rapidly establish a new face to the wood which will in truth be equally natural in aspect, and, whether regarded as the foreground of a distant view or looked at closely for its local beauty, far more charming than the best that nature, *unencouraged,* would much more slowly give you.

Why is it more irrational to thus sympathetically cooperate with nature for the end which you have in view in your use of this property, than for that of raising apples, corn, or buckwheat, where nature, left to herself, would not provide them?

And yet the process I have here imagined, of laying out a road, determining its courses and grades with no regard to scenery, and then adapting scenery to them, is by no means a completely rational or economical one.

Second, then, sound art, following sound sense and sound economy, will require, at the first step, and at every step afterward, a forecast of the best attainable ultimate results, and in view of them will waive a little of directness here, a little of grade there, so as to spare an interesting group of trees, or a bold rock, and place them at such a distance from, and in such relation of elevation to, the eye

of those passing on the road, as to enhance their value. Sound sense and economy will make a similar concession in view of the poverty of some broad, flat, uninteresting body of rock; bending the road slightly from its direct course, or carrying it up a little more rapidly with a view either of putting the rock out of sight under the road, or of leaving sufficient beds of soil for the growth of plantations to cover it.

This, then, is the precept which a more mature study of art would have reached. A road must be located not alone with reference to economy of construction in respect to convenience of passage from one point to another, but with reference to *economy in the ultimate development of resources of poetic charm of scenery;* and these resources must be considered comprehensively and interactingly with reference to the entire property.

This is not simply a requirement of art over and above the requirements of mere engineering, but, as with reference to the manner in which the first road-making on the mountain was done differently from that I had provided for, is a requirement of sound in distinction from unsound art; of good art over bad. Those who urge the rejection of the good and the adoption of the bad, under the impression that something is to be thus gained in economy, are the real spendthrifts and prodigals. And the principle, thus illustrated, applies to every thing to be done — quite as much, for instance, to walks, staircases, seats, shelters, shades (and shade trees), to gutters, gratings, drinking fountains, and horse-watering-places, as to wheel-ways; most of all to any necessary buildings.

One of the most inconsiderately wasteful ways of spending money on the mountain to which you are liable to be tempted, is that of the introduction upon it of flower-beds, clumps of flowering shrubs, cushions of rhododendrons or azaleas, schools of roses — possibly ribband-gardening, floral embroidery, sub-tropical bor-

CITY PARKS
AND IMPROVED
USE OF
METROPOLITAN
SPACES
210

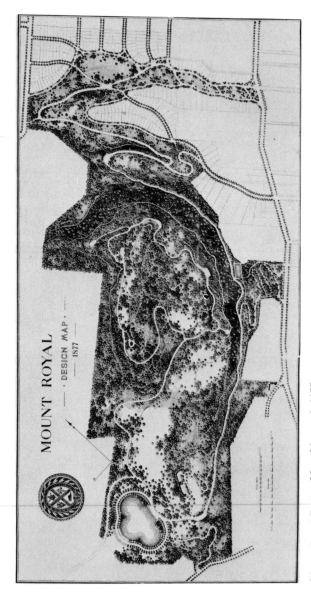

Mount Royal Design Map, Montreal, 1877.

ders, and whatever is commonly found on a polished lawn of the present fashion in lawns, in a place furnished with propagating houses and wintering pits, and given over to a fashionable gardener.

The delusion that these things may be of the required proper furniture of a public park, as they more or less may be of a luxurious private residence, of a botanic garden, or an urban promenade, is the more to be guarded against, because culpable neglect of the permanent and substantial business of the undertaking can be so readily glossed over by means of them, and the question will often be pressed, Why should the taste that they gratify not be catered to?

It should not, because the result would be an adulteration and counteraction of the wholesome influence of the appropriate scenery of the mountain, which alone supplies a sound justification for any of the outlay to be made on it, and the management which resorts to it will be tearing down with one hand what it builds up with the other.*

But does it follow that you can have none of the refinement of grace, delicacy, color, and incense which is supplied by flowering plants? By no means. There can be no greater mistake than to suppose either that dug beds or borders and garden primness are necessary to this end, or that it is inconsistent with mountain character.

I once stood at an elevation seventeen times higher than Mount Royal; great fields of snow below, and, in a general view, nothing to be seen for hundreds of acres about me but shapeless fragments of rock; yet casting the eye downward, everywhere, even in the darkest shadows, there were gleams of color; and, upon looking closely, there was, in every slightest shelter, a most exquisite bloom and verdure.

What, then, is not practicable that you can reasonably wish to

* "Few human beings have contravened nature's laws more than our flower-gardeners."
— Robinson. *The Sub-tropical Garden*. London, Murray.

CITY PARKS
AND IMPROVED
USE OF
METROPOLITAN
SPACES
212

have of floral wealth in your little mountain, clear of snow as it is for more than half the year, and with a climate which, on its sunny side at least, is not found inhospitable to more than one of the trees which grow naturally in association with the fig and the olive?

Let it be borne always in mind that your mountain of less than a thousand feet of elevation is royal only by courtesy, and that if you attempt to deal with it as if it had the impregnable majesty of an alpine monarch, you only make it ridiculous.

Be assured that if you will keep but one good honest man intelligently at work for the purpose, you may in five years find upon it charming refinements of mountain beauty, refinements which will be thoroughly appropriate and add incalculably to its value.*

I will go further, and tell you that if you cannot afford to keep a single man so employed, there are hundreds of little places on the mountain within which, if you can but persuade yourselves to regard them as sacred places and save them from sacrilegious hands and feet, the original Gardener of Eden will delight your eyes with little pictures within greater pictures of indescribable loveliness. And remember that it is the lilies of the field, not the lilies of the garden we are bid to consider.

Such beauty as is thus available, will make no amends for rudeness, coarseness, and vulgarity in the borders of your roads and walks; it will but make what is crude and unnatural the more conspicuous, as a jewel set upon soiled linen makes it the more offensive. But when you have natural homes for it, especially with much and rapid inflections of surface, as in the little rocky notches and gaps, dinglets and runlets of the Brackenfell, you need not be

* Read upon this I beg, simply as giving hints as to how much can be done with little effort. Mr. Robinson's two little books: one upon "Wild Gardening," the other upon "Alpine Flowers" (London, Murray, 1870). The very best things for your purpose are such as, once established and a little guarded, will take care of themselves, propagate and spread, like our common American wild flowers.

afraid of too great a profusion nor too great a variety of perennial and annual plants; of too much color, nor of a growth too intricate and mazy.

This is not the most difficult form of refinement for you to gain; indeed, it is so easy, so cheap, that when I was last on the mountain I found many places where no small degree of it already existed, and places, too, which, when I had first studied them in 1874, appeared rude, raw, and barren. To what did you owe this improvement? To any digging and bedding; raking, sowing or weeding of a florist? Not at all, but simply and solely to the fact, as far as I could judge, that before that time cattle had been ranging over the ground, and afterward it had been protected from them.

But remember that there is nothing to prevent a hundred men from trampling over one of these spots tomorrow and making a complete wreck of it, destroying not only the plants but the conditions of their reproduction. . . .

Among properties of its class your mountain possesses one marked advantage over all others. I mean that of noble landscapes extending far beyond its borders. These are of such extent and so composed, and their foregrounds within the property are to be so easily adapted to increase their value; their interest is so varied according to the direction of the outlook and the passing effects of clouds and atmospheric conditions, that it is not only impossible to speak of them in adequate terms of admiration, but, trying to take a business estimate of them, and seeking standards of comparison for the purpose, it will be found that the best that other communities have been able to obtain by expenditures counting in millions of dollars, is really too insignificant to be available for the purpose.

And yet, trying still to take a business view of them, simply as an element in the general value of the mountain as a city property,

CITY PARKS
AND IMPROVED
USE OF
METROPOLITAN
SPACES
214

it may possibly come about that you would be richer without them. I say this because among the currents of public opinion of which I had some experience with you, there was a certain spendthrift tendency to slight every element of value in the property except that of the great views. There were those who would have thought it a triumph of art to whisk people up to the highest eminence of the mountain, give them a big mouthful of landscape beauty, and slide them back to town in the shortest possible way; and there were, even before I was consulted, speculations afoot for doing something of the kind at so much a head.

It might be to some a question whether the most valuable influence of properties of this class is to be found in such distinct sensational features, even though provided by nature, as are commonly most consciously felt, talked about, and written about, or in more unobtrusive, pervading, home-like qualities of which the effects come to one less in a torrent-like way, than as the gentle, persuasive dew, falling so softly as to be imperceptible, and yet delightfully reinvigorating in its results. Even this might be to some a question; but let any man ask himself whether the value of such views as the grandest the mountain offers, is greater when they are made distinct spectacles or when they are enjoyed as successive incidents of a sustained landscape poem, to each of which the mind is gradually and sweetly led up, and from which it is gradually and sweetly led away, so that they become a part of a consistent experience, — let him ask this with reference to the soothing and refreshment of a town-strained human organization, and he will not need argument to lead him to a sound conclusion.

But as you have the one thing and as yet have not the other, except in a very crude and imperfect form, disturbed throughout with blotches, it may be worth while to try, if ever so poorly, to suggest what would rule a wise economy. (Would that a literary artist would undertake the duty.)

It is not the stronger but the weaker links of a chain that you must consider in determining what strain you will put upon it. Fit your work on the mountain to over-weighted nervous conditions and you may be sure that it will suit the robust and light-hearted.

On this principle it is better in dealing with it to cultivate the habit of thoughtful attention to the feebler sort of folk — of asking, for instance, can this or that be made easier and more grateful to an old woman or a sick child, without, on the whole, additional expense, except in thoughtfulness? If so, ten to one, the little improvement will simply be that refinement of judgment which is the larger part of the difference between good and poor art, and the enjoyment of every man will be increased by it, though he may not know just how.

With this idea in mind think over what you would like to be able to do if you were much concerned about the health of a father, brother, or son whose private business cares you saw to be wearing upon him to a point of danger; who was growing morbidly irritable and despondent, or, what is quite as bad, morbidly sanguine and reckless. Or again, take the case of a woman recovering with tedious slowness from a severe illness, still weak, low in spirits, and under obvious nervous prostration. Take cases such as these, that you never have to go far to find, and ask what of all practicable ways of turning the mountain to business account for their benefit a reasonably refined common-sense would lead you to adopt?

Would you, if you could take the man from his counting-room, the woman from her sick-room, and plant them both as quickly and abruptly as possible before the finest view on the mountain, keep them there till they tired of it, and then send them straightway back again?

Let us try to imagine a better way.

First, then, taking our friends in a carriage, we should find, under wise arrangements, that without going far we could turn into

CITY PARKS
AND IMPROVED
USE OF
METROPOLITAN
SPACES
216

a road leading toward the mountain, by which noisy and jolting pavements would be escaped. In this road there would be no heavy grades to overcome; no street railways to be avoided; no funeral processions to be passed; but the carriage, moving at a steady pace, and with the least occasion to awaken sadness, irritation, anxiety, or impatience, would, in a few moments, have slipped easily out of town, and be passing along a shady, soft, and quiet suburban street, like a village highroad.

This would be lined on one side with cottages, before which trees would be rapidly falling out of lines into groups and spreading from groups into groves. The village would be divided by a pretty open green with a quietly undulating surface, skirting which our road would bend away to avoid too steep a course. Then, getting more and more out of town, it would wind along with gentle curves as the movement of the ground and the openings among the trees should invite. (This may be the Côte Placide of my plan.)

At a fork of the ways the last of the village houses would be passed, the surface grow more diversified, stretches of pasture land would open on both sides, and bits of stony ground appear. Presently there would be a rocky bank in a dark shade of hemlocks, its base lost in a thicket of brambles, brake, goldenrod, Solomon's-seal, and fringed gentian; preluding the mountain. Then moving along easily higher and higher, the ground would become more rocky, the herbage more tufty, till, at a turn in the road, views through the trees would open: on one side, of distant steeples over houses and gardens; on the other, of a stretch of woodland. (This from the Piedmont.)

Then, going on, the prospect on each side would be more confined, but by glimpses between the trees we should be aware that not far away to the left there was a great picturesque declivity shadowed by hanging woods. Before our attention had been fully

fixed in the direction, it would be drawn off by a broad gap among the trees to the right, and we should find that we had already attained a sufficient elevation to command a far view to the northwest. The carriage would stop, and we should look upon a broad country-side with woods and fields, orchards and gardens, farmhouses and village spires, all sloping gently from distant blue hills down to a stream hidden among the trees of the intervening dale. (A peaceful, soothing prospect, this may be cheaply made, in which, though accessible in twenty minutes from the post office, and at a third the cost of a visit to the heights, the town may be left far out of sight and further out of mind.)

If it is the first airing of the convalescent here might well be the end of her day's journey. There would be a little inn near by at which she could rest, or from which she would perhaps be served with warm milk or tea; after which, varying the return road, within an hour from the time of starting, she would be back again in her armchair.

But going on after a few minutes' halt the scenery would become wilder and more forest-like, and as the road, winding where spurs of the ledge, and heaps of fallen rock, and old water-ways gave opportunity, led higher and higher, but always by easy grades, and, without apparent effort, following a course invited by nature, the trees would stand closer and the roadsides be crowded by underwood. Between and beneath overhanging foliage, glimpses would be caught, on the right, of the near crag-side decked with dark bushy evergreens and draped with creepers, mosses, and blooming alpine plants; on the other hand, out of deep shade, through chance loopholes of the verdant screen, of a distant gleaming river and a sunny expanse beyond it.

The crags passed, the underwood becoming more scattered, the wood more open, the road would now lead along a mountain slope

CITY PARKS
AND IMPROVED
USE OF
METROPOLITAN
SPACES
218

of constantly gaining quietness, with gleams of sunlight falling upon ferny dells, until again, the tree tops opening to the right and left, the carriage would stop, and over a rapidly declining, bosky surface another outlook would be gained, revealing a lake-like expanse of water lying in a broad valley stretching far away to a faint horizon, beyond which the evening mists would be gathering to receive the declining sun.

After this, the road would presently lead out upon a broad highland valley, all its soft features bathed in sunshine unbroken by foliage. From its wooded borders would rise rocky and fir-crested steeps, but crossing the space between them and following near the edge of the northern woods, we should be led, by quiet curves and with an easy ascent, to a position from which having now so long left the city, it would be looked down upon from the brink of a woody cliff. High above its roofs, beyond the harbor with its stately ships, a great champaign would open, broken by a few noble hills, and beyond all, the distant billows of the Adirondacks.

Turning back from this scene which, were it not familiar, might as yet be too strong for our purpose, it would be a relief to course along the edge of woods in which, while the surface is rough and the trees tell the story of much harder exposure than those we have seen below, there are pleasant sheltered and sunny openings in which groups of children will be at play.

Still rising, the road will then lead with more rapid turns along the face of a steeper slope till, wheeling upon the depression of a narrow spur, a northern outlook is gained, with the lower valley of the great river spreading before the eye; that lovely view to which I have before referred.

At the next move, steeper and wilder declivities would be skirted, and the foreground show yet more evidence of elevation and the severity of its winter in the aspects of the rocks and the picturesque

character of the vegetation, until with a final rapid turn the carriage would stop at the open porch of a timber-built hospice, so situated upon the highest rock of the mountain that from chairs on its wide galleries the nearest thing to be seen would, on all sides, be a broad mass of tree-top foliage, sloping quietly away in simple undulations of light and shade to a rounded edge distinctly defined against a much lower and more remote middle distance.

Looking over this deep foreground of forest, we should now have before us more extended views in all directions than we had had before in any. Did they offer nothing for our enjoyment but a rolling surface of grass or an endless prospect of desert sand, with only sky and clouds to relieve its monotony of color, the effect would be irresistible. As it is, what element of interest could be added without crowding? What new object of beauty without disturbance? Yet, gradually led up to it from the streets, as I have supposed our friends to be, so that it comes in natural and consistent sequence of the entire preceding experience, the impression could but carry to a still higher point the restful, soothing, and refreshing influence of the entire work.

I deplore my inability to present the purpose which good management of this property would have exclusively before it, in a manner more worthy than that of this scrappy memorandum of what might be offered even to a poor invalid taken up the mountain in a carriage. But in truth, the heart of the argument lies in something which it would be beyond the power of even a gifted writer to represent, and to which not the greatest of landscape painters could nearly do justice.

Yet if you have kindly let your imagination aid me you can hardly fail to see wherein the advantage of the property lies, not simply in the direction in which I have been pointing, as a sanitary influence, but also as an educative and civilizing agency, standing

CITY PARKS
AND IMPROVED
USE OF
METROPOLITAN
SPACES
220

in winning competition against the sordid and corrupting tempta-
tions of the town. You can hardly fail to realize how much greater
wealth it thus places within your reach than is to be found in the
ordinary parks and gardens, not to say the museums and galleries,
which are the pride of other cities, and which millions have been
thriftily expended to obtain. Nor can you fail to recognize that
what remains for your securing of this wealth is not any towering
constructions, princely expenditure, or heavy addition to your
taxation, but simply moderate ability, though of a special kind,
continuously directed in a modest and frugal way by a suitable, sin-
cere, consistent purpose. A purpose in which there shall be no mix-
ture, for instance, of the motives proper to a circus or a variety
show, to military parades or agricultural fairs, to race-courses or
cemeteries. An intelligent purpose to bring out the latent loveliness
of mountain beauty, which you have bought with the property, in
such manner as shall make it of the highest distinctive value. Think-
ing over all that I have advised to be done as an affair of years,
take the largest estimate of the cost and trouble of securing what is
necessary to it that you can; all I ask is that you think out also what
will become of the property, what will be spent and what will be
lost, if it shall continue long to be managed with no more distinct
purpose, upon no more firmly defined principles of economy, with
no sharper limits to the enterprise of successive councils and com-
missioners (leaping from the ranks to the supreme command of it)
than economy has thus far been held to require.

Boston: Parks and
Parkways — a Green Ribbon[25]

CHARLES H. DALTON, ESQ., CHAIRMAN OF THE PARK COMMISSION:
Sir,
 The Park system for Boston, advised by your Commission, though of smaller area than that of many other cities, differs from all others in the scope of its landscape design; and this is, in part, due to topographical opportunities possessed by Boston, which, for the purpose in view, are probably unrivalled.
 On the other hand, as my counsel has heretofore been asked by several other cities, when engaged with municipal problems of the same general class as that of which your proposed system is offered as a solution, it will not, I trust, be thought beyond my duty if I point to a circumstance which appears to me to be operating as yet not a little to the disadvantage of Boston.
 It is that the Boston of today is largely made up of what were formerly a number of distinct local communities, each habituated to regard its public affairs from an independent point of view, and sometimes in a spirit of competition and jealousy toward the others. The larger part of Boston, territorially considered, has till lately been so divided. Possibly, also, the marked topographical divisions of the old city induced separate local interests in an unusual degree.
 There is now a habit of looking upon the proposed parks of the city, each apart and independently of its relations to others of the system, as if it were to be of little value except to the people of the districts adjoining it. And this habit is so much evinced by intelligent and generally well-informed citizens that it must be supposed to be an inheritance from those older conditions. It presents a difficulty which should be contended with; for, unquestionably, if it is maintained and allowed influence in legislation, it will be likely to

[25] Frederick Law Olmsted, "Seventh Annual Report of the Board of Commissioners of the Department of Parks for the City of Boston for the year 1881," City Document No. 16, 1882, pp. 24–28.

CITY PARKS
AND IMPROVED
USE OF
METROPOLITAN
SPACES
222

nullify half the value to the city of the properties now proposed to be acquired for parks.

For example, a site has been selected at West Roxbury for a large park, because of the topographical advantages for a paticular class of park purposes which nature has there provided. It is not uncommon to hear it referred to as if it were to be a special property of the West Roxbury community, and its chief value lie in what that community would gain from it. If this were just, the project would not be worthy of a moment's consideration. Moreover, if it were to be adopted and carried out in this limited spirit at the cost of the city, the people of the locality would not gain those advantages from it that a wiser policy would have in view for them.

A site for a park to stand by itself and be little used except by those living near it should be a very different one from that for a park designed for more general use, and especially for a park which is to stand as one of a series. In the latter case the fitness of a site will largely be found in its adaptation to supply some form of park refreshment that others of the series are ill-adapted to supply or are naturally excluded from supplying. The qualities of a park which the West Roxbury site offers in generous measure at very moderate cost, could not, for example, be gained in a tenth part of that measure at ten times the cost on the proposed park-site near Chestnut Hill, — "Brighton Park," — or on any other which the city has had under consideration. But the converse is equally true; the Brighton site offers features of great interest, ready made, which could not be as well provided in the West Roxbury tract by an outlay in millions. Moreover, the attempt to introduce the more valuable qualities to be thus found at Brighton in the midst of those to be found at Roxbury, would be destructive of the latter, and any expense incurred for the purpose in behalf of the city would be

much worse than wasted. In one word, the aim of design under the policy of the city which your Commission has been so long trying to establish, can only wisely be to develop qualities in each locality which will give it a more distinctive and grateful interest because of the development of quite other distinctive qualities elsewhere.

The accompanying map shows a series of sites which are now under consideration by the city government, and which your Commission has been authorized to purchase — if it shall be found possible to do so within fixed limits of price — together with the connections which are contemplated between them and by which they would, should the scheme be carried out, be tied to existing city properties.

It will be obvious at a glance, to any one having a superficial knowledge of the several localities named upon the map, that, if due advantage is taken of the distinctive capabilities of each and due respect paid to the distinctive limitations of each, the results to all concerned, of whatever part of the city resident, will be incomparably more interesting and valuable than they can possibly be under a policy such as seems to be commonly entertained of regarding each proposed park and parklet as an independent affair, deriving no interest from its relation to others, and imparting nothing of value to the interest of others.

Regarding the natural opportunities and limitations of the several localities to be named below, it will be found that each will, through a judicious method of improvement, be adapted to induce a distinct impression; and that, in each, the space to be applied to this impression is sufficient for the purpose, yet none too large to accomplish it with a determined avoidance of peep-show and theatrically scenic effects. While, except at West Roxbury, which is the one ground in the entire series to be with strict propriety called a park, the spaces to be taken are nowhere to be broad, the impres-

CITY PARKS
AND IMPROVED
USE OF
METROPOLITAN
SPACES
224

sions which under judicious designing will be had in view are such as may be obtained within the limited scopes proposed.

The following is a memorandum which may suggest to any one looking at the map one or two of the more distinctive landscape qualities of the several locations mentioned, the note being in each case of the briefest, and intended only to give a slight lead to the imagination:

MEMORANDUM

The Common, Public Garden, and Commonwealth Ave. — Turf, trees, water, and other natural objects unnaturally arranged, but not in the main unpleasingly in consideration of the stately rows of buildings and other architectural and artificial objects with which they must stand associated, and the necessary thoroughfares passing among them.

Charles River Embankment. — Broad bay and river views with a rus-urban background seen from a stately promenade.

Back Bay. — Scenery of a winding, brackish creek, within wooded banks; gaining interest from the meandering course of the water; numerous points and coves softened in their outlines by thickets and with much delicate variety in tone and color through varied, and, in landscape art, novel, forms of perennial and herbaceous growths, the picturesque elements emphasized by a few necessary structures, strong but unobtrusive.

Muddy River. — The natural sequence upon slightly higher ground to the last in following up a fresh-water course bordered by passages of rushy meadow and varied slopes from the adjoining upland; trees in groups, diversified by thickets and open glades.

Upper Valley of Muddy River. — A chain of picturesque fresh-water ponds, alternating with attractive natural groves and meads, the uppermost of these ponds being —

Photo. Pamela Bruns

CITY PARKS
AND IMPROVED
USE OF
METROPOLITAN
SPACES
226

Jamaica Pond, — a natural sheet of water, with quiet, graceful shores, rear banks of varied elevation and contour, for the most part shaded by a fine natural forest-growth to be brought out over-hangingly, darkening the water's edge and favoring great beauty in reflections and flickering half-lights. At conspicuous points numerous well-grown pines, happily massed, and picturesquely disposed.

The Arboretum. — (Independently of its imposed features.) Rocky hill-sides, partly wooded with numerous great trees, and a hanging-wood of hemlocks of great beauty. Eminences commanding distant prospects, in one direction seaward over the city, in the other across a charming country-side to blue distant hills.

West Roxbury Park. — Complete escape from the town. Open country. Pastoral scenery. A lovely dale gently winding between low wooded slopes, giving a broad expanse of unbroken turf, lost in the distance under scattered trees.

To the above, as constituent features of the sylvan system of Boston, as had in view by your Commission, are to be added two pieces of ground not shown in the present map; one commanding a close view of the lower harbor, and a distant outlook over the ocean; the other having grandeur of rocks with extraordinary beauty of form and tinting, and such interest of forest wildness as might be looked for in the midst of unpeopled mountains.

The above hint as to what may be ultimately hoped to result from the improvements in progress on the Back Bay, looks in a direction so diverse from that formerly entertained, and which seems still to be adhered to by many, that it will be right again to briefly characterize that undertaking, at present more prominently before the public than any other of the series.

The leading and only justifying purpose of the Back Bay Improvement, under the present design, is the abatement of a compli-

cated nuisance, threatening soon to be a deadly peril to the whole city as a propagating and breeding-ground of pestilential epidemics. A second purpose is the reconciliation of convenient means of general public communication through the adjoining districts of the city with the means taken to accomplish the first purpose. A third purpose is the dressing and embellishment of the banks, basins, bridges, and causeways, requisite under the first and second, suitably to the relation in which they will stand to the adjoining streets, and the improvements which it is the interest of the city that private enterprise should be encouraged to make upon them. A fourth purpose is to thriftily turn to account whatever shall be found requisite under the first, second, and third, as a distinctive incident, element, and feature in a general scheme of sylvan improvement for the city, looking to the development of local variety harmonizing in one comprehensive design. It may be observed that the continued application of the term *park* to an undertaking of the character thus indicated tends to perpetuate an unfortunate delusion, and to invite unjust expectations and criticisms.

A like fourfold purpose has controlled the selection of ground and the plan, as shown on the map, of the projected Muddy River Improvement. In general design, these two sections of the park system are one, the only division between the two being a concealed bar, which, in the Muddy River section, will permit fresh-water vegetation to be used along the water sides.

Respectfully submitted,
Frederick Law Olmsted,
Landscape Architect Advisory.

CITY PARKS
AND IMPROVED
USE OF
METROPOLITAN
SPACES
228

To the Commissioner of Parks:

Gentlemen, —

In a plan which I had the honor, in conjunction with the City Engineer, to submit to you a year ago, the drainage difficulties of Back Bay were proposed to be met by forming a part of it into a basin in which water would, under ordinary circumstances, be maintained at a nearly uniform level, but in which, when an unusually high tide would for a few hours prevent outflow, a larger amount could be harmlessly stored. Public roads were to be laid out around and across this basin, and its banks to be planted, and otherwise treated picturesquely.

The plan was adopted, and with the concurrence of the City Council work is now advancing under it. In presenting it last January to the Council, you pointed out that while its scope was limited to that part of the Back Bay which had some years before been placed in your charge with a view to a public park, the evils which it was designed to meet would still remain to be dealt with in that arm of the bay known as Muddy River.

The question has since been raised whether the best plan for this purpose might not be found in extending a corresponding arm of the Back Bay basin to the head of tide-water in Muddy River, and the present report is designed to present this suggestion (as far as practicable in advance of surveys and mature study) in a form to invite preliminary discussion.

The tidal part of Muddy River above the basin now under construction has the usual character of a salt creek winding through a valley, the marshy surface of which, lying from fifteen to twenty feet below the general level of the adjoining uplands, is partially submerged at extreme high-water. The tide ordinarily flows to a point about a mile above the basin. Streets have been laid out upon

26 Frederick Law Olmsted, "Suggestions for the Improvement of the Muddy River," "Sixth Annual Report of the Board of Commissioners of the Department of Parks for the City of Boston for the year 1880," City Document No. 12, 1881, pp. 13–16.

the uplands upon no continuous system; those of each side inde-
pendently, and regardless of what may be eventually required in
the low lands; the leading motive being to make small bodies of
land immediately available, at little cost, for suburban residences.
The city is rapidly advancing in compact blocks towards the region,
and public convenience will, before many years, require a more
comprehensive treatment of it.

It usually happens when a town is building up on both sides of
a small water-course and valley that the sanitary and other disad-
vantages of the low ground prevent it from being much occupied,
except in a way damaging to the value of the adjoining properties.
In process of time the stream and valley and the uses to which they
are put, come to be regarded as a nuisance; and radical measures,
such as the construction of a great underground channel, and the
filling up of the valley, are urged as the only adequate remedy. The
cost of these, and the local disturbance they make, excite opposition
to them; their complete beneficial operation is long delayed, and the
character of the district becomes so strongly fixed before this
period is reached that it can only be partially changed. Though
necessary, therefore, to public health and to convenience of general
transit through the district the result in the increased tax-bearing
capacity of the locality is no compensation for the required outlay.

As an alternative to such a possible course the policy now sug-
gested for Muddy River would look to the preservation of the
present channel with certain modifications and improvements
adapted to make it permanently attractive and wholesome, and an
element of constantly increasing advantage to the neighborhood.
Except where the valley is now narrowest, it would be reduced in
width by artificial banks, so that the river with its shores would
everywhere have a general character, resembling that which it now
has near Longwood bridge, only that its water would be kept at
a nearly uniform level, and guarded from defilement by intercept-

CITY PARKS
AND IMPROVED
USE OF
METROPOLITAN
SPACES
230

ing sewers and otherwise. The Brookline margin would be the broadened base of the present railroad embankment, bearing a woody thicket. The opposite or Boston bank would have an elevation above the water of ten feet, rising where the natural bank is used to twenty feet. Upon this would be laid out a public way ninety feet wide in continuation of that now forming upon the Back Bay basin; divided like that into foot, carriage, and saddle courses, and designed to serve as a public promenade along the river bank, as well as a trunk line giving an element of continuity to the street system of the neighborhood.

It is proposed that this park-way should be continued along the small water-course above and through the valley to Jamaica Pond, which would add another mile to its length. There are three smaller ponds near the head of the valley, which would thus be skirted, and below them a large marsh, which, though formerly reached by the tide, is now a fresh-water swamp, and cannot long remain in its present condition without great peril to the health and life of the increasing population of the adjoining parts, both of Boston and Brookline. Physicians practising in the neighborhood believe it to have been already the source of serious epidemics.

The supply of water to it from local springs is supposed to be large enough to maintain a pond to be formed by a dam at the lower end, by which it would be changed from a foul and noisome to a pleasing and healthful circumstance. The property is of little value speculatively, and of none otherwise, and the improvement thus projected would be neither difficult nor costly. If the fresh-water supply should finally be thought insufficient for the purpose, it would be possible to extend the salt-water basin to cover the ground. The swamp-soil excavated would be of value for covering the slopes below, and the operation would not be costly.

Adopting either expedient, the result would be a chain of pleas-

ant waters, including the four closely adjoining ponds above the swamp, extending from the "mill-dam" on Beacon Street to the far end of Jamaica Pond, all of natural and in some degree picturesque outline, with banks wooded and easily to be furnished with verdure and foliage throughout. Except at one point where there are about a dozen cheaply-built wooden dwellings and shops, the whole would be formed on land of little value, occupied by no buildings, and for no productive purposes, and all of it now in a condition hazardous to public health.

Such a chain of waters, even if connected and having a sweeping current, always becomes objectionable in a town, when streets are so laid out that its immediate borders are private property, or have private properties backing upon them. In such case it is found necessary to give it the character of a canal, to wall its banks with masonry, and, if the water supply greatly fluctuates, to take other measures to prevent its becoming a nuisance. At the best it is an eyesore. But if uniformly filled, its banks made comely, and kept neatly, in the usual manner of public parks, and if no private property is allowed to abut upon them, any natural water-course will be attractive and wholesome.

On the other hand, private property looking upon the park-way would at small cost be well drained; there would be nothing objectionable in its rear but in general a pleasant neighborhood, already formed, and, as it would lie midway between an attractive urban and an an attractive suburban residence district, agreeably connected, there would be no doubt as to its ultimate character, or that it would be rapidly taken up for dwellings of a superior class. This prospect would have an immediate favorable influence on adjoining properties, and the entire operation would be attended by an advance of market and taxable values securing the city a rapid return for its outlay.

CITY PARKS
AND IMPROVED
USE OF
METROPOLITAN
SPACES
232

Photo. Pamela Bruns

The indirect course of the park-way, following the river bank, would prevent its being much used for purposes of heavy transportation. It would thus, without offensive exclusiveness or special police regulation, be left free to be used as a pleasure route.

The Brookline Branch Railroad and the drive of the parkway, where they come nearest together, would be 200 feet apart, and there would be a double screen of foliage between them.

Taken in connection with the mall upon Commonwealth Avenue, the Public Garden and the Common, the park-way would complete a pleasure-route from the heart of the city a distance of six miles into its suburbs. These older pleasure-grounds, while continuing to serve equally well all their present purposes, would, by becoming part of an extended system, acquire increased importance and value. They would have a larger use, be more effective as appliances for public health, and every dollar expended for their maintenance would return a larger dividend.

The scheme offers hardly less advantage to Brookline than to Boston, and a plan of equitable cooperation in carrying it out is probably feasible. . . .

NOTES ON THE PLAN OF FRANKLIN PARK[27]

Within the city of Boston, or close upon its border, there are nearly two hundred public properties which are not held with a view to building over them, and most of which are secured by legal enactments from ever being built over. Omitting the larger spaces recently acquired and held by the Department of Parks, these grounds are on an average thirteen acres each in area. Omitting the islands, the burial grounds, the larger grounds of the Department, and all that would not ordinarily be classed with "city squares and

[27] Frederick Law Olmsted, "Notes on the Plan of Franklin Park and Related Matters," City of Boston, Park Department, 1886, pp. 21, 31–36, 39–46, 90–97, 105–108.

CITY PARKS
AND IMPROVED
USE OF
METROPOLITAN
SPACES
234

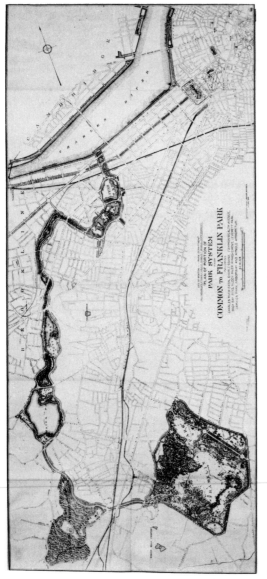

Plan of Portion of Park System from Common to Franklin Park, Boston.

gardens," the latter have an average area of about four acres each.

The area of the entire number of public properties numbered on the map, and of which a classified list follows showing the situation and area of each, is 3356.63 acres, or over five square miles. Of those likely to be permanent green oases among the buildings of the city, the area is about four square miles, or nearly as much as the entire building space within the walls of some cities that had great importance in the world when the building of Boston was begun.

Before taking up the question of the proposed large park, it may be desirable to form some idea of the present standard for the equipment of cities in respect to public grounds other than large parks, and consider how Boston's possessions, as they have been set out, may be rated by it. Of course this can be done but loosely, but the purpose may be carried far enough to answer with assurance the question, How are the people of Boston faring and likely to fare in this particular in comparison with civilized townspeople generally?

For this purpose it must be kept in mind that the public grounds of most cities have come to be what they are and where they are by various detached and desultory proceedings, of which the result, as a whole, illustrates penny-wise pound-foolish wisdom quite as much as the result of laying out streets with reference to immediate local and personal interests, regardless of burdens loading up to be carried by an entire city ever after.

Of late, however, ideas of systematization, with a view to comprehensive and long-sighted public economy, have taken root, and in a few instances are growing to profitable results.

These ideas move in two directions; and as confusion between them can only lead to blunders, it is well to see where the parting occurs.

CITY PARKS
AND IMPROVED
USE OF
METROPOLITAN
SPACES
236

If a large town were about to be built on a previously determined plan, a series of public grounds might be contemplated, to be situated at regular distances apart, all of the same extent, and all looking to a similarity and an equality of provisions for the use of those who would resort to them, the aim being to distribute the value of whatever should be done for the purpose of public recreation, as nearly as possible, equitably among the several corresponding districts of the city. A type of grounds would result, an inclination to approach which is here and there evident.

Certain advantages follow, but they are obtained at a cost that would be unreasonable in any city, the site of which was not generally flat, rockless, and treeless, or in any of the natural growth, expansion on all sides and prosperity of which were not singularly assured. Nor are the advantages aimed at in such a system, so far as attainable, of controlling importance.

As cities grow in a manner not to be accurately foreseen, as centres of business and centres of residence sometimes shift, and in the course of years become interchanged, and *as some parts of the site or the neighborhood of a city will nearly always be specially favorable to provisions of recreation of one class, other parts to provisions of another class*, it is generally better to have in view the development of some peculiar excellence in each of several grounds. And this may be considered the central idea of the alternative system, only that in proceeding with reference to it, it is to be remembered that cities are built compactly because of the economy of placing many varied facilities of exchange of service in close and direct intercommunication. Any large area within a city, not occupied by buildings, and not available as a means of communication between them, lessens this advantage, compelling circuitous routes to be taken and increasing the cost of the ex-

changes of service, upon the facilities offered for which the pros-
perity of the city depends.

It follows that so far as any purpose of public grounds can be
well provided for on a small ground, it is better to so provide for
it, rather than to multiply and complicate the purposes to be pro-
vided for on a larger ground. In a system determined with un-
qualified regard to this principle no ground would be used for any
purpose of recreation which purpose could as well be served by
itself elsewhere, on a small ground.

It follows, also, that the larger the ground needed for any special
purpose, the more desirable it is (other things being equal) that
that ground should be at a distance from the centres of exchange,
which will be the denser parts of the city, and out of the main lines
of the compact outward growth of the city.

The smaller grounds of the class designed for general use (being
such as are commonly called squares and places) may with ad-
vantage, as far as practicable, be evenly distributed, with a view
to local convenience, throughout a city. Yet, with regard to these,
there are at least three circumstances which should make numerous
deviations from such equalizing distribution: First, topographical
circumstances may compel spaces unsuitable for building to be
left between streets, which it will be economical to use for such
grounds; many such are found in and about Boston. Second,
spaces should be left about public buildings, in order to give them
better light, remove them from the noise of the streets, protect
them from conflagrations, and make the value of their architecture
available. Such spaces will economically become small public
grounds.

Lastly, it is most desirable to make use of any local circumstance
of the slightest dignity of character to supply a centre of interest

CITY PARKS
AND IMPROVED
USE OF
METROPOLITAN
SPACES
238

Photo. Pamela Bruns

for such grounds. Such a circumstance may be found, for instance, in a natural feature, as a notable rock, or in a historical feature, as the site of an old fort, or in the birthplace of a great man, or simply in a point of vantage for a view, as a prospect down the harbor. There is no better example of a very small public ground than one in Paris, where a beautiful church tower, decorated by centuries of superficial decay and mossy incrustations, has been taken as the centre of the work, the body of the church being removed and its place occupied by seats and gardenry.

Usually, however, there is nothing better for the purpose of this class of grounds than a simple open grove, or, on the smaller spaces, a group of forest trees (selected with regard for probable vigor and permanent health under the circumstances) with a walk through or around it, proper provisions against injury and unseemly use, a drinking fountain, and convenient seats out of the lines of passage, of which type there are good illustrations in Boston.

Playgrounds for children need not be so large as to interfere with direct, short communication, and should be evenly distributed in the residential part of the town, except as special localities are to be preferred on account of unusual topographical fitness.

If it is thought desirable to make any special provision for carriage and saddle exercise without going far from the central parts of the town, the most convenient and economical plan is that of a passage having the character of a street of extraordinary width, strung with verdant features and other objects of interest, so laid out as not to seriously interfere with the primary business of the city; that is to say, with convenience of exchange. Such passages are found between the principal palaces and better-built parts and the more frequented parks in Paris, Berlin, Brussels, Dijon, and

CITY PARKS
AND IMPROVED
USE OF
METROPOLITAN
SPACES
240

other European cities, and are there more commonly classed as boulevards; in America they are to be found notably in Buffalo and Chicago, and are there called parkways.

To further develop a system of public grounds, areas will be selected as far as practicable in parts of the city where they will least interrupt desirable general communication, the topographical conditions of each of which adapt it to a special purpose, and each of these will be fitted for public use upon a plan intended to make the most of its special advantages for its special purposes.

These observations may be considered to suggest the present standard of civilization in respect to the urban grounds of a city situated as Boston is. Looking with reference to this standard to Boston possessions and Boston's opportunities held in reserve to be used as her borders extend, hardly another city will be found in an equally satisfactory condition. . . .

Looking for deficiencies in this system of non-rural grounds, the chief will be found to be the want of sufficient local and suitable general grounds for active exercises. It would be a good thing for the city to have a large, plain, flat, undecorated ground, not far away, easily accessible, if practicable, both by rail and boat, adapted to military and athletic exercises.

Considering the advantage which pertains to the subdivision of the city by bays and rivers, and the constant movement through and around it of strong tidal currents, and the advantages thus offered for boating and bathing, as well as for obtaining unstagnant air, it is believed that this exhibit of Boston's breathing-places will be found gratifying. Few cities have a larger number of small urban grounds proportionately to their population; and, while some of Boston's grounds are of a nondescript character, serving no particular purpose very well, others are models of their class, and in no northern city is the average usefulness of such grounds greater.

As to reservations for the future, in respect to this class of grounds, no city is more forehanded. . . .

OF CERTAIN CONDITIONS OF THE SITE OF FRANKLIN PARK

That the site for Franklin Park could have been rationally bought only with a view to a purpose previously not all provided for, and that no use of the ground should now be permitted likely to lessen its value for this distinctive purpose, will yet more clearly appear if the topography of the ground and the manner of its selection are considered.

The scheme of Franklin Park, as it now stands, is a contraction of a much larger scheme outlined to the city government in 1869. This larger scheme included bodies of comparatively rich, humid, flat land, much better adapted to provide many forms of public ground than any within the field of the present scheme; a parade ground, for instance, and ball grounds; much better adapted, also, to the beauty to be obtained through refined horticulture, floral displays, and other decorations. It included streams of water and areas in which lakes with provisions for boating, skating, and bathing, as well as water-side beauty, could have been readily provided. All such ground has, long since, upon mature consideration by the city government, been thrown out of the scheme.

The ground finally selected has in its larger part the usual characteristics of the stony upland pasture, and the rocky divides between streams commonly found in New England, covered by what are called "second growth" woods, the trees slow growing from the stumps of previous woods, crowded, somewhat stunted, spindling; not beautiful individually, but, in combination forming impressive masses of foliage. It not only contains no lake, permanent pool or stream of water, but it commands no distant water view. It includes no single natural feature of distinguished beauty or popular inter-

CITY PARKS
AND IMPROVED
USE OF
METROPOLITAN
SPACES
242

est. It is in all parts underlaid by ledges which break out at some points in a bold and picturesque way, at others in such a manner only as to make barren patches, with scanty vegetation that wilts and becomes shabby in dry, hot weather. It is thickly strewn with boulders; even in parts where the surface appears smooth and clear, their presence just below it generally becomes obvious in dry weather, and they are turned out by the plough in great numbers. Any fine cultivation of the ground will be comparatively costly. It is not generally adaptable at moderate expense for lawn-like treatment, nor to the development of what are commonly, though perhaps not accurately, regarded as the beauties of landscape gardening. As a whole, it is rugged, intractable, and as little suitable to be worked to conditions harmonious with urban elegance as the site of the Back Bay Drainage Basins, Mount Royal Park at Montreal, East Rock Park at New Haven, or Arthur's Seat at Edinburgh.

It is on the borders of the city, remote from its more populous quarters, remote, also, from any of its excellent water highways, and out of the line of its leading land thoroughfares.

What can be said for the property as a whole is this: That there is not within or near the city any other equal extent of ground of as simple, and pleasingly simple, rural aspect. It has been at various points harshly gashed by rudely engineered roads, scarred by quarries and gravel pits, and disruralized by artificially disposed trees and pseudo-rustic structures, but, considering its proximity to the compact town, it has remarkably escaped disturbances of this character.

THE PURPOSE OF THE PLAN

. . . What is the special purpose of a large park in distinction from the various purposes that may be served by such smaller grounds as Boston is provided with?

In the first division of these pages reference has been made to the manner in which various evils of town life, by the introduction of one special expedient after another, have been gradually so well contended with, that in cities that at present have several times the population they had in the last century, much less time is now lost than then to productive industry; the average length of life much advanced, and the value of life augmented. The evils in question have been for the most part intangible, and to those who were not close students of them have been considered inscrutable; not to be measured and reckoned up like the evils of fire and flood, famine, war, and lawlessness. Consequently plans for overcoming them have always been regarded for a time as fanciful, and those urging them as theorists and enthusiasts. For a time, no city outlays have been so grudgingly made or given so much dissatisfaction to taxpayers as those required to advance measures of this class. Looking back upon their results, after a few years, it is admitted that no other money has been so profitably expended. No one thinks that they were untimely or were advanced too rapidly.

Of this class of evils there is one rapidly growing in Boston, in contention with which nothing has yet been accomplished. It is an evil dependent on a condition involved in the purpose of placing many stacks of artificial conveniences for the interchange of services closely together. It may be suggested if not explained (for evils of this class are seldom fully explainable) in this way.

A man's eyes cannot be as much occupied as they are in large cities by artificial things, or by natural things seen under obviously artificial conditions, without a harmful effect, first on his mental and nervous system and ultimately on his entire constitutional organization.

That relief from this evil is to be obtained through recreation is often said, without sufficient discrimination as to the nature of the

CITY PARKS
AND IMPROVED
USE OF
METROPOLITAN
SPACES
244

recreation required. The several varieties of recreation to be obtained in churches, newspapers, theatres, picture galleries, billiard rooms, base ball grounds, trotting courses, and flower gardens, may each serve to supply a mitigating influence. An influence is desirable, however, that, acting through the eye, shall be more than mitigative, that shall be antithetical, reversive, and antidotal. Such an influence is found in what, in notes to follow, will be called the enjoyment of pleasing rural scenery.

But to understand what will be meant by this term as here to be used, two ideas must not be allowed to run together, that few minds are trained to keep apart. To separate them let it be reflected, first, that the word beauty is commonly used with respect to two quite distinct aspects of the things that enter visibly into the composition of parks and gardens. A little violet or a great magnolia blossom, the frond of a fern, a carpet of fine turf of the form and size of a prayer rug, a block of carved and polished marble, a vase or a jet of water, — in the beauty of all these things unalloyed pleasure may be taken in the heart of a city. And pleasure in their beauty may be enhanced by aggregations and combinations of them, as it is in arrangement of bouquets and head-dresses, the decoration of the dinner-tables, window-sills and dooryards, or, in a more complex and largely effective way, in such elaborate exhibitions of high horticultural art as the city maintains in the Public Garden.

But there is a pleasure-bringing beauty in the same class of objects — foliage, flowers, verdure, rocks, and water — not to be enjoyed under the same circumstances or under similar combinations; a beauty which appeals to *a different class of human sensibilities,* a beauty the art of securing which is hardly more akin with the art of securing beauty on a dinner-table, a window-sill, a dooryard, or an urban garden, than the work of the sculptor is akin with the work of the painter.

Let beauty of the first kind be called here urban beauty, not because it cannot be had elsewhere than in a city, but because the distinction may thus, for the sake of argument in this particular case, be kept in mind between it and that beauty of the same things which can only be had clear of the confinement of a city, and which it is convenient therefore to refer to as the beauty of rural scenery.

Now as to this term scenery, it is to be borne in mind that we do not speak of what may be observed in the flower and foliage decorations of a dinner-table, window-sill, or dooryard, scarcely of what may be seen in even a large urban garden, as scenery. Scenery is more than an object or a series of objects; more than a spectacle, more than a scene or a series of scenes, more than a landscape, and other than a series of landscapes. Moreover, there may be beautiful scenery in which not a beautiful blossom or leaf or rock, bush or tree, not a gleam of water or of turf shall be visible. But there is no beautiful scenery that does not give the mind an emotional impulse different from that resulting from whatever beauty may be found in a room, courtyard, or garden, within which vision is obviously confined by walls or other surrounding artificial constructions.

It is necessary to be thus and even more particular in defining the term used to denote the paramount purpose embodied in the plan of Franklin Park, because many men, having a keen enjoyment of certain forms of beauty in vegetation, and even of things found only in the country, habitually class much as rural that is not only not rural, but is even the reverse of rural as that term is to be here used.

For example: in a region of undulating surface with a meandering stream and winding valleys, with much naturally disposed wood, there is a house with outbuildings and enclosures, roads, walks, trees, bushes, and flowering plants. If the constructions are of the natural materials of the locality and not fashioned expressly

CITY PARKS
AND IMPROVED
USE OF
METROPOLITAN
SPACES
246

Photo. Pamela Bruns

to manifest the wealth or art of the builders, if they are of the texture and the grain and the hues that such materials will naturally become if no effort to hide or disguise them is made, if the lines of the roads and walks are adapted to curves of the natural surface, and if the trees and plants are of a natural character naturally disposed, the result will be congruous with the general natural rural scenery of the locality, its rural quality being, perhaps, enhanced by these unobtrusive artificial elements. But in such a situation it oftener than otherwise occurs that customs will be followed which had their origin in a desire to obtain results that should be pleasing, not through congruity with pleasing natural rural circumstances, but through incongruity with them. Why? Simply because those designing them had been oppressed by a monotony of rural scenery, and desired to find relief from it, and because also they desired to manifest the triumph of civilized forces over nature. And on account of the general association with rural scenery of things determined by fashions originating in these desires, they are carelessly thought of as rural things, and the pleasure to be derived from them is esteemed a part of the pleasure taken in rural scenery.

It thus happens that things come to be regarded as elements of rural scenery which are simply cheap and fragmentary efforts to realize something of the pleasingness which the countryman finds in the artificialness of the city. This is why, to cite a few examples familiar to every one, wooden houses are fashioned in forms and with decorations copied from houses of masonry, and why the wood of them is not left of its natural color, or given a tint harmonious with natural objects, but for distinction's sake smeared over with glistening white lead. This is the reason why trees are transplanted from natural to unnatural situations about houses so treated, why they are formally disposed, why forms are preferred for them to be obtained only by artificial processes, as grafting,

CITY PARKS
AND IMPROVED
USE OF
METROPOLITAN
SPACES
248

pruning, and shearing; why shrubs are worked into fantastic shapes that cannot possibly be mistaken for natural growths; why groups are made studiously formal, why the trunks of trees are sometimes whitewashed; why rocks too heavy to be put out of sight are cleared of their natural beauty, and even sometimes also whitewashed; why flowering plants are often arranged as artificially as the stones of a mosaic pavement; why pools are furnished with clean and rigid stone margins and jets of water thrown from them; why specimens of rustic work and of rock work are displayed conspicuously that have been plainly designed to signalize, not to subordinate or soften, the artificialness of artificial conveniences.

Defining the purpose of the plan of Franklin Park to be that of placing within the easy reach of the people of the city the enjoyment of such a measure as is practicable of rural scenery, all such misunderstanding of the term as has thus been explained must be guarded against.

That rural scenery has the effect alleged, of counteracting a certain oppression of town life, is too well established to need argument, but as the manner of its action will have a practical bearing on the purpose of the plan, the circumstance may be recalled that the evil to be met is most apt to appear in excessive nervous tension, over-anxiety, hasteful disposition, impatience, irritability, and that the grateful effect of a contemplation of pleasing rural scenery is proverbially regarded as the reverse of this. It is, for example, of the enjoyment of this pleasure, and not simply of air and exercise, that Emerson says, "It soothes and sympathizes," that Lowell says, "It pours oil and wine on the smarts of the mind," and which Ruskin describes as "absolute peace."

It is not an easy matter, in the immediate outskirts of a great city, to make a provision of scenery which shall be so far rural in char-

acter and pleasing in effect as to have a high degree of the influence desired.

Some wise men are accustomed to ridicule the earlier result of efforts to that end by comparing it with scenery remote from cities the rurality of which owes nothing to human care. But these higher examples not being available for the frequent use of the mass of the people of a city, it is only a question whether a result is to be gained under such conditions as are offered in the site of Franklin Park which shall be of so much value in this respect that it will be worth more than it will cost. And, in considering this question, it is to be borne in mind that the purpose requires no elements of scenery of a class that would induce sensational effects. It will be answered in a measure — it is a question whether it may not even be better answered — by scenery that may be comparatively characterized as tame and homely. It is almost certainly better that the aim in overcoming the difficulties of securing such scenery should be modest, provided a modest aim can be sustained, and the temptation to put it out of countenance by bits of irrelevant finery resisted.

Given sufficient space, scenery of much simpler elements than are found in the site of Franklin Park may possess the soothing charm which lies in the qualities of breadth, distance, depth, intricacy, atmospheric perspective, and mystery. It may have picturesque passages (that is to say, more than picturesque objects or picturesque "bits"). It may have passages, indeed, of an aspect approaching grandeur and sublimity. . . .

OF THE SUPREME IMPORTANCE THAT A LARGE PARK

MAY COME TO HAVE IN THE HISTORY OF A CITY

It is contrary to habitual modes of thought to take due account of the comparative economico-political importance of what is at stake

CITY PARKS
AND IMPROVED
USE OF
METROPOLITAN
SPACES
250

in a large park undertaking — to recognize how costly a park may be, otherwise than through the taxation which it directly calls for; how useful it may be in wholly different ways from those most readily and customarily thought about. How it has come to be so will be partly explained later. The purpose of what is immediately to follow is to give a single reason for soliciting a more thorough consideration of various aspects of the subject than the occasion will be generally thought to require.

It is to be considered, to begin with, how much less likely than we are apt to suppose, the larger fortune of a city is, in these days, to turn controllingly and lastingly upon the local legislation that from year to year is led up to and brought about through an activity of local public opinion favorable to its object: how much more the historic course of the city is commonly determined by a discovery or an invention, for example, made by someone having no personal interest or direct part in it, as of a cotton-gin, a steel process, or of gold in a river-bed.

When currents of such exterior sources have once been established, the local defects of a city, with reference to them, are apt sooner or later, at more or less cost, to be remedied. The methods by which needed means for this purpose shall ultimately be reached, may vary radically, as, with reference to the currents of modern oceanic commerce, in the landing and loading facilities of the ports, respectively, of Liverpool, New York, and New Orleans. But the tendency to come nearer to a common standard of utility in essential results is so strong that if at one time a mistake of dealing inadequately with a problem is made, while the blunder will be costly, it is but a question of time when a sufficiently courageous and well-considered effort is to follow and sweep it away and build anew on firmer ground.

It may be considered, also, how much more cities gain on an

average in all that makes them converging points of the growth of nations in population, wealth, and refinement, from general currents of scientific progress by which all the world benefits, than from political proceedings of local origin and special local application.

It is, for instance, through falling into such a current that the ancient city of Cairo has come to be so relieved from its former annual devastations by the Plague, that the life of its people has come to be twice as long as it was in the first half of the century, and the value of life in it has been more than doubled through avoidance of pain, anxiety, and sadness, and the steadier profits of all industry. It is by falling into such a current that most of our southern cities have come to keep at home and in active employment during the entire summer a large part of the population, that would otherwise go out from them at the cost of a general suspension of many profitable branches of their trade, and nearly all important productive industry.

Through the tendency thus illustrated, to work up to standards mainly provided by agencies acting on public opinion from without, and established no one quite knows how, it occurs, notwithstanding the great differences of origin and historical development, of early social circumstances, of climate, of back-country conditions, and of resources of wealth and products to be dealt with, that schools, churches, hospitals, courts, police, jails, methods of fire protection, methods in politics, in benevolence and almsgiving, in journalism, in banking and exchange, are rapidly growing to be closely alike in San Francisco and in Boston. . . .

Looking for important advantages which one city may possess permanently over another in respect to the constant value of life of those who are to dwell in it, in scarcely anything, perhaps in nothing, will the estate of cities, as it may be affected by local

CITY PARKS
AND IMPROVED
USE OF
METROPOLITAN
SPACES
252

wisdom, effort, and timely legislation, be found to vary more and more lastingly than in the matter of public grounds. In scarcely anything is the general drift of civilized progress to be less depended on to set right the results of crude and short-sighted measures. In scarcely anything, therefore, to be determined by local public opinion acting influentially upon local legislation and administration, is a city as likely to be so much made or marred for all its future as in proceedings in prosecution of a park project.

To many who have not been closely following the history of park enterprises, and tracing cause and effect in connection with them, this will seem to be the assertion of a man with a hobby. But let what has been occurring at the port of New York, in a large degree under the direct observation of thousands of the more active-minded business men of Boston, be thoroughly reviewed, and it will not be found unreasonable.

First, let it be reflected how little of permanent consequence in the history of New York has come about through the spontaneous movements of local public opinion as reflected in legislation during the last thirty years, of which the broad, essential results were not almost a matter of course. It has been little more than a question of time, for instance, when and how the port should be provided with docks, basins, elevators, and better general water-side facilities for commerce; when certain streets should be widened; when rapid transit for long, and street cars for short, transportation, a civilized cab system, telegraphs, telephones, and electric lights should be introduced, better conveyances across the rivers gained, better accommodations for courts provided, the aqueduct enlarged, public schools multiplied, graded, and made more educational, industrial and night schools started, public museums of art and natural history founded, the militia made more serviceable, the volunteer fire department superseded, and a strong police force organized.

Photo. Pamela Bruns

CITY PARKS
AND IMPROVED
USE OF
METROPOLITAN
SPACES
254

There is nothing of general and permanent consequence in all that has been gained in these particulars that could have been more than delayed and made foolishly costly by careless, capricious, or perverse local public opinion and corresponding legislation. The same general currents of civilization that have brought what has been gained to New York in these respects have brought results answering the same general purposes to Philadelphia and to Boston, to Cincinnati and to Montreal. Or, if not fully so in each case, every live man in those cities looks to see like results reached in a few years, — makes his business plans, builds his house, orders his investments, educates his children, with reference to them. The general plan of the combined city of New York harbor, the position severally, for example, of its domestic, its manufacturing, and its trade quarters, has been very little determined as the result of local legislation or of a settled purpose of public opinion. Such changes of domestic and social habits as have occurred are much less to be attributed to any of these improvements than to circumstances governing the general increase and distribution of wealth throughout the world, to the general advances of science, and to fashions originating in Europe.

But now let it be considered how it has been with regard to what has occurred through the park enterprises. Each of the two large parks that during the same period have been set a-growing through local agitation and the careless legislation it has obtained, has had more such effect than all the other measures of that class together. The Central Park blocks fifty streets that, had it not been formed, would now be direct channels of commerce and of domestic movement from river to river. It takes out of the heart of the city two square miles of building-space, as completely and as permanently as a gulf formed by an earthquake could do, and for several square miles about this place it determines an occupation of land and a

use of real estate very different from what would have been other-
wise possible. Its effect on social customs may be illustrated by
the statement that to enjoy the use of the park, within a few years
after it became available, the dinner hour of thousands of families
was permanently changed, the number of private carriages kept in
the city was increased tenfold, the number of saddle horses a hun-
dredfold, the business of livery stables more than doubled, the
investment of many millions of private capital in public convey-
ances made profitable.

It is often asked, How could New York have got on without the
park? Twelve million visits are made to it every year. The poor
and the rich come together in it in larger numbers than anywhere
else, and enjoy what they find in it in more complete sympathy than
they enjoy anything else together. The movement to and from it is
enormous. If there were no park, with what different results in habit
and fashions, customs and manners, would the time spent in it be
occupied. It is often said that the park has made New York a dif-
ferent city. If it has not done so already, it surely will soon have
made New York a city differing more from what it would have
been but for the park than Boston differs either from San Francisco
or from Liverpool.

And the park of Brooklyn, while it has not as yet equally
changed the destiny of this branch of the town, is sure, as the city
grows, to be a matter of the most important moulding consequence,
— more so than the great bridge; more so than any single affair
with which the local government has had to do in the entire history
of the city.

Similar results may be seen, or surely foreseen, from the new
parks in each case of Philadelphia, of Chicago, of Buffalo, of St.
Louis, of San Francisco.

Not less significant illustrations of the general fact may be found

CITY PARKS
AND IMPROVED
USE OF
METROPOLITAN
SPACES
256

abroad, in Paris and in Liverpool, for instance, and in Melbourne, Australia.

But, it may be asked, if the Central Park had not been formed as it was, would not another park have been formed before this time? No doubt; but if so, the results of a different park would have been more importantly different from those that have followed the Central Park than the results of any determination of the city's fortune equally open to be made thirty years ago, through the action of its local government, in any matter of architecture, of engineering, of jurisprudence, or of popular education.

But before the comparative importance of what is to be determined by a park work in the history of a city can be at all realized, a very different view must be taken from that which is common of the irretrievableness of any blundering in its direction.

THE ELEMENT OF LASTINGNESS AS AFFECTING THE IMPORTANCE OF WHAT IS TO BE DETERMINED IN THE EARLY WORK OF A PARK

It needs to be emphatically urged (for a reverse impression is often apparent) that the plans of no other class of the public works of a city are to be rightly devised with reference to as prolonged and unchanging methods of usefulness as those of parks.

That the fact of the matter in this respect may be understood, let it be first reflected that the value of a large park does not lie, as is apt to be thoughtlessly taken for granted, in those elements which cost and manifest the most labor and the largest absorption of taxes; that is to say, in the roads, walks, bridges, buildings, and other obviously constructed features. These have value as conveniences for making the larger elements of a park available for the enjoyment of the public. If these larger elements are destroyed, the value of the artificial elements is lost. In the degree that they are ill-treated the value of the artificial elements depreciates. A

park road is pleasant by reason of that which adjoins it, or is open to contemplation from it, not because it favors speed. Mainly the value of a park depends on the disposition and the quality of its woods, and the relation of its woods to other natural features; ledges, boulders, declivities, swells, dimples, and to qualities of surface, as verdure and tuftiness. Under good management these things do not, like roads and walks, wear out or in any way lose value with age. Individual trees must from time to time be removed to avoid crowding, or because of decay; but, as a rule, the older the wood, and the less of newness and rawness there is to be seen in all the elements of a park, the better it serves its purpose. This rule holds for centuries — without limit.

It is very different with nearly every other material thing — material in distinction from moral or educational — to which a city may direct outlay from its treasury. The highest value, for example, of civic buildings, of pavements, aqueducts, sewers, bridges, is realized while they are yet new; afterwards a continual deterioration must be expected. As to a park, when the principal outlay has been made, the result may, and under good management must, for many years afterwards, be *increasing in value at a constantly advancing rate of increase, and never cease to increase as long as the city endures.*

This will be obviously true as to the principal element of a park — its plantations. But whatever value a park may reach simply through the age of its well ordered plantations, some thing of that value will be lost wherever repairs, additions, or restorations are made by which the dignity of age in its general aspect (or what the ancients called the local genius) is impaired. Looking at the artificial elements of parks in Europe — the seats, bridges, terraces, staircases, or any substantial furniture of them, supposing that they are not ruinous — it cannot be questioned that they are pleasing

CITY PARKS
AND IMPROVED
USE OF
METROPOLITAN
SPACES
258

in the degree that they are old and bear evidence of long action of natural influences upon them — the most pleasing being those which nature seems to have adopted for her own, so that only by critical inspection is human workmanship to be recognized. Hence, not only should park things be built for permanence, but ingeniously with a view to a ready adoption and adornment of them by nature, so that they may come rapidly and without weakness to gain the charm characteristic of old things. For every thousand dollars judiciously invested in a park the dividends to the second generation of the citizens possessing it will be much larger than to the first; the dividends to the third generation much larger than to the second. . . .

THE VALUE OF A RURAL PARK TO THE PARTS OF A CITY MORE DISTANT FROM IT

That a well prepared and arranged rural park adds greatly to the value of real estate in its neighborhood is well known. It may be questioned if the gain at one point is not balanced by loss at another. But in all growing towns which have a rural park evidence appears that, on the whole, it is not. With a good route of approach, such as was provided by the Champs Elysées and the Avenue du Bois de Boulogne in Paris, Unter den Linden in Berlin, the Parkways in Chicago, and such as will be supplied by Columbia Street, Humboldt Avenue, and the Riverdale Parkway from Back Bay, in Boston, people who ride or drive do not object to a lengthened passage between their residences and a park. As to others, the mass, even of habitual users, do not use a rural park daily, but at intervals, mostly on holidays and Saturdays, birthdays, and other special occasions. How much less than is apt to be considered, in the early stages of a park undertaking, such use of a park is affected by its being at the far side of a town, has been shown in Brooklyn.

When the rural park of Brooklyn was determined on, the people

of a part of that city, the most remote from the site taken, pleading their distance from it and the difficulties of communication with it, were able to obtain a special exemption from the taxation that it would enforce. They had local advantages for recreation, and would never, it was thought, want to cross the town to be better provided in that respect at its opposite side. Nevertheless, long before the plan of the park had been fully carried out, the people of this very district began to resort to it in such numbers that two lines of street cars were established, and on holidays these are now found insufficient, to meet their demand.

There is no doubt that the health, strength, and earning capacity of these people is increased by the park; that the value of life in their quarter of the town is increased; that the intrinsic value, as well as the market rating, of its real estate is increased.

The larger part of the people to whom the Brooklyn Park has thus proved unexpectedly helpful are the very best sort of frugal and thrifty working-men, their wives, and their children.

Every successful park (for there are rural parks so badly managed that they cannot be called successful) draws visitors from a distance much greater than its projectors had supposed that it would. It is common for people living out of New York, anywhere within a hundred miles, to visit its park in pleasure parties on all manner of festive occasions. In Paris, the celebration of weddings by the excursion of an invited party to a park and an entertainment in it, is so common with people of moderate means that the writer has seen ten companies of marriage guests in the Bois de Boulogne in a single day.

THE BEARING OF THE DIFFICULTIES THAT HAVE BEEN REVIEWED

UPON THE MAIN END OF THESE NOTES

First, the chief end of a large park is an effect on the human orga-

CITY PARKS
AND IMPROVED
USE OF
METROPOLITAN
SPACES
260

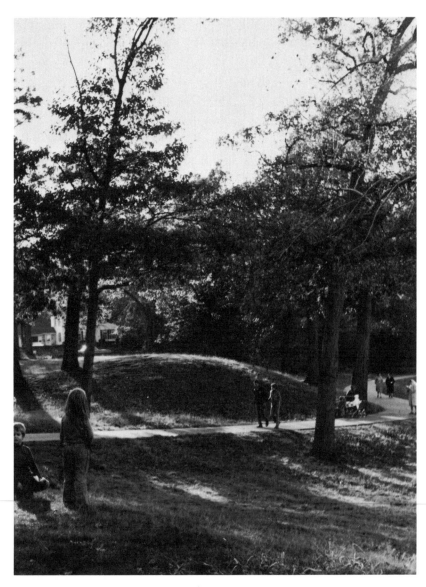

Photo, Pamela Bruns

nism by an action of what it presents to view, which action, like that of music, is of a kind that goes back of thought, and cannot be fully given the form of words.*

Excellence in the elaboration and carrying out a plan of work of this kind will be largely dependent on the degree in which those having to do with it are impressed with the importance of the intangible end of providing the refreshment of rural scenery, believe in it, and are sympathetic with the spirit of the design for attaining it. Now, it has happened that Mayors, Members of City Councils, Commissioners, Superintendents, Gardeners, Architects, and Engineers, having to do with a park work, have not only been wanting in this respect, but have been known to imagine that it would be pleasing to the public that they should hold up to ridicule any purpose in a park work not of a class to be popularly defined as strictly and definitely utilitarian and "practical," and should seek to eliminate from it all refinement of motive as childish, unbusiness-like, pottering, and wasteful. In the history of the park of New York, three gentlemen of wealth, education, and of eminent political position, two of them Commissioners of the park, have used the word landscape to define that which they desired should be avoided and overcome on the park. One of them, and a man of good social position, a patron of landscape arts for the walls of private houses, said in a debate in regard to the removal of certain trees: "The park is no place for art, no place for landscape effects; it is a place in which to get exercise, and take the air. Trees are wanted to shade the roads and walks, and turf is wanted because without it the ground would be glaring and fatiguing to the eye; nothing more, nothing

* "It gives an appetite, a feeling, and a love that have no need of a remoter charm by thought supplied." — Wordsworth, with reference to rural scenery. "It would be difficult to conceive a scene less dependent on any other interest than that of its own secluded and serious beauty. . . . *the first utterance of those mighty mountain symphonies.*" — Ruskin.

CITY PARKS
AND IMPROVED
USE OF
METROPOLITAN
SPACES
262

else." He believed that in saying this he was expressing the public opinion of the city, and at the time it was not as certain as it has since come to be that he was not.

Second, spaciousness is of the essence of a park. Franklin Park is to take the best part of a mile square of land out of the space otherwise available for the further building of the city of Boston. There are countless things to be desired for the people of a city, an important element of the cost of providing which is ground space. It is the consequent crowded condition of a city that makes the sight of merely uncrowded ground in a park the relief and refreshment to the mind that it is. The first condition of a good park, therefore, is that from the start a limited number of leading ends shall be fixed upon, to serve which as well as possible *will compel opportunity for serving others on the space allotted to it to be excluded.* The desirability of opportunity for using it for some of the ends thus set aside will be constant, and in a great city there will always be not only thousands in whose minds some one of them will be of more distinct and realizable importance than those that have been provided for in the plan of the ground, and who will be moved to undervalue, relatively to them, that which has been done and been reserved for the accepted purposes; but many thousands more who will fail to see that the introduction of appliances for promoting new purposes is going to lessen the value of the ground for its primary purposes. Where a strong and definite personal interest is taken, even by a few persons, in any purpose that is indirectly and furtively at issue with a purpose of comparatively indefinite general interest to a community, the only permanent security for the efficient sustenance of the larger purpose lies in a strong conviction of its importance pervading the community. . . .

4 Suburban Solutions

Not completely satisfied with either rural or — at least in its familiar manifestations — urban existence, Olmsted found his ideal compromise in exurban communities. As he describes them in the two reports which follow, these communities resemble garden cities in the British sense, rather than American "suburbs" as we usually conceive of them.

The Berkeley project was never started for financial reasons. The Olmsted and Vaux plan for Riverside, Illinois, was adopted, minus, however, the six-mile parkway they proposed to link the community to Chicago. Today, approximately 10,000 people live in Riverside. The town still retains the character of the original design but, like others, has not been spared the effects of the population and automobile explosion.

Berkeley:
A University
Community[28]

To the Reverend S. H. Willey, Chairman of Committee:

Sir,

The portion of the estate of the College of California, for the improvement of which a plan is required, lies immediately below the steep declivities of the coast range, north and east of that which has already been laid out in rectangular blocks and streets, and sold in village house lots by the Trustees. No change is proposed to be made in the existing public roads and streets, with which, therefore, any improvements to be made are required to be conveniently associated.

When I first visited the ground at your request, it was proposed that the buildings to be erected for the Institution should be placed upon a site which looked down upon the surrounding country on every side except that which would be to their rear, and that the remainder of the property should be formed into a *park*, for which it was desired that I should furnish a plan.

After some preliminary study, I advised you that whatever advantages such an arrangement might have in a different climate and soil, it would in my judgment be inappropriate to your site and inconvenient to your purposes, while it would permanently entail burdensome expenses upon your institution.

My objections to the original project having been deemed conclusive, I was requested to review the whole question of the placing of the college buildings and the disposition to be made of the tract within which it had been determined that a situation for them should be selected. The general conclusions to which I was brought by this review having been verbally presented to your Committee, I was instructed to draft a plan in accordance with them. This I have done, and in the present report I have to show how this plan is

[28] Frederick Law Olmsted, "Report upon a Projected Improvement of the Estate of the College of California, at Berkeley, Near Oakland" (San Francisco: Towne and Bacon, 1866), pp. 3–26.

adapted to serve the main purposes of your corporation, as well as some others of public interest.

The question as to the local circumstances that would be most favorable to the attainment of the objects of a college, is mainly a question of adjustment between a suitable degree of seclusion and a suitable degree of association with the active life of that part of the world not given to the pursuits of scholars. The organic error in this respect of the institutions of the middle ages and the barrenness of monastic study in the present day, is too apparent to be disregarded. Scholars should be prepared to lead, not to follow reluctantly after, the advancing line of civilization. To be qualified as leaders they must have an intelligent appreciation of and sympathy with the real life of civilization, and this can only be acquired through a familiarity with the higher and more characteristic forms in which it is developed. For this reason it is desirable that scholars, at least during the period of life in which character is most easily moulded, should be surrounded by manifestations of refined domestic life, these being unquestionably the ripest and best fruits of civilization. It is also desirable that they should be free to use at frequent intervals those opportunities of enjoying treasures of art which are generally found in large towns and seldom elsewhere.

Such is the argument against a completely rural situation for a college.

On the other hand, the heated, noisy life of a large town is obviously not favorable to the formation of habits of methodical scholarship.

The locality which you have selected is presumed to be judiciously chosen in respect to its proximity to San Francisco. Although it has the advantage of being close by a large town, however, the vicinity is nevertheless as yet not merely in a rural but a completely rustic and almost uninhabited condition, two small families

of farmers only having an established home within half a mile of it. This is its chief defect, and the first requirement of a plan for its improvement is that it should present sufficient inducements to the formation of a neighborhood of refined and elegant homes in the immediate vicinity of the principal college buildings.

The second requirement of a plan, is that, while presenting advantages for scholarly and domestic life, it shall not be calculated to draw noisy and disturbing commerce to the neighborhood, or any thing else which would destroy its general tranquility.

The third requirement of a plan is, that it shall admit of the erection of all the buildings, the need of which for college duties can be distinctly foreseen, in convenient and dignified positions, and leave free a sufficient space of ground for such additional buildings as experience may hereafter suggest, as well as for exercise grounds, gardens, etc.

I proceed to a consideration of the means of meeting the first of these requirements.

San Francisco is so situated with regard to the commercial demands of various bodies of the human race, that it may be adopted as one of the elements of the problem to be solved, that many men will gain wealth there, that the number of such men will be constantly increasing for a long time to come, and that a large number of residences will be needed for these suited to a family life in accordance with a high scale of civilized requirements. If these requirements can be more completely satisfied in the neighborhood of the college than elsewhere, it may be reasonably anticipated that it will eventually be occupied by such a class as is desired.

We have to consider then, what these requirements are, and whether, by any arrangements you can make or initiate, they may be provided for in an especially complete way, on the property which you have to dispose of.

We shall gain but little light in this matter by studying the practice of those who have had it in their power to choose the circumstances of their residence, the difference in this respect being very great, and leading to no clear, general conclusions. Some, for instance, as soon as they are able to withdraw from the active and regular pursuit of their business in towns, seem to have cared for nothing but to go far away from their friends, and to rid themselves of the refinements of life and the various civilized comforts to which they have been previously accustomed. Others can only make a choice among lofty structures, the windows of which look out on busy streets, so that the roar of toiling, pushing crowds is never escaped from, while for any enjoyment of natural beauty, the occupants might as well be confined in a prison.

In England, the prevailing fashion of wealthy men for several centuries, has been to build great stacks of buildings, more nearly represented by some of our hotels than anything else we have, and to place these in the most isolated positions possible, in the midst of large domains, with every sign of human surroundings not in a condition of servility or of friendly obligation to themselves carefully obliterated or planted out.

This fashion, growing as it doubtless has, out of a conservative disposition in regard to feudal social forms, has also been frequently followed in a cheap and shabby way by many in America, especially in the southern states, yet no argument can be needed to show its utter inadaptation, even with profuse expenditure, to the commonest domestic requirements of our period of civilization.

The incompleteness of all these arrangements is easily traced to the ordinary inclination of mankind to over-estimate the value of that which happens to have been difficult to obtain or to have seemed to be so, and to overlook the importance of things which are within comparatively easy reach.

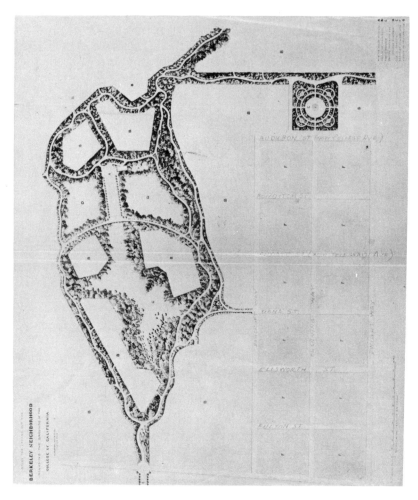

Study for Laying Out the Berkeley Neighborhood, Including the Grounds of the College
of California.

It is only by reference to some general rule that will satisfy the common sense, that the comparative value of one or the other of the possible conditions of a residence can be safely estimated, so that those things which are essentially important, may not be sacrificed to matters which are of value only as they gratify a temporary personal fancy or caprice of taste.

Such a general rule may, I think, be stated as follows:

The relative importance of the different provisions for human comfort that go to make up a residence is proportionate to the degree in which, ultimately, the health of the inmates is likely to be favorably influenced by each, whether through the facility it offers to the cheerful occupation of time and a healthful exercise of the faculties, or through any more direct and constant action.

Every civilized home centres in an artificial shelter from the elements; a contrivance to shut out rain, and wind and cold. But little judgment is required to make a shelter sufficiently large and effective. To accomplish this in a way that will be compatible with a due provision of sunlight and fresh air, however, is more difficult. In fact, perfect shelter at all times and as free a supply of fresh air and sunlight as is desirable to be used by every human being at intervals, is impossible. Yet, as their use seems to be always free to the poorest and least intelligent of men, it seldom occurs to such as are intent on making good provision in other respects for the comfort of their families, to take great care to make the use of sunlight and air easy and agreeable. The consequence is that their houses are really no better in this respect than those of careless and indolent men; often not as good, the advantages of the latter in this one particular being sacrificed by the more prudent to more complete arrangements for accomplishing the primary purpose of shelter.

More unhappiness probably arises from this cause, in houses

which are in most respects luxuriously appointed, than from any other which can be clearly defined and guarded against.

Attractive open-air apartments, so formed that they can be often occupied for hours at a time, with convenience and ease in every respect, without the interruption of ordinary occupations or difficulty of conversation, are indeed indispensable in the present state of society to the preservation of health and cheerfulness in families otherwise living in luxury. The inmates of houses which are well built and furnished in other respects, but in which such apartments are lacking, are almost certain, before many years, to be much troubled with languor, dullness of perceptions, nervous debility or distinct nervous diseases. The effort to resist or overcome these tendencies, except by very inconvenient expedients, such as traveling abroad, or others of which it is impossible to make habitual use without a sacrifice of the most valuable domestic influences, leads to a disposition to indulge in unhealthy excitements, to depraved imaginations and appetites, and frequently to habits of dissipation.

It may be thought that this is a defect which, in most houses with private grounds about them, might be so easily remedied that it is hardly credible that I do not exaggerate the degree in which it mars the happiness of families who are so fortunate as to live out of the midst of towns. But it is a great mistake to suppose that it is a simple matter to make it convenient and agreeable, to delicate women especially, to spend much time healthfully in the open air. Lord Bacon, three hundred years ago, sagaciously observed:

"God Almighty *first* planted a garden, and, indeed, it is the purest of human pleasures; it is the greatest of refreshment to the spirits of man, without which buildings and palaces are but gross handiworks: *and a man shall ever see that when ages grow to*

civility and elegance, men come to build stately sooner than to garden finely — as if gardening were the greater perfection."
In the formation of country residences of the smallest pretensions far greater study and a far larger proportionate expenditure is generally made in England, and in most countries where civilization has been long established, upon matters of out of door domestic convenience than in America. Yet the difficulties to be overcome and the need to overcome them, are incomparably greater in America, and especially in California, than in England. The truth is they are so great that they are commonly regarded as insurmountable, and a deliberate effort to make sure that the out-of-door part of a residence shall be conveniently habitable and enjoyable is not thought of. The "garden" and "grounds" are regarded merely as ornamental appendages of a house, marks of the social ambitions of the owner, like the plate and carpets within, rather than as essentials of health and comfort, like the beds and baths. Yet the frequent action of free sun-lighted air upon the lungs for a considerable space of time is unquestionably more important than the frequent washing of the skin with water or the perfection of nightly repose.

Another class of civilized requirements frequently forgotten by men who have earned, by their skill and industry in providing for the wants of others, the right to live luxuriously, consists of those which can only be met by the services of numerous persons who are not members of the family requiring them, such as purveyors of various articles of food and bodily refreshment; artisans, musicians, nurses, seamstresses, and various occasional servants. (Physicians, teachers and clergymen might be added, but the absence of these from a neighborhood is less frequently overlooked.) Townspeople who have been accustomed to find those able to render such

services always within ready call are particularly apt to neglect to consider how much of their comfort is dependent on this circumstance, and often discover it only after they have, by a large expenditure, made a home for themselves in which they are obliged to live in a state which, by comparison with their town life, seems one of almost savage privation.

The first of the two classes of requirements to which I have referred, it is obvious, can never be satisfactorily provided for in a town house, as towns are usually laid out. Hence, as statistics testify, families living in such towns, except where habitual resort is had to parks or gardens, or to annual journeys in the country, constantly tend to increasing feebleness of constitution, and generally become extinct from this cause in a few generations. The second class can not be provided for in an isolated country house. Hence, in a great measure the frequency with which wealthy men who have spent enormous sums to provide themselves country houses abounding in luxury, are willing, after the experience of a few years, to dispose of them at great pecuniary sacrifice.

It is true, that by great expenditure, many of the usual inconveniences and deprivations of a residence in the country may be made of small account. But often it is found that with double the current expenditure in a country house of the most luxurious equipment, the same variety of civilized enjoyments can not be obtained as are to be had in town houses of a much more modest description. There are certain very desirable commodities, indeed, that very poor families can enjoy when living in or near large towns, that even the very rich commonly dispense with when they live in the country. These constitute a large part of the attractions which such towns have for poor and rich alike.

There can be no question, that, as a general rule, people of easy circumstances, especially those who have the habits of townspeople,

if they want to make the most of life, should not undertake to live where they will be necessarily dependent in any degree much greater than is usual in towns for the supply of their every day material requirements upon labor performed within their own walls, nor where they can be deprived at any time of the year, much more than they would be in towns, of good roads and walks, and other advantages for exercise, and easy, cheerful use of whatever advantages there may be near them for social intercourse. Yet it is equally certain that if they fail to secure fresh air in abundance, pleasant natural scenery, trees, flowers, birds, and, in short, all the essential advantages of a rural residence, they will possess but a meagre share of the reward which Providence offers in this world to the exercise of prudence, economy, and wise forecast. But if we are thus compelled to seek the site for a residence "out of town," and to take care that all effort to secure comfort in it is not exhausted in the plan of the mere house, or shelter from the elements, we must also remember that to keep extensive private grounds in good repair, and perfectly fresh and clean, requires more skill and labor, as well as administrative ability, than all the rest of the ordinary housekeeping affairs of a moderate family. And as, unless they are so kept, extensive private grounds are not simply useless, but absolutely irksome, when associated with a family residence, and as it is hardly possible in America to maintain for any lengthened period a large body of efficient domestic servants, however extravagantly disposed a man may be in this particular, the folly of attempting to imitate the aristocratic English custom which has been referred to is evident.

It may be laid down, then, as a rule, to which there will be but few exceptions, and these only in the case of families not only of very unusual wealth, but of quite exceptional tastes, that for the daily use of a family, no matter how rich, if the site be well chosen,

and the *surrounding circumstances are favorable,* a space of private ground of many acres in extent, is entirely undesirable.

If the surrounding circumstances are *not* favorable — if there are dirty roads, ugly buildings, noisy taverns, or the haunts of drunken or disorderly people near by, ground which it would otherwise be undesirable to hold may be wanted in which to plant them out of sight and hearing; if the country in the neighborhood is not agreeable to walk, ride, or drive through, a large space may be wanted in which to form extended private walks, rides, and drives, which shall be artificially agreeable; if one's neighbors are of surly, hot-blooded, undisciplined, quarrelsome character, he will want to buy them out of their land in order to have them at a greater distance, and to be free from the danger of their return. If he is himself of an ostentatious, romantic, and dramatic disposition, he may require, more than any other luxury, to have a large body of servile dependents about him, and may want to disguise the fact of his actual insignificance among his neighbors by establishing his house at a distance from anything that he can not think of as belonging to himself or subordinate to his will. But the great majority of men who have the ability to gain or hold wealth in America come under neither of these heads, and in the choice of a place of residence will find it best, at the outset, to avoid, if they have the opportunity to do so, all such conditions as have been enumerated.

A respectable college could not be established in any locality without bringing to it a certain amount of neighborhood advantages, while if it is not positively repellant to, it at least can have no direct attraction for, the more common constituents of a bad neighborhood, that is, for those things which every man must wish to keep at a great distance from his house. If, then, you can make your neighborhood positively attractive in other respects, especially if you can make it in important particulars more attractive than any

other suburb of San Francisco, you can offer your land for sale, for villa residences, in lots of moderate size, with entire confidence that you will thus cause to grow up about it such a neighborhood as is most desirable, with reference to your first purpose.

What, then, are the requisites (exterior to private ground) of an attractive neighborhood, besides good neighbors, and such institutions as are tolerably sure to be established among good neighbors? The most important, I believe, will be found in all cases to be that of good *out-goings* from the private grounds, whether with reference to social visiting, or merely to the pleasure and healthfulness of occasional changes of scene, and more extended free movement than it is convenient to maintain the means of exercising within private grounds.

For this purpose the common roads and walks of the immediate neighborhood, at all times of the year, must be neither muddy nor dusty, nor rough, nor steep, nor excessively exposed to the heat of the sun or the fierceness of the wind. Just so far as they fail in any of these respects, whatever is beautiful in the neighborhood, whatever is useful — churches, schools, and neighbors included — becomes in a certain degree disagreeable, and a source of discomfort and privation. No matter what a neighborhood may be in all other respects, therefore, if it fails in these it must be condemned as unfit for a civilized residence. It is folly to suppose that compensation for the ill-health and the vexations that will daily arise from a poor provision in this respect will be found in such other circumstances as a beautiful prospect from a house, or a rich soil, or springs of water or fine trees about it, or any other mere private or local possession, for the lack of these can generally be remedied in large degree by individual wisdom and expenditure, while the lack of good out-goings cannot.

The desideratum of a residence next in importance will be points

in the neighborhood at which there are scenes, either local or distant, either natural or artificial, calculated to draw women out of their houses and private grounds, or which will at least form apparent objects before them when they go out. It will be all the better if many are likely to resort to these points, and they thus become social rendezvous of the neighborhood.

Next to points at some distance from a house commanding beautiful views, it is desirable to be able to look out from the house itself upon an interesting distant scene. This is generally not too little but too much thought of, the location of many houses being determined by regard for this circumstance alone, and things of far greater importance being sacrificed to it. It will be found that when this is the case — when, for instance, a house is placed in a lonely, bleak position, on the top of a hill difficult to ascend — the most charming prospect soon loses its attractiveness, and from association with privation and fatigue becomes absolutely repulsive.

Nor is it desirable that a fine distant view should be seen from all parts of the house, or of the grounds about it. This, indeed, is impossible, if the house and grounds are in themselves completely agreeable. The first and most essential condition of a home, is domestic seclusion. It is this which makes it home, the special belonging of a family. If it is not attractive within itself, and made so by, or for the sake of, the family, it is no home, but merely a camp; an expedient of barbarism made use of to serve a temporary purpose of a civilized family. Yet it is a good thing to be able at times, without going far, within or without the house, to take a seat from which, while in the midst of the comfort and freedom from anxiety of a home, a beautiful or interesting distant scene can be commanded. It is not desirable to have such a scene constantly before one. If within control, it should be held only where it can be enjoyed under circumstances favorable to sympathetic contemplation.

The class of views most desirable thus to be had within easy reach, is probably that which will include all well balanced and complete landscapes. The general quality of the distant scene should be natural and tranquil; in the details, however, there had better be something of human interest. But whatever the character of the distant outlook, it is always desirable that the line or space of division between that which is interior and essential to the home itself and that without which is looked upon from it, should be distinct and unmistakable. That is to say, whenever there is an open or distant view from a residence, the grounds, constructions and planations about the house should form a fitting foreground to that view, well-defined, suitably proportioned, salient, elegant and finished.

It may be observed that such an arrangement is not compatible with what some writers on landscape gardening have said of "appropriation of ground;" but it need hardly be argued that a man is going wrongly to work to make a home for himself when he begins by studying how he can make that appear to be a part of his home which is not so.

Even if this appropriated ground were public ground, to look at it from a private house without seeing a well defined line of separation between it and the family property, or without a marked distinction of character between the two, in the details of the scenery, would be to have the family property made public rather than the public property made private.

If it is desirable that the distinction between the character of the ground which forms a part of the home and of that which forms a part of the neighborhood beyond the home, should be thus emphasized, it is also desirable, and for a like reason, that there should be a somewhat similar gradation between that which constitutes the neighborhood and that which is more distant. In other words, the

existence of a neighborhood should be obvious, and for this reason the scenery which marks the neighborhood should be readily distinguishable. The view from the window or balcony should, in short, be artistically divisible into the three parts of; first, the home view or immediate foreground; second, the neighborhood view or middle distance; and third, the far outlook or background. Each one of these points should be so related to each other as to enhance its distinctive beauty, and it will be fortunate if the whole should form a symmetrical, harmonious and complete landscape composition.

Of these three desiderata, the first only can be supplied by private effort. A site for a residence, therefore, should be selected, if possible, where the other two are found ready at hand.

For the purpose of ascertaining what was necessary to be supplied upon your ground to give it the advantages which have been described, and others, generally recognized to be essential to a neighborhood of the best form of civilized homes; I visited it under a variety of circumstances, in summer and winter, by night and by day, and I now propose to state what are its natural conditions; what are the artificial conditions required, and how these may be best secured.

First. — In respect of soil, exposure, natural foliage and water supply, your ground is, to say the least, unsurpassed in the vicinity of San Francisco.

Second. —There are few if any suburbs which command as fine a distant prospect. The undulations of the ground and the difference of elevation between the upper and the lower parts give the advantage of this prospect in its main features to a large number of points of view, so situated that the erection of buildings and the growth of trees at other points will be no interruption to it.

Third. — With respect to climate and adaptation to out-of-door occupation, persons who had resided upon the ground or who had

had frequent occasion to cross it, having stated that the sea-winds which nearly everywhere else near San Francisco are in summer extremely harsh, chilling and disagreeable to all, and often very trying to delicate persons, were felt at this point very little, I gave this alleged advantage particular consideration.

During the month of August I spent ten days on the ground, usually coming from San Francisco in the morning and returning at night. The climate of San Francisco was at this time extremely disagreeable, while that of the college property was as fine as possible. One morning, when I left San Francisco at nine o'clock, though the air was clear, a light but chilling north-west wind was blowing. The same wind, somewhat modified, prevailed at Oakland. At Berkeley the air was perfectly calm. Ascending the mountain side a few hundred feet, I again encountered the wind. Descending, it was lost, and the air remained calm until I left at five in the afternoon; the temperature being at the same time agreeably mild. During all the day I observed that San Francisco was enveloped in fog and that fog and smoke drifted rapidly from it over the bay and over Oakland. At five o'clock, in returning to San Francisco, after driving two miles toward Oakland, I had need to put on my overcoat. In the cabin of the ferry-boat, with doors closed, I saw women and children shivering, and heard the suggestion that the boat should be warmed in such weather. At San Francisco I found a blustering, damp wind and my friends sitting about a fire. The following day there was in the morning a pleasant, soft breeze at Berkeley, but late in the afternoon it fell to a complete calm. I determined to remain on the ground for the purpose of ascertaining whether this would continue or whether it preceded a change of temperature and a visit of the sea-wind after nightfall. At sunset the fog-clouds were rolling over the mountain tops back of San Francisco, gorgeous in rosy and golden

light; the city itself was obscured by a drifting scud. At Berkeley the air remained perfectly serene, and, except for the fog-banks in the southwest, which soon became silvery and very beautiful in the moonlight, I never saw a clearer or brighter sky. It remained the same, the air being still of a delightful temperature, till morning, when the sun, rising over the mountains in the rear, gave a new glory to the constant clouds overhanging the heights on each side of the "Golden Gate." Going back in the afternoon to San Francisco, I again found the temperature in contrast to that of Berkeley disagreeably chilling, though the day was considered there an uncommonly fine one and the wind was less severe than usual.

I have visited the other suburbs of San Francisco and studied them with some care, and, without being able to express a definite estimate of the degree of difference between their climate and that of Berkeley, and without being able to assert from my limited observation, that the immunity of the latter from the chilling sea-wind is absolutely complete and constant, I think that I am warranted in endorsing the opinion that the climate of Berkeley is distinguished for a peculiar serenity, cheerfulness and healthfulness.

I know of no entirely satisfactory explanation of the fact. But it may be observed that it lies to the northward of the course of the northwest wind which draws through the Golden Gate and which sweeps the peninsula to the southward of the city and the Contra Costa country south of Oakland, and that there are to the northward and northwestward of it several spurs of the Monte Diabolo range, the form of which is calculated to deflect currents of air setting down the bay from the northward. The form of the trees on the top of the nearest of these hills indicates an upward deflection of the northerly wind.

It will be seen that the natural advantages which led to the choice

of the locality for the college, adapt it still more for a neighborhood of luxurious family residences.

The disadvantages of the site, as compared with districts in other parts of the world, which are considered to be of choice character for rural or suburban residences, are those which are common to all the country near San Francisco, and most of these it possesses in less degree than any other I have seen, while, at the same time, there are in the local conditions, unusual advantages for overcoming them. If, therefore, these advantages are made use of in a large, bold and resolute way, the neighborhood will ultimately possess attractions, especially for those with whose memories of childhood the rural scenes of the Atlantic States, or of most of Northern Europe are associated, with which there will be nothing else to compare in the vicinity. I say this, not out of regard for the charm which such scenes would have from mere association with youthful pleasures, but for the fact that there is a real relationship of cause and effect between the conditions which are necessary to the elements of those scenes, and those which are required to contribute to the comfort of mankind. For instance, the ground will not often be found hard, nor harsh, nor sticky, and neither mud nor dust will cause annoyance when a ramble is taken over surface all of which is either sheltered by foliage, or covered with turf. Again, in a country of thick, umbrageous, pendulous woods, coppices and thickets, protection from severe winds, and from the direct rays of the sun everywhere appears to be close at hand, and we feel less instinctively disinclined to venture forth freely in it. Moreover, when these elements of scenery are found in profusion, the scene before us, as we move in any direction, is constantly interrupted by the bodies of foliage, and re-arranged into new combinations and these often have a proportion and relation of parts which satisfies the requirements of an artistic instinct, and which,

in a complete realization, constitutes what is technically termed a composition. For this reason, although it may not command our wonder, or any profound feeling, it gives promise of constant interest, and cheerfully influences the imagination. There will be greater interest also, in the details of such scenery which must be closely observed, than in any other. Birds and flowers, for instance, will be more evenly distributed over it, so that even in their absence, we never know that we may not, at the next moment come upon them.

But let any one go out into the country near San Francisco, in any direction, and he will rarely find his interest thus stimulated. At one season he will every where find abundant flowers, and in some of the gulches he may always find bushes and birds. Looking at the distant hills from a high position again, he may see a certain beauty of scenery, yet it can seldom be said that he has before him a completely beautiful landscape; probably never, in any place otherwise suitable for a home, and during any considerable part of the year. The nearer part of the natural landscape will nearly everywhere be coarse, rude, raw; grand or picturesque possibly, but never beautiful or appropriate to a home. Nor, however great the beauty, in certain states of the atmosphere, of the distant hills and water, is there anything in nature which seems to invite or welcome one to ramble. The surface of the ground beyond the immediate foreground commonly seems hard, bare, dead and bleak; what few trees there are appear stiff and rigid, and are as dull and monotonous in color as they are ungraceful in form. Even the atmosphere, when it is not foggy and chilly, is colorless and toneless. Only in the far distance is there any delicacy and softness.

Thus, however grand it may be, and whatever interest it may possess, the region about San Francisco, is peculiarly destitute of

what I may denominate domestic beauty, and of that kind of interest which is appropriate to domestic occupation.

It would be audacious to suppose that even in a neighborhood of a mile or two in extent, these defects could be completely remedied, or that they could be remedied in any notable degree in a very short time, or without much judiciously applied labor. But, if what is proposed to be accomplished, is modestly conceived, and the requisite effort is made and sustained for a sufficient period, it is unquestionable that the more uninviting elements of the existing scenery may be reduced in importance, and its more attractive features presented to much greater advantage than they are under merely natural circumstances, or under any artificial conditions yet in existence. It may also be confidently anticipated that the result will be peculiarly home-like and grateful in contrast to the ordinary aspect of the open country of California.

For instance, if we imagine the greater part of your property to have passed in tracts of from two to five acres into the possession of men each of whom shall have formed, as a part of his private residence, a proper foreground of foliage to his own home outlook, it follows, from what I have before argued, that one of the chief defects of the scenery would be in a great degree remedied. For these bodies of rich and carefully nurtured foliage would form part of an artistic middle distance to all other points in the vicinity which would overlook them, and would so frame under the more distant prospect from these exterior points of view, that a strong gradation of aerial perspective would occur; and the fact will be observed that if the range of the eye is thus carried but to a certain distance, especially to the westward or southward, the view is everywhere exceedingly beautiful, both in respect to the form of the hills and their beauty of color and tone, under all atmospheric con-

ditions. Even in stormy weather, there is great grandeur in the movements of the clouds rolling over their sombre slopes and declivities, and I remember a single scene of this kind as one of the most impressive that I have ever witnessed. But on ordinary occasions the view to the westward, if the eye does not regard the dullness of the nearer part of the landscape, while it is one of great depth and breadth, is also one of peculiarly cheerful interest.

The main requirements of a plan, then, for the improvement of this region, with reference to residences, must be, first, so to arrange the roads upon which private property will front as to secure the best practicable landscape effects from the largest number of points of view; second, so to arrange the roads and public ground as to give the owners of the private property satisfactory outgoings, in respect, first, to convenience of use; second, to attractiveness in their borders; and, third, to command of occasional distant views and complete landscapes.

To meet the second of these requirements, the borders of the roads should be absolutely neat or even nice; there should be no raw banks or bare neglected looking places, nor drifts of rubbish by their side. . . .

The course of the roads, as laid down in the plan, generally follows the natural depressions of the surface, and I am strongly of the opinion that in these situations, if not on the more elevated parts of all the ground included in the plan, there would soon be a natural growth of trees and shrubs if perfect protection were secured for a few years from the action of fire and the close cropping of animals, and I can have no doubt that when the ground shall have been well trenched, nearly all the trees and shrubs which grow naturally in the more favored canyons of the Coast Range, as well as many others, if planted and carefully tended for two or three

years, would thereafter grow healthfully, rapidly, and in graceful forms.

It will be seen . . . that all the ground, not required for other purposes, is laid out in a number of divisions, varying in length and breadth, but each of such a form that it could be easily sub-divided by simple lines into lots, each of one to five acres in extent, of suitable shape and favorably situated in all respects for a family home. The relative position of the houses erected, and trees grown upon the different lots, may be such that the best view from each site will remain not only uninterrupted, but rather improved by that below it. The divisions are separated one from the other by land bordered, as already explained, on each side by continu-ous thick groves, and access to each private lot from these lanes is arranged by short approaches branching from them. The area of ground contained in these divisions is 195 acres, (including nearly 90 acres belonging to private owners between the college property and the adjoining public roads), and might with advantage be occupied by from 50 to 100 private families.

The lanes are arranged with reference to continuations to the northward and southward, should additional accommodation of the same character be hereafter found desirable. Connection is also made by shaded roads with the village already laid out in the vicinity, and a public garden, containing a children's playground, with a series of shaded walks and arbors about it, is provided for, adjoining this village.

Between the garden and the village, a street is widened so as to form a small plaza or village market place.

There are three entrances to the series of lanes from the general direction of San Francisco. One of these is intended to be ap-proached by a projected street railroad, and also by a direct ave-

nue from the proposed steamboat landing at that point of the bay which is nearest to the property. The second approach is through the midst of the village. The third is by a new road which I recommend should be laid out as a pleasure drive from Oakland. This road would be to the southward of, and run parallel with the present Telegraph road, until after it has passed the vicinity of the new cemetery, where it would curve upon a long radius to the left, and passing to the eastward of some of the lowest foot hills, cross the Telegraph road near the foot of the mountains, and approach Berkeley on a line parallel with the range, passing along the east side of the public garden, and reaching the vicinity of the College without entering the village, as shown upon the plan. Such a road would form a drive much more attractive than any now in use out of Oakland, and would lay open a most desirable region for residences all along the foot of the mountains. . . .

The extent of the sylvan lanes would be about five miles. At several points upon them there would be very fine distant views, each having some distinctive advantage. The local scenery would also at many points be not only quite interesting, even without any effort to produce special effects by planting, but it would have considerable variety, much more so than might be supposed from the drawing. The road is designed to be laid out in such a way as to make the most of the natural features, while preserving their completely sylvan and rural character, being carried with frequent curves in such a way as to make the best use of the picturesque banks of the arroyas and the existing trees upon them. These are sometimes allowed to divide it into two parts. Notwithstanding the varied curves which the arrangement involves, the general course of the lanes will be found simple and the connection between the more important points sufficiently direct. This is especially the

case with the approaches to the College site from the points nearest
it at which the neighborhood is entered.

A tract of low, flat ground, twenty-seven acres in extent, pleas-
antly surrounded on three sides by moderate elevations, two of
which retire so as to form a long bay or dell, is proposed to be
formed into a small park or general pleasure ground. The site is
naturally more moist, fertile and meadow-like than any other in
the vicinity and a considerable number of old and somewhat quaint
and picturesque oaks are growing in a portion of it. This occur-
rence, with a thick growth of underwood and of rank, herbaceous
plants, leads me to think if it were thoroughly drained, cleaned
and tilled, trees would naturally grow upon it in more umbrageous
and elegant forms than elsewhere, and that turf could be more
easily formed and maintained upon its surface. I recommend that
it should be surrounded by a thick plantation similar to that pro-
posed to be formed by the side of the lanes, and that in the front of
this, trees should be planted singly and in small detached groups, as
they are often seen in open pastures in the East, while in the central
portions of it a perfect living green sward should if possible be
formed. . . .

The main features of the plan have thus been sufficiently ex-
plained to show how it is intended to meet the principal require-
ment, namely, to offer inducements which will draw about the col-
lege a neighborhood of refined and elegant homes.

The second requirement of a plan was stated to be that, while
presenting domestic attractions, the improvements proposed should
not be of a character to draw about your college a noisy, disturbing
commerce, or anything calculated to destroy the general tranquility
of the neighborhood. It will be observed, that with reference to this
requirement, while the roads are so laid out as to afford moderately

direct routes of communication between the different parts of the neighborhood, they would be inconvenient to follow for any purpose of business beyond the mere supplying of the wants of the neighborhood itself, — that is to say, it would be easier for any man wishing to convey merchandise from any point a short distance on one side of your neighborhood to a point a short distance on the other side, to go around it rather than go through it. As a further protection, when it shall be found necessary, the property may be enclosed and gates established at the entrances, so as to exclude from the lanes whatever it may be thought undesirable to admit. This precaution would probably be unnecessary, however, for many years to come.

As you have been unable to instruct me what college buildings should be introduced, I have been obliged to trust to my own judgment of your probable requirements, and form a general building plan accordingly, taking care, however, that the area and the shape of the ground proposed to be reserved for the purpose, while fitted to such an arrangement as I conjecture will be satisfactory, should at the same time leave you with considerable freedom to vary from it.

I have thought it best to assume that two considerable buildings would be required at an early period of the history of the college. One designed to contain its library, records, and scientific collections, and therefore constructed of brick, stone and iron, and as nearly fireproof as you could afford to make it. The other to contain a general hall of assembly, and a series of class-rooms, lecture rooms, and rooms for the use of your faculty.

Whenever it should be found necessary in the future, to enlarge the library accommodations, the scientific collections might be removed to a new building, to be erected especially for that purpose, and the whole of the original building thus devoted to the library,

or if less than this should be required, a smaller building might be erected for a special division, or for certain departments of the scientific collections, as has been done at Amherst College, a single large building being there devoted to a special class of fossils, while the general geological collection remains in another. Whenever, also, the accommodations of the second building should be found insufficient, a new one may be erected for the purpose of general assembly, and the class-rooms be enlarged by the addition of the space occupied by the assembly hall in the original building.

With regard to dwellings for the students, my enquiries lead me to believe that the experience of eastern colleges is equally unfavorable with regard to the old plan of large barracks and commons, and to the plan of trusting that the student will be properly accommodated with board and lodging by arrangements with private families or at hotels. Establishments seem likely to be finally preferred, in which buildings erected by the College will be used, having the general appearance of large domestic houses, and containing a respectably furnished drawing-room and dining-room for the common use of the students, together with a sufficient number of private rooms to accommodate from twenty to forty lodgers.

If a similar plan should be adopted at Berkeley, there need never be any very large buildings erected there in addition to the two central ones which have been proposed, and as it would be equally convenient for all purposes, as far as I can see, and much more consistent with the character of scholarly and domestic seclusion, which it is desirable should pervade the neighborhood, I should contemplate the erection of no buildings for college purposes, whether large or small, except as detached structures, each designed by itself, and as would be found most convenient for the purpose to which it was to be devoted. In other words, I would propose to adopt a picturesque, rather than a formal and perfectly

symmetrical arrangement, for the two reasons that the former would better harmonize artistically with the general character desired for the neighborhood, and that it would allow any enlargement or modification of the general plan of building at present adopted for the college, which may in the future be found desirable.

I may observe that in the large Eastern colleges the original design of arranging all the buildings of a growing institution in a symmetrical way has in every case proved impracticable and been given up, while so far as it has been carried out it is a cause of great inconvenience and perplexity to those at present concerned.

With these views, having fixed a centre with which the different buildings to be hereafter erected as from time to time shall be found necessary, I propose to reserve from sale for private residences, as much ground in the vicinity of this centre as is likely to be needed for all purposes by your corporation in the future.

The central buildings are intended to be placed upon an artificial plateau at the head of the dell before described. This site, while moderately elevated, yet appears slightly embayed among the slopes of the hills on all sides except that toward the park, over which the outlook to the westward is unconfined and reaches to the horizon of the ocean. The west front of this plateau is designed to take the form of an architectural terrace from which two broad walks between the lines of a formal avenue lead directly to the head of the dell in the park. At the foot of these walks appropriate entrances are provided from a carriage way. . . .

The construction of the necessary plateau upon the site proposed will not be an expensive undertaking as the working plan will show, and the terrace may be finished, if desired, very plainly and cheaply. At the same time the introduction of a high degree of art, at any time in the future, will be practicable, in the form of statues, fountains, and a highly decorated parapet with tile and marble

pavement upon the terrace, and on each side of the broad-walks, the intermediate quadrangle and the stair and entrance ways.

Respectfully;
Fred. Law Olmsted.
Olmsted, Vaux & Co.,
110 Broadway,
New York, June 29th, 1866.

Riverside, Illinois:
A Planned
Community
near Chicago[29]

To the Riverside Improvement Company

Gentlemen:

You have requested a report from us, upon an enterprise which you desire to bring before the public, and which appears to rest on the following grounds:

First — Owing partly to the low, flat, miry, and forlorn character of the greater part of the country immediately about Chicago, and the bleak surface, arid soil, and exposure of the remainder to occasional harsh and frigid gusts of wind off the lake, and partly to the fact that the rapidity with which the town is being enlarged, causes all the available environs to be laid out with a view to a future demand solely for town purposes, and with no regard to the satisfaction of rural tastes, the city, as yet, has no true suburbs or quarters in which urban and rural advantages are agreeably combined with any prospect of long continuance.

Second — If, under these circumstances, sites offering any very decided and permanent advantages for suburban residences could be put in the market, there would at once be a demand for them, which would continue and increase with the enlargement and progress in wealth and taste of the population of the city.

Third — You have secured a large body of land, which, much beyond any other, has natural advantages for this purpose.

Fourth — If, by a large outlay, these advantages could be developed to the utmost, and could be supplemented by abundant artificial conveniences of a high order, and the locality could thus be rendered not only very greatly superior to any other near Chicago, but could be made to compare satisfactorily, on the whole, with the most favored suburbs to be found anywhere else, a good

29 Olmsted, Vaux & Co, "Preliminary Report upon the Proposed Suburban Village at Riverside, near Chicago" (New York: Sutton, Browne & Co., 1868), pp. 3–14, 16–18, 23–29.

return for such outlay might reasonably be expected.

We propose to review these grounds so far as they are not matters of fact easily put to the test of observation by those interested.

To understand the character of the probable demand for semi-rural residences near Chicago, it must be considered that the most prominent characteristic of the present period of civilization has been the strong tendency of people to flock together in great towns. This tendency unquestionably is concurrent, and probably identical, with an equally unprecedented movement of invention, energy, and skill, toward the production of certain classes of conveniences and luxuries, which, even yet, can generally be fully enjoyed by great numbers of people only in large towns. Arrangements for the easy gratification of certain tastes, which, until recently, were possessed by but a very few, even of the most wealthy class of any country, have consequently, of late, become common to thousands in every civilized land, while numerous luxuries, that the largest fortunes in the old world could not have commanded even half a century since, are enjoyed by families of comparatively moderate means, in towns which have sprung up from the wilderness, within the memory of some still living in them.

Progress in this way was never more rapid than at the present moment, yet in respect to the corresponding movement of populations there are symptoms of a change; a counter-tide of migration, especially affecting the more intelligent and more fortunate classes, although as yet of but moderate strength, is clearly perceptible, and almost equally so, in Paris, London, Vienna, Berlin, New York, Boston and Philadelphia. The most substantial manifestation of it perhaps, is to be found in the vast increase in value of eligible sites for dwellings near public parks, and in all localities of much natural beauty within several hours' journey of every great town.

Another evidence of the same tendency, not less conclusive because it indicates an impulse as yet undecided and incomplete, is found in the constant modification which has occurred in the manner of laying out all growing towns, and which is invariably in the direction of a separation of business and dwelling streets, and toward rural spaciousness in the latter. The broader the streets are made, provided they are well prepared in respect to what are significantly designated "the modern conveniences," and especially if some slight rural element is connected with them, as by rows of trees or little enclosures of turf and foliage, the greater is the demand for dwelling-places upon them.

There is no evidence that the large class of conveniences, comforts and luxuries, which have been heretofore gained by close congregation, is beginning to have less positive attractiveness or commercial value, but it is very clear that the conviction is becoming established in the minds of great numbers of people that the advance in this respect, which has occurred in towns, has been made at too great a sacrifice of certain advantages which can at present be only enjoyed by going out of them. That this is a sound conviction, and not a mere whim, caprice, or reaction of fancy, temporarily affecting the rich, fashionable and frivolous, appears from the fact that it is universally held as the result of careful study by philanthropists, physicians and men of science. . . .

It thus becomes evident that the present outward tendency of town populations is not so much an ebb as a higher rise of the same flood, the end of which must be, not a sacrifice of urban conveniences, but their combination with the special charms and substantial advantages of rural conditions of life. Hence a series of neighborhoods of a peculiar character is already growing up in close relation with all large towns, and though many of these are as yet

little better than rude over-dressed villages, or fragmentary half-made towns, it can hardly be questioned that, already, there are to be found among them the most attractive, the most refined and the most soundly wholesome forms of domestic life, and the best application of the arts of civilization to which mankind has yet attained.

It would appear then, that the demands of suburban life, with reference to civilized refinement, are not to be a retrogression from, but an advance upon, those which are characteristic of town life, and that no great town can long exist without great suburbs. It would also appear that whatever element of convenient residence is demanded in a town will soon be demanded in a suburb, so far as is possible for it to be associated with the conditions which are the peculiar advantage of the country, such as purity of air, umbrageousness, facilities for quiet out-of-door recreation and distance from the jar, noise, confusion, and bustle of commercial thoroughfares.

There need then be no fear that a happy combination of these conditions would ever fail to be exceedingly attractive to the people of Chicago, or that a demand for residences where it is found, would be liable to decline; on the contrary, it would be as sure to increase, as the city is sure to increase in population and in wealth, and for the same reason.

We proceed to consider the intrinsic value of your property for the purpose in view.

The question of access first demands attention. The centre of the proposed suburb is nine miles from the business centre of Chicago, the nearer points being about six miles apart. There is a double-track railroad from Chicago of remarkably good construction, with its first out-of-town station, at which every train is required to

stop, in the midst of your property. The advantages of the locality, in this respect, are already superior to those of many thriving suburbs.

A railroad, however, at the best affords a very inadequate and unsatisfactory means of communication between a rural habitation and a town, either for a family or for a man of business: as, moreover, one of the chief advantages of a suburban home, is the opportunity which it gives of taking air and exercise in driving, riding, and walking, it is a great desideratum, especially where time is so valuable as it is generally in Chicago, that a business man should be able to enjoy such an opportunity incidentally to his necessary communication with his store or office.

We find that the surface of the country over which a drive must be taken to reach your property, examined with reference to this requirement, is like the country generally about Chicago, not merely uninteresting, but, during much of the year, positively dreary. Driving across it, at present, so far from being a diversion or matter of pleasure, is a tedious task. Being nearly a dead flat, its natural drainage is very bad, parts of it are marshy, and the whole, after storms, is miry, and remains for a long time half covered with broad mud-puddles. Since railroads were established, the intercourse between the town and country, in this direction, by ordinary-wheeled vehicles, has been so slight that the old roads, which were never tolerably well-made, are scarcely kept in sufficiently good order to be traveled safely, even by very strong and heavy wagons. In their best condition they are extremely rough, and require slow and cautious driving, while in the Spring they are sometimes quite impassible.

It is obvious that no ordinary arrangement will suffice to make a rapid drive in a light carriage, or a canter on horseback, over this region, one that can be daily taken with pleasure throughout

the year, or to prevent the attempt to secure exercise and recreation in this way from becoming an intolerably tedious effort on the part of any suburban resident who wishes to attend to business in town. . . .

On reviewing these conditions we conclude that the formation of an approach road, much better adapted to the requirements of pleasure-driving than any other leading out of Chicago, and with varied and agreeable accessories and appurtenances, is perfectly practicable.

We should advise you, in the first place, to obtain possession, if possible, of a strip of ground from two hundred to six hundred feet wide, extending from the city to the nearest border of your property, to secure its thorough drainage, to plant it with trees, and to carry through it a series of separate, but adjoining ways, especially adapted in construction — first for walking, second for riding, third for pleasure-driving, and fourth to give convenient access to houses to be built on the route and accommodate heavy freighting, without inconvenience to the through pleasure travel.

The main drive should be constructed in a very thorough and finished manner, so that, without perfect rigidity of surface, it will be storm- and frost-proof.

The ride should adjoin the drive, so that equestrians can at pleasure turn from it to converse with friends in carriages; it should have a soft and slightly yielding surface, that the great jar and danger of slipping, which occurs in a paved road, may be avoided.

The grateful influences of the grove extending through the prairie, with the amelioration of climate and soil which would result from thorough drainage and wind-breaks, and the advantages which would be found in the several proposed means of communication at all seasons of the year, would be such that con-

tinuous lines of villas and gardens would undoubtedly soon be established adjoining it, and the hour's drive through it, necessary to reach your property, would be neither tedious nor fatiguing.

At certain intervals upon the route, it would be desirable to provide openings with some special decorations, and here should be sheltered seats and watering places.

We see no reason why, if this suggestion is carried out liberally, it should not provide, or, at least, begin to provide, another pressing desideratum of the city of Chicago, namely, a general promenade ground. . . .

By making the accommodations of your approach sufficiently large and sufficiently attractive, by associating with it several turning-points and resting-places in the midst of pleasure-grounds of moderate extent, your enterprise would, therefore, not merely supply Chicago, as you propose that it shall do, with a suburb, as well adapted as any of the suburbs of other cities, both for permanent habitations and country seats, and for occasional rural fêtes and holiday recreations of families living in the town, but, in all probability, would provide it also with a permanent promenade-ground, having a character peculiar to itself, and not without special advantages. This result would be greatly enhanced if, as would probably be the case, certain entirely practicable improvements of the plan of the city should be made in connection with the construction of your approach.

The benefit which would result from this to your original enterprise is evident. Having means of communication with the city through the midst of such a ground, made gay and interesting by the movement of fine horses and carriages, and of numbers of well-dressed people, mainly cheerful with the enjoyment of recreation and the common entertainment, the distance would not be

too great for the interchange of friendly visits, for the exercise of hospitality to a large circle of acquaintance, or for the enjoyment of the essential, intellectual, artistic, and social privileges which specially pertain to a metropolitan condition of society; and yet it would be sufficient to justify a neglect, on the part of a suburban resident, of most of those ceremonial social duties which custom seems to require, and in which so much time is necessarily spent in all great towns. . . .

We proceed to consider the artificial requirements.

The chief advantages which a suburb can possess over a town on the one hand, and over a wilderness on the other, will consist in those which favor open-air recreation beyond the limits which economy and convenience prescribe for private grounds and gardens. The main artificial requirements of a suburb then, are good roads and walks, pleasant to the eye within themselves, and having at intervals pleasant openings and outlooks, with suggestions of refined domestic life, secluded, but not far removed from the life of the community.

The misfortune of most existing suburbs is, that in such parts of them as have been built up little by little, without any general plan, the highways are usually adapted only to serve the bare irresistible requirements of agriculture, and that in such other parts as have been laid out more methodically, no intelligent design has been pursued to secure any distinctly rural attractiveness, the only aim apparently being to have a plan, which, seen on paper, shall suggest the possibility of an extension of the town-streets over the suburb, and of thus giving a town value to the lots upon them.

Exactly the opposite of this should be aimed at in your case, and, in regard to those special features whereby the town is distinguished from the country, there should be the greatest possible contrast

which is compatible with the convenient communication and pleasant abode of a community; economy of room, and facilities for business, being minor considerations.

In the highways, celerity will be of less importance than comfort and convenience of movement, and as the ordinary directness of line in town-streets, with its resultant regularity of plan would suggest eagerness to press forward, without looking to the right hand or the left, we should recommend the general adoption, in the design of your roads, of gracefully-curved lines, generous spaces, and the absence of sharp corners, the idea being to suggest and imply leisure, contemplativeness and happy tranquility.

Without turf, and foliage, and birds, the character of the highways, whatever their ground plan, would differ from those of the town chiefly in the quality of desolation and dreariness. Turf and trees should abound then, and this implies much space in the highways, besides that which is requisite for the passage of vehicles and people on foot.

The first requirement of convenience in a wheelway or footway is cleanliness and smoothness of surface. The fact that this primary requirement is found in American suburban highways, much less frequently, even, than in towns, notwithstanding the apparent disadvantages of towns growing out of the greater amount of travel which their highways have to sustain, shows how difficult it must be to secure, and makes it our business to enquire in what the difficulty consists.

The chief essential difference between town and suburban highway arrangements comes from the fact that in the suburb there is much greater space on an average between the houses fronting upon the roadways than in the town. . . . This, as far both as general rural effect and domestic seclusion is concerned, gives a clear advantage, against which experience will simply place the greater

inconvenience of communication between the carriage-way and the house-door.

There is but one remedy for this inconvenience which will not be destructive of neatness and good order in the road, and that is the adoption of private roads leading into the house lots.

It should here be considered that there is nothing in all the expensive constructions which have been prescribed as the necessary foundation work of a satisfactory suburban highway, that would attract as much attention as the rude and inefficient appointments ordinarily seen. There is nothing townlike about them, narrow strips of clean gravel, with other strips of undulating turf from the higher parts of which trees would spring, are all that would appear of them above ground. But all that can be said of this arrangement is that it is inoffensive; it is convenient and tidy, nothing more. Line a highway, so formed, with coal-yards, breweries, forges, warehouses, soap-works, shambles, and shanties, and there certainly would be nothing charming about it. Line it with ill-proportioned, vilely-colored, shabby-genteel dwelling-houses, pushing their gables or eaveboards impertinently over the sidewalk as if for the advertising of domestic infelicity and eagerness for public sympathy, and it would be anything but attractive to people of taste and refinement. Line it again with high dead-walls, as of a series of private mad houses, as is done in some English suburbs, and it will be more repulsive to many than the window-lighted walls of the town blocks. Nothing of this kind is wanted in a suburb or a rural village. Nothing of this kind must be permitted if we would have it wholly satisfactory. On the contrary, we must secure something very different.

We cannot judiciously attempt to control the form of the houses which men shall build, we can only, at most, take care that if they build very ugly and inappropriate houses, they shall not be al-

lowed to force them disagreeably upon our attention when we desire to pass along the road upon which they stand. We can require that no house shall be built within a certain number of feet of the highway, and we can insist that each house-holder shall maintain one or two living trees between his house and his highway-line.

A few simple precautions of this kind, added to a tasteful and convenient disposition of shade trees, and other planting along the roadsides and public places, will, in a few years, cause the whole locality, no matter how far the plan may be extended, to possess, not only the attraction of neatness and convenience, and the charm of refined sylvan beauty and grateful umbrageousness, but an aspect of secluded peacefulness and tranquility more general and pervading than can possibly be found in suburbs which have grown up in a desultory, haphazard way. If the general plan of such a suburb is properly designed on the principles which have been suggested, its character will inevitably also, notwithstanding its tidiness, be not only informal, but, in a moderate way, positively picturesque, and when contrasted with the constantly repeated right angles, straight lines, and flat surfaces which characterize our large modern towns, thoroughly refreshing. . . .

The suggestion that your property might be formed into a "park," most of the land within which might be divided by lines, mainly imaginary, into building lots, and sold as demand should require, has been publicly made with apparent confidence in its feasibility and advantage, and as it seems to have attractions, we shall endeavor to show why we cannot advise you to adopt it.

The landscape character of a park, or of any ground to which that term is applied with strict propriety, is that of an idealized, broad stretch of pasture, offering in its fair, sloping surfaces, dressed with fine, close herbage, its ready alternatives of shade with

sunny spaces, and its still waters of easy approach, attractive promises in every direction, and, consequently, invitations to movement on all sides, go through it where one may. Thus the essential qualification of a park is *range*, and to the emphasizing of the idea of range in a park, buildings and all artificial constructions should be subordinated.

The essential qualification of a suburb is domesticity, and to the emphasizing of the idea of habitation, all that favors movement should be subordinated. Thus the two ideals are not likely to be successfully followed on the same ground. One or the other should be abandoned wholly. The greater part of your Riverside property has hardly any specially good conditions for a park, while it has many for a suburb.

There are two aspects of suburban habitation that need to be considered to ensure success; first, that of the domiciliation of men by families, each family being well provided for in regard to its domestic indoor and outdoor private life; second, that of the harmonious association and co-operation of men in a community, and the intimate relationship and constant intercourse, and inter-dependence between families. Each has its charm, and the charm of both should be aided and acknowledged by all means in the general plan of every suburb.

As, however, it can be no part of a general plan to provide for the interior arrangements of ground which is to be private, the domestic advantages which a suburb will possess can be little more than suggested through the arrangement of the means of division, and of passage between private and public ground. It is especially desirable, therefore, that these means of division and of passage should be carefully studied. They should be enjoyable in themselves; they should on no account be imaginary lines, nor should they be obscured or concealed. . . .

We should recommend the appropriation of some of the best
of your property for public grounds, and that most of these should
have the character of informal village-greens, commons and play-
grounds, rather than of enclosed and defended parks or gardens.
We would have, indeed, at frequent intervals in every road, an
opening large enough for a natural group of trees, and often pro-
vide at such points croquet or ball grounds, sheltered seats and
drinking fountains, or some other objects which would be of gen-
eral interest or convenience to passers-by.

It will probably be best to increase the height of the mill-dam so
as to enlarge the area of the public water suitable for boating and
skating, and so as to completely cover some low, flat ground now
exposed in low stages of the river. At the same time, a larger outlet
should be provided to prevent floods above the dam from injuring
the shore. A public drive and walk should be carried near the edge
of the bank in such a way as to avoid destroying the more valuable
trees growing upon it, and there should be pretty boat-landings,
terraces, balconies overhanging the water, and pavilions at points
desirable for observing regattas, mainly of rustic character, and
to be half overgrown with vines.

All desirable improvements of this character, more and better
than can be found in any existing suburb in the United States, can
be easily supplied at comparatively small cost. That which it is of
far more consequence to secure at the outset, and which cannot be
obtained at small cost, unfortunately, is a system of public ways
of thoroughly good construction.

As we have already shown, in speaking upon the question of
approach, your property is not without special advantages for this
purpose, and, on the whole, we feel warranted in expressing the
opinion that your scheme, though it will necessarily require a large
outlay of capital, is a perfectly practicable one, and if carried out

would give Chicago a suburb of highly attractive and substantially excellent character. . . .

Respectfully,
Olmsted, Vaux & Co.,
Landscape Architects.
110 Broadway, New York, Sept. 1, 1868.

Index